LOS ANGELES COUNTY MUSEUM OF ART

JAPANESE

AGENCY FOR CULTURAL AFFAIRS, GOVERNMENT OF JAPAN

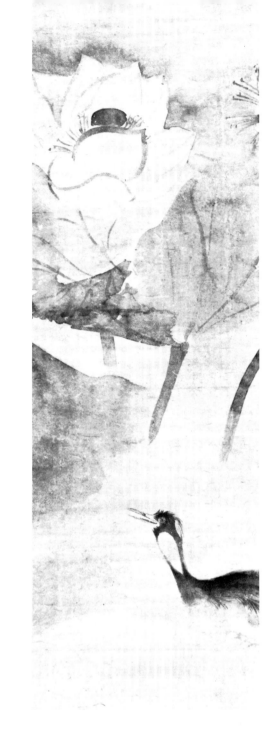

INK PAINTING

Miyajima Shin'ichi

Satō Yasuhiro

George Kuwayama
Editor

O
ND
2071
.M59
1985

Los Angeles County Museum of Art
March 10–May 12, 1985

This exhibition has been made possible by grants from the National Endowment for the Arts, the Japan Foundation, and the California Arts Council, and by an indemnity from the Federal Council on the Arts and the Humanities.

Library of Congress Cataloging in Publication Data

Miyajima, Shin'ichi.
 Japanese ink painting.

 Catalogue of a loan exhibition of Japanese ink painting, Los Angeles County Museum of Art, March 10–May 12, 1985.
 Bibliography: p.
 Includes index.
 1. Ink painting, Japanese—Kamakura-Momoyama periods, 1185–1600.
2. Ink painting, Japanese—Edo period, 1600–1868—Exhibitions. I. Kuwayama, George.
II. Satō, Yasuhiro. III. Los Angeles County Museum of Art. IV. Japan. Bunkachō.
ND2071.M59 1985 759.952'074'019494 84-26088

ISBN 0-87587-123-2

Published by the Los Angeles County
Museum of Art
5905 Wilshire Boulevard
Los Angeles, California 90036

Cover: *Water Birds on a Lotus Pond* (cat. no. 35)
Front endsheet: *Herons under Willows*
(detail, cat. no. 22)
Back endsheet: *Sparrows in Bamboo*
(detail, cat. no. 22)

CONTENTS

FOREWORD

The Los Angeles County Museum of Art is extremely pleased and honored to present a major international loan exhibition of Japanese ink painting. It is one more instance of the close cultural relations that the United States and Japan enjoy. This exhibition, which will be shown only in Los Angeles because of the extreme delicacy and rarity of the objects, permits our museum visitors to see and appreciate an astonishing achievement of Japanese art: a wide range of images from subtle, intuitive statements to powerful, expressionistic works created by an agile brush with monochrome ink.

We are especially appreciative of the large number of masterpieces, classified by the Japanese government as National Treasures, Important Cultural Properties, and Important Art Objects, which were lent to this exhibition. Included are the rare, subtly rendered landscapes of the Muromachi period by Bunsei, Sesshū, and Sesson; the monumental Daitokuji panels by Kanō Eitoku; and the magnificent screens by Tōhaku, Yūshō, and Tōgan. Equally splendid are the paintings by Sōtatsu and Kōrin, by the Maruyama and Shijō masters, and the bizarre images created by the Kyoto Eccentrics. Perhaps the most stunning, and certainly the most broadly represented, are the works by Nanga artists with the inclusion of famous masterpieces by Hyakusen, Taiga, Buson, Gyokudō, and Mokubei. Especially intriguing are the little-known new discoveries that are part of this exhibition, superb paintings that have been secreted away in private vaults and temple storehouses, in some cases for many centuries.

Los Angeles today has evolved into a major international cultural center and its ties to Japan are not only historical but cultural. Japanese influence can be seen as importantly influencing architecture, landscape design, painting, and ceramics. And soon the Los Angeles County Museum of Art will construct a separate pavilion to house the art of Japan, made possible by a generous gift from Mr. and Mrs. Joe D. Price.

This exhibition could not have been held without the generous support given by the Bunkachō, the Agency for Cultural Affairs of the Japanese government. A debt of gratitude is owed Suzuki Isao, commissioner general of the Bunkachō, Kato Moriyuki, vice-commissioner general, Nishikawa Kyōtarō, councillor, and Yamamoto Nobuyoshi, director of its Fine Arts Division. Bunkachō staff members have worked closely with us in organizing this exhibition, obtaining loans, and writing portions of the catalogue. I also wish to thank George Kuwayama, senior curator of Far Eastern Art, who has curated the exhibition for the museum.

Earl A. Powell III
Director, Los Angeles County Museum of Art

PREFACE

Every year the Agency for Cultural Affairs, Bunkachō, collaborates with major art museums in sponsoring exhibitions designed to introduce Japanese culture to the peoples of other countries, thereby fostering international understanding through the medium of cultural properties. Now, together with the Los Angeles County Museum of Art, we are pleased to present the exhibition *Japanese Ink Painting*.

It is well known that ink painting (*sumi-e*) arose during the Tang dynasty in China. Upon its spread to Korea and Japan, ink painting continued to develop independent characteristics in those countries. Although ink painting only flourished among those peoples who employed the simple tools of brush and ink for written and pictorial expression, in recent years the audience for ink painting has broadened. Yet the many great American and European collections largely concentrate on Chinese, rather than Japanese, ink painting.

Japanese ink painting manifested individual tendencies from an early stage, but it would be impossible in a single exhibition to trace the entire history of this subject. Many years have passed since the exhibition in 1970 of *Zen Painting and Calligraphy* held at the Museum of Fine Arts, Boston. That exhibition brought together masterpieces of Chinese and Japanese art dating largely from the fourteenth through seventeenth centuries. The paintings in this exhibition depart in spirit and subject matter from those of an earlier age. From the seventeenth century onward, individual painters began to free themselves from traditional subjects and techniques in order to experiment with the vast potentials of the brush-and-ink medium. Thus this exhibition primarily illustrates creative innovations in the works of these later artists.

Both to safeguard their preservation and exhibit a greater variety of paintings, the exhibition has been divided into two sections. The first presentation highlights masters of the Momoyama period: Kanō Eitoku, Hasegawa Tōhaku, Unkoku Tōgan, and others are represented by bold compositions in large format. Tawaraya Sōtatsu's masterful *Water Birds on a Lotus Pond* is one of the finest of all Japanese works in ink wash. The second half of the exhibition brings together major literati (*bunjin*) painters, Ike no Taiga and Yosa Buson, as well as late Edo-period individualists such as Itō Jakuchū, Soga Shōhaku, and Maruyama Ōkyo. Although exhibitions devoted either to individual painters or their schools have flourished in recent years, this is a significant first attempt to spotlight the great range of artists and styles within the whole of late ink painting.

The Los Angeles County Museum of Art has collaborated with the Agency for Cultural Affairs ever since the 1965 exhibition *Art Treasures from Japan*. That exhibition presented a survey of Japanese art in all media from the Nara to Edo periods. Since that time specialized exhibitions throughout the United States have become more common. Indeed, we were gratified that the 1983 exhibition of Japanese narrative scrolls, *Emaki*, held at the Asia Society in New York, was cited by the *New York Times* as one of the year's ten best exhibitions. Although ink painting appears to be the opposite pole from the lavish beauty of Japanese picture scrolls, it is nevertheless equally representative of Japanese art. We sincerely hope that the strong character and subtle depths of the works exhibited here will achieve similar success.

I would like to extend my heartfelt thanks to the director of the Los Angeles County Museum of Art, Earl A. Powell III, to his diligent staff, and to the many Japanese collaborators who helped bring this exhibition to fruition.

Suzuki Isao
Commissioner General, Agency for Cultural Affairs

ACKNOWLEDGMENTS

S umi-e ink painting is the unique artistic contribution of East Asian art and a subject of absorbing interest for all those interested in Japanese culture. This exhibition of sumi-e was first conceived in 1979 and after several metamorphoses it has taken its present form. An agreement was reached in 1982 between Earl A. Powell III, director of the Los Angeles County Museum of Art, and Yamamoto Nobuyoshi, chief of the Fine Arts Division of the Bunkachō, the official Japanese Agency of Cultural Affairs, to develop cooperatively a major exhibition on the subject of Japanese ink painting. The assistance of Professor Sasaki Jōhei of Kyoto University, formerly on the staff of the Bunkachō, was invaluable in these negotiations. Without the support of the members of the Board of Trustees of the Los Angeles County Museum of Art and the able leadership and continuing encouragement given by its director, this exhibition would not have taken place.

Japanese Ink Painting is the happy result of the cooperative efforts of a large number of people. First and foremost are the staff members of the Bunkachō. To Yamamoto Nobuyoshi, to Watanabe Akiyoshi, head of the Painting Department, and to that department's curatorial staff members Miyajima Shin'ichi and Satō Yasuhiro go our sincerest thanks for selecting the paintings, negotiating the loans, and arranging for their presentation in Los Angeles. Messrs. Miyajima and Satō also wrote the accompanying art historical essays and annotated commentary on each of the paintings for the catalogue. The difficult task of translation and English adaptation was undertaken by Christine Guth Kanda for Mr. Miyajima's essay and by Karen L. Brock for Mr. Satō's essay as well as for all the annotated entries. The catalogue was produced by the talented efforts of Myrna Smoot, assistant director for Museum Programs, and her staff. The handsome design is the work of Sandy Bell; the English text was judiciously edited by Mitch Tuchman.

The exhibition installation was designed by Bernard Kester, and the complex tasks of construction and preparation were executed by James Peoples and his staff of carpenters, painters, electricians, and preparators. The intricacies of registration, shipping, and insurance were attended to by Renee Montgomery and her assistants, while the problems of environmental control and preservation were assuaged by William Leisher and his capable staff of conservators. The Press Office, led by Pamela Jenkinson Leavitt, has ably disseminated information about this important international cultural event. William Lillys and Jane Burrell of the Education Department have coordinated an illuminating program of educational events. Previously as curatorial assistant, Far Eastern Art, Ms. Burrell assisted in the organization of this exhibition during its formative stages. Finally, I would especially like to thank Hollis Goodall-Cristante of the Far Eastern Art Department for her unstinting efforts in all phases of this exhibition.

George Kuwayama
Senior Curator, Far Eastern Art

LENDERS TO THE EXHIBITION

Bekka Hiroaki Collection, Shimane Prefecture
Bunkachō
Chōdenji, Mie Prefecture
Chōrinji, Tochigi Prefecture
Egawa Art Museum, Hyōgo Prefecture
Enkōji, Kyoto
Gumma Prefectural Modern Art Museum
Hasegawa Jirobei Collection, Mie Prefecture
Hasegawa Yoshio Collection, Yamagata Prefecture
Idemitsu Art Museum, Tokyo
Ii Family Collection, Shiga Prefecture
Imperial Household Collection
Izumi City Kubosō Memorial Museum
Jukōin, Daitokuji, Kyoto
Kaizōji, Aichi Prefecture
Kanmanji, Akita Prefecture
Kawabata Yasunari Kinenkan, Kanagawa Prefecture
Kumaya Art Museum, Yamaguchi Prefecture
Kurokawa Kobunka Kenkyūjo, Hyōgo Prefecture
Kyoto National Museum
Kyūridō Bunko, Kyoto
MOA Art Museum, Shizouka Prefecture
Maruoka Muneo Collection, Tokyo
Masaki Art Museum, Osaka
Matsushita Kōnosuke Collection, Hyōgo Prefecture
Nagoya Castle, Aichi Prefecture
Nagoya Municipal Museum, Aichi Prefecture
Ogino Kyūjirō Collection, Okayama Prefecture
Ohara Ken'ichirō Collection, Kyoto
Osaka Municipal Museum
Osumi Yaemon Collection, Shiga Prefecture
Saifukuji, Osaka
Seikadō, Tokyo
Seiryōji, Kyoto
Sennyūji, Kyoto
Shimosaka Nichinan Collection, Tokyo
Shinjuan, Daitokuji, Kyoto
Sumitomo Kichizaemon Collection, Kyoto
Takahashi Haseo Collection, Yamagata Prefecture
Takahashi Kayo Collection, Kyoto
Teramura Yōko Collection, Kyoto
Tokyo National Museum
Tokyo University of Fine Arts
Tomioka Masutarō Collection, Kyoto
Wakimura Reijirō Collection, Kanagawa Prefecture
Yabumoto Kōzō Collection, Hyōgo Prefecture
Yabumoto Sōshirō Collection, Tokyo
Yamaguchi Prefectural Museum
Yamauchi Yūkō Collection, Tokyo
Zenrinji, Kyoto
Several anonymous private collections in Japan

PRE-MEIJI JAPAN

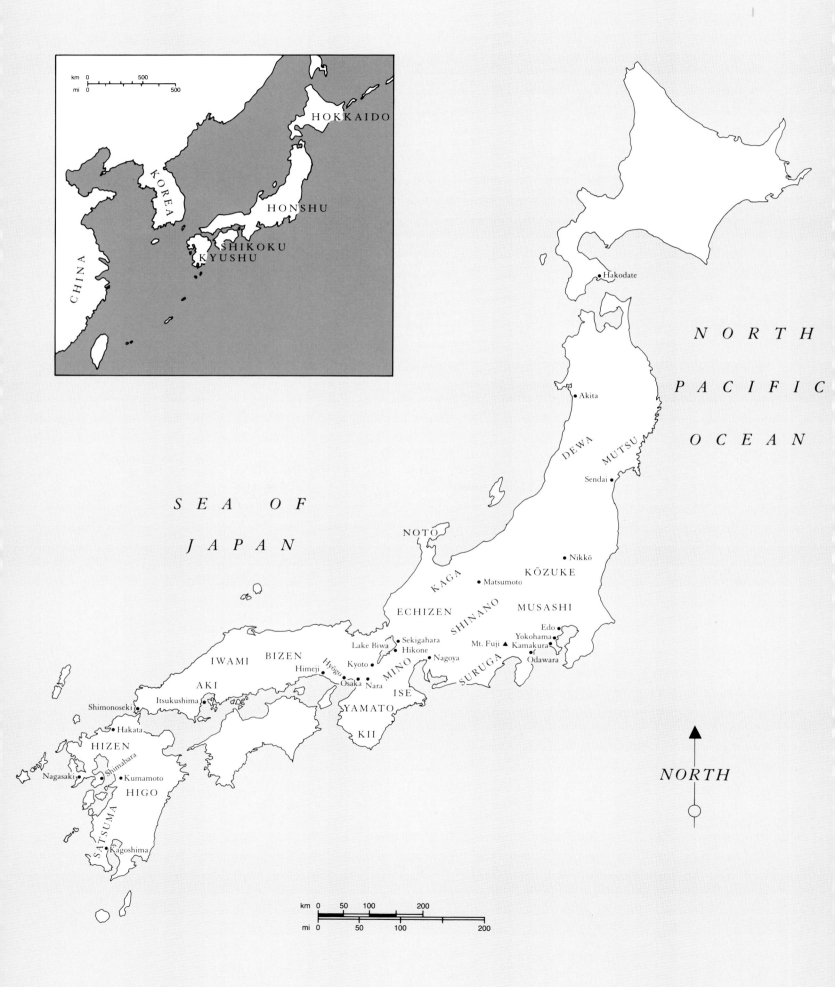

HOKKAIDO

KOREA

CHINA

HONSHU

SHIKOKU
KYUSHU

km 0 500
mi 0 500

Hakodate

NORTH

PACIFIC

OCEAN

Akita

DEWA

MUTSU

Sendai

SEA OF

JAPAN

NOTO

Nikkō

KAGA

KŌZUKE

Matsumoto

ECHIZEN

SHINANO

MUSASHI

Edo

Sekigahara

Lake Biwa

Hikone

Yokohama

IWAMI

BIZEN

Nagoya

Mt. Fuji ▲ Kamakura

Himeji

Hyōgo

Kyoto

MINO

SURUGA

Odawara

AKI

Osaka

Nara

ISE

Shimonoseki

Itsukushima

YAMATO

Hakata

KII

HIZEN

Nagasaki

Shimabara

Kumamoto

HIGO

SATSUMA

Kagoshima

NORTH

km 0 50 100 200
mi 0 50 100 200

CHRONOLOGICAL CHARTS

Chinese historical periods

Prehistoric	to 1523 B.C.
Shang dynasty	1523–1028 B.C.
Zhou dynasty	1027–221 B.C.
Qin dynasty	221–206 B.C.
Han dynasty	206 B.C.–A.D. 220
Three Kingdoms	A.D. 220–265
Six Dynasties	265–581
Sui dynasty	581–618
Tang dynasty	618–906
Five Dynasties	907–960
Northern Song dynasty	960–1127
Southern Song dynasty	1127–1279
Yuan dynasty	1279–1368
Ming dynasty	1368–1644
Qing dynasty	1644–1912
Modern period	1912–

Japanese historical periods

Jōmon period	4500–200 B.C.
Yayoi period	c. 200 B.C.–A.D. 250
Kofun period	c. 250–552
Asuka period	552–645
Nara period	645–794
Early Nara (Hakuhō)	645–710
Late Nara (Tempyō)	710–794
Heian period	794–1185
Early Heian (Jōgan)	794–897
Late Heian (Fujiwara)	897–1185
Kamakura period	1185–1392
Nambokuchō period	1333–1392
Muromachi period	1392–1568
Momoyama period	1568–1615
Edo period	1615–1868
Meiji period	1868–1912
Taishō period	1912–1926
Shōwa period	1926–

INTRODUCTION

George Kuwayama

Sumi-e ink painting more than any other medium best expresses the Japanese aesthetic sensibility. Wielding a brush dipped in black ink, the artist created ineffable forms, defining mass or suggesting movement. Strong, simple strokes, effortlessly laid down, emerged from years of practice and the profound understanding that accrued with time. In successful works the inspired spirit of a master infused abstract ink forms with a vital force. Sumi-e is the incomparable artistic contribution of the Far East.

In the West oil has been the preferred medium for painting. A palette of brilliant colors, the play of light and shade, and the illusionistic depiction of mass and space have engrossed European and American artists for centuries. While the human figure has been the enduring theme in Western civilization, in East Asia the landscape (*sansui*), birds and flowers (*kachō*), and nature's other myriad forms have absorbed the attention of artists. It is a naturalistic rather than an anthropocentric view of the world, in which man ceases to be the measure of all things.

Unique Aspects of Japanese Art

A recurring cycle of cultural importation from the Chinese mainland followed by a period of assimilation and native development has been a fundamental characteristic of Japanese civilization. Two grand cycles can be defined, one from the Asuka through the Heian periods and the other from the Kamakura through the Muromachi to the secluded Edo period. Intermittent influences from East Asia and the West occurred during the later eras of Momoyama and Edo.

The history of Japanese painting can be broadly categorized into two major stylistic traditions with numerous offshoots: Yamato-e, a Japanese style, and Kara-e, or Kanga, a Sino-Japanese style utilizing sumi-e, or *suibokuga*.[1]

Yamato-e arose during the Heian period, a time of reflection and reassessment after several centuries of intense Chinese influence. It was a colorful, refined, and decoratively composed style that grew out of the polychrome Buddhist and secular painting of Tang China, which was introduced to Japan in the Nara period. Fine, wirelike lines defined forms filled with opaque color, in which highly saturated paints were thickly applied in flat planes. Gorgeous compositions that were conceptually decorative resulted. With Yamato-e, Japanese painting acquired its native character and an artistic mode consonant with Japanese aesthetic aspirations.

The Japanese preference for Zen Buddhism during the Kamakura and Muromachi periods and the adoption of Chinese Southern Song culture into Japanese life led to the introduction of Song-Yuan- and Ming Zhe-school sumi-e ink painting styles. These austere Kanga styles, with their strong brushwork, repudiated the chromatic and decorative qualities of Yamato-e and exploited the expressive possibilities inherent in the calligraphic line and in the infinite range of ink tones from the lightest gray to the deepest black.

The ancient Sino-Japanese art of calligraphy was fostered by a written language of pictographic and ideographic characters. These required not only technical facility with brush and ink but an acute awareness of the challenges of spatial planning within a two-dimensional format as well. The constant writing of these characters naturally developed an artistic sensitivity to compositional balance, proportion, and dramatic accent. There is a close relationship between the calligraphic strokes in a character and the dots, dabs, and brush strokes that comprise the type-forms, or building blocks, of a painting. A calligraphic line can evoke a sense of mass and space. The narrowing and widening trail of a moving brush can produce powerful plastic forms. There can be a play of light and shade in a single

stroke through a changing balance of ink and water.

Sumi-e artists preferred monochrome ink to the use of color because of the medium's greater subtlety and richness of expression. The artist always strove to imbue his painting with a spiritual vitality that captured the natural rhythm and essence of his subject. The skillful handling of the brush, with a bravura of line and nuance of tone, resulted in a spontaneously executed work with an asymmetrically arranged composition and dynamic use of negative space.

These stylistic elements became the fundamental bases of Japanese ink painting from the fourteenth to the sixteenth centuries. Utilizing divergent methods and the artistic vocabulary of Song-Yuan, Japanese painters created works of art with a sensibility and spirit that was innately Japanese. They produced an abstract medium of understated forms that required the viewer to participate in the creative act, completing the suggested images in his mind. Although this exhibition and catalogue concentrate on the development of sumi-e from late Muromachi through Edo, the history of Japanese painting is largely an account of the independent existence of and interaction between Yamato-e and sumi-e.

Distinctions among Far Eastern Painting Traditions

The Japanese, the Chinese, and the Koreans share a civilization rooted in ancient China, but their cultures and aesthetic sensibilities differ markedly. The Japanese have a preference for stylistic perfection, seen, for instance, in balanced, asymmetrical compositions, which are marvels of abstract design, independent of their meaning or content. This is expressed in the Japanese genius for decorative design.

Although the art of sumi-e had its roots in China, it flowered differently in Japan than it did in China. The Chinese ideal of the artist as a cultivated gentleman and the narrow definition of fine art as calligraphy and painting led to the creation of magnificent and highly idiosyncratic expressions whose forms and iconography were rooted in Chinese art history. In Japan fine art was less narrowly defined, and Japanese artists often excelled in a variety of arts from ceramics to calligraphy, bringing the experience and insights gained in one to the enrichment of another. The work of Miyamoto Niten, Kōrin, and Mokubei, for instance, exemplify this.

Korean painting was admired for its expressive vigor and emulated by Japanese artists during the Muromachi period and perhaps again in the eighteenth century with the works of the Kyoto eccentrics. During the Yi dynasty (1392–1910), Korean painting was strongly influenced by Chinese traditions, but a uniquely Korean style arose illustrating native subjects and executed with strong, expressionistic brushwork, abstract texturing, and an enchanting naivete.

A Historical Survey of Japanese Sumi-e

From the developments of the Kamakura era, the arts advanced during the Muromachi. These were centuries notable for their cultural achievements which firmly established ink painting as well as other Japanese arts, among them the tea ceremony and the Nō drama. It was also an era that saw a number of architectural developments, such as the tea room and *tokonoma* alcove for the domestic display of paintings and other precious objects. During the succeeding Momoyama period the rise to power of a new group of military lords led to the construction of castles and grand palaces. Their interior halls were embellished with monumental wall and screen paintings intended to impress both friend and foe by their splendor. A grand style of ink painting with powerful lines and strong tonal contrasts arose which was consonant with the heroic character of the age.

13

The foundation was thus laid by the late Muromachi and Momoyama periods for painting styles that flourished in the Edo period, during which there was an amazing proliferation of schools and styles. With the closing of Japan to foreign contact in 1641, the inventive energies of the Japanese people turned inward, as they had during the Heian period.

Traditionally patronage in Japan came from the court, military rulers, Buddhist temples, and Shinto shrines. During the Edo period the masters of the Tosa and Sumiyoshi schools of Yamato-e continued as official court painters but lost the vitality of their predecessors. The Kanō school, with its Sino-Japanese style of bold, angular line and wash and surface texturing with "ax-cut" strokes, was the major school from late Muromachi through the mid-seventeenth century. Kanō masters were retained as official artists to the Tokugawa shogun but gradually declined in their inventive vigor after the middle of the seventeenth century. Nevertheless they served the vital role of training young artists in the arduous discipline of ink painting throughout the Edo period.

With enormous economic growth from late Muromachi onward, an emerging class of townsmen prospered in the burgeoning cities. These merchants provided a new source of patronage. Unencumbered by the mores sedulously observed by daimyo and courtiers, they enjoyed their worldly possessions and amusements without pretense. A few were sophisticated patrons uninterested in the conventions of traditional painting who encouraged artists to develop in strikingly novel ways.

Genre painting received major impetus with the Ukiyo-e school, whose members recorded the hedonistic pleasures and charming aspects of the world around them. Rinpa-school artists adapted Yamato-e to large-scale compositions with soft, supple lines that were light in tone and the pure, bright colors of Yamato-e. They were brilliant designers of abstract, two-dimensional compositions with an unsurpassed decorative flare, but they also produced monochrome ink paintings with suave lines and subtle tones and invented *tarashikomi* (dripped and puddled ink), which captured the random effects of spreading pools.

Naturalism flourished and received special impetus with the painters of the Maruyama school, who were inspired by Western modes gained from studying European engravings. The Maruyama masters were noted for their realism and the careful rendering of optically observed details; nevertheless their paintings typically betray a Japanese decorative sense.

Nanga, or *bunjinga*, artists sought to emulate the noble spirit of the cultivated man represented by the Chinese literati artist. The Japanese term Nanga refers to Southern School painting, an aspect of Chinese literati culture, admired for its humanism, scholarship, and wisdom. Japanese painters remaining outside the established academies found artistic solutions in Nanga's individualism and the amateur ideal. They employed the techniques of the Chinese literati: dry brush lines, texturing dabs, and pointillistic dots of the Chinese Southern School as well as other Ming and Qing techniques.

Shijō-school artists created lyrical works with poetic allusions, using soft contour lines and graded tonal washes.

This legacy of magnificent sumi-e paintings attests to the enormous creativity of the Edo period. The Tosa, Sumiyoshi, Ukiyo-e, Nagasaki, and European-influenced schools, also prolific during this period, remained largely peripheral to developments in ink painting, however, because of their use of color, perspective, and other techniques.

Japanese Aesthetics

The character of Japanese art has been affected by a number of aesthetic ideas that have guided its development. Since Heian times the concepts of *aware* and *yūgen* have deeply influenced the aesthetic ideals of artists. Aware extolled the appreciation of unusual beauty and deep emotions tinged with a gentle melancholy. Yūgen sought beauty in the profound, the remote, and the mysterious, in which content is intimated rather than explicitly stated. When applied to painting, beautiful forms were incorporated into compositions that suggested the eternal essence stripped of color and externals.

Zen Buddhism has had a radical effect on Japanese culture, and its tenets were a source of several important aesthetic principles that influenced Japanese ink painting. Zen principles are consonant with Japanese philosophical aspirations, and the intuitive aspects of sumi-e received strong impetus from Zen. The act of meditation, which pacifies the mind and purges it of emotions, is conducive to a transcendental view of all phenomena. Meditation and its self-discipline foster individualism, which in turn free the artist for acts of inspired creativity.

The austere, understated character of Zen painting and the selection of simple, common subjects from nature, like a bird or a plum branch, symbolized the notion that an initial understanding of a tiny part could eventually lead to a comprehension of the universal whole. The Zen-inspired precepts *wabi*, *sabi*, and *shibui*, when applied to ink painting, extolled brevity and simplicity with emphasis on the essentials, spontaneous execution, and the use of understatement and suggestion. Dramatic contrast and asymmetrical designs were used to heighten effects that are harmoniously resolved in dynamic balance. The splashed ink plays of *haboku* painting epitomized these Zen maxims with their spontaneity and intuitive brilliance.

Nature in Japanese Art

That Japanese ink painting, like all arts past and present, reflected the cultural predilections of a people can be seen in landscape, bird-and-flower painting, and portraiture. In Japanese art there remains a harmonious relationship between man and nature that is unlike the human conquest of the natural world characteristic of the West. The traditional European landscape painting was frequently "domesticated" with barnyard animals in pastoral settings, broad hillsides with clusters of cottages, or romantic views of ancient ruins and medieval castles. In contrast to these scenes of man's exploitation of nature, the Japanese artist was deeply inspired by all natural phenomena and filled with a reverence for them. This affinity between man and nature continues to be fostered by the ancient native religion of Shinto. The themes of Japanese art derive from nature, with autumn grasses, birds and flowers, animals, fish and fowl as recurring subjects.

For European artists the definition of mass and visual space was a major concern, addressed by modeling with light and shade and the invention of linear perspective. One-point perspective helped describe space illusionistically and provided compositional unity in depth. In the Far East space was defined symbolically by a tripartite division of foreground, middle ground, and distant background. Atmospheric perspective, a sense of depth through decreasing clarity, was provided by mist-laden passages.

Sumi-e, with its soft linear contours and subdued washes of ink, was ideally suited to capturing the misty atmosphere of Japan. The picturesque countryside was conducive to creating decorative patterns with understated forms, visual in-

intimate in scale and personal in their rendering. The handscroll, a long, horizontal scroll, was unrolled and rolled section by section, allowing sequential viewing of narrative themes or gradual passage through a panoramic landscape. The folding fan and the album, which was a series of illustrated pages in a booklike format, were small in scale and encouraged the creation of spontaneous sketches, often drawn with great wit.

In the creation of a work of art, the artist sought to capture the vitalizing force and essence of his subject. This subject was transformed in the mind of the artist, and his interpretation and feelings were expressed in the character of each brush stroke and the resulting forms. The artist withheld his brush until he had determined the intention of his work, its composition, the position of each stroke, and how it was to function. But there were more elemental decisions before the first stroke was ventured: the size of brush and the kind of hair or fur that would give the desired effect to the stroke. The choice of an ink stick, with its proper color and artistic qualities, was made with utmost care, and once the ink was prepared, it had to have the right viscosity, the desired degree of textural depth, and the proper tonal richness. When the ink was right, the desired tone, luster, and shadings were obtained. Paper or silk was judiciously selected for color, sheen, and texture; for absorbency or resistence to the penetration of ink; and for receptivity to the flow of a brush across its surface.

The tufts of brushes occurred in a bewildering array of hairs and furs and commonly included deer, badger, rabbit, squirrel, wild boar, and sheep. According to their size, shape, strength, pliability, or stiffness, different qualities of line or texture were imparted to each stroke, introducing endless possibilities for the artist.

The soft, pliant brush required a light, swift, and delicate touch. The correct amount of water had to be absorbed when the brush was dipped on the ink stone. The ink could not blot; it had to flow as desired. A noted artist once admonished:

> Do not overfeed with ink;
> starve the brush. . . .
> Now, a sweep of the brush;
> ecstacy beyond words.[3]

The art of sumi-e required enormous discipline; there was no hiding a defect, no repainting, for the integrity of a brush stroke would be ruined. The Japanese artist was trained in an atelier, apprenticed to a master for a decade or more, perfecting his technique. By faithfully copying his teacher's models, the young artist gradually mastered the myriad brush strokes, the vocabulary of type-forms, and the process of creating a harmonious, effective composition. The long apprenticeship resulted in a curious combination of convention and originality. The creative act was a virtuoso execution, in which the inventiveness and sensitivity of a superb performance infused the painting with its spiritual expressiveness. The finished work then was as appealing to the intellect as it was to the senses.

The process of learning by faithful copying and the entrepreneurial talents of forgers have resulted in serious problems of connoisseurship. Throughout the ages excellent copies have been made of great paintings, and sometimes they bear false colophons, signatures, and seals. Connoisseurs or knaves have added spurious seals to fine, early, but unsigned paintings as a means of attributing them to admired masters. Only critical examination of the seals, signatures, and colophons may determine their genuineness. The history of a work of art can be uncovered by identifying owners' seals and the writers of colophons and can be elucidated further through catalogues, temple records, and daimyo inventories. Additional corroborating evidence can be obtained by ascertaining the kind of silk or paper used and

the nature of the ink. Yet it is only thorough analysis of the painting itself, with stylistic comparisons of brushwork, composition, and the execution of details, that will decide its authenticity. Unfortunately, in very early paintings with few comparative works extant, any conclusion is subject to heated controversy.

NOTES

1. Sumi-e in its original definition refers to ink painting executed from the Nara to the Kamakura periods which was based on the Chinese linear style of the Tang dynasty. Japanese ink painting styles of the Kamakura and Muromachi periods that were influenced by Chinese Song-Yuan- and Zhe-school styles are commonly referred to as *suibokuga*. In common usage, however, both sumi-e and suibokuga are all-encompassing terms referring to ink painting.

2. Irving Sandler, *The New York School: The Painters and Sculptors of the Fifties* (New York: Harper & Row, 1978), p. 170.

3. Huang Yueh, "Twenty-four Qualities of Chinese Painting," in Tseng Yu-ho, *Some Contemporary Elements in Classical Chinese Art* (Honolulu: University of Hawaii Press, 1963), p. 11.

Miyajima Shin'ichi

The Beginnings of Sumi-e in Japan

Japan reached full mastery of the techniques and expressive potential of sumi-e in the fourteenth century, but the foundations for this progress were laid in the twelfth century, when Japanese Buddhist monks, such as Shunjōbō Chōgen (1121–1206) of Tōdaiji and Shunjō (1166–1227) of Sennyūji, returned from their travels in China with sets of paintings representing the Sixteen Lohan, a favorite theme among Chinese Buddhist painters. Monochrome ink paintings of Lohan and background sumi-e elements on polychrome Lohan paintings of the Southern Song period were major stylistic sources for Japanese monk-artists, more so than the "farewell paintings" in monochrome ink depicting a boat leaving shore that were occasionally given to Japanese Zen pilgrims.

The number and variety of Chinese paintings brought to Japan increased progressively over the course of the thirteenth century. Painters like Myō-e Shonin (1173-1232), who never traveled to China but had close ties with monks who had been there, were among the first to have the opportunity to study the new brush techniques used in their creation. For this Kōzanji, a temple on the outskirts of Kyoto, reestablished in the early thirteenth century, was an important center. There professional, Buddhist painters, amateur, monastic painters, painters affiliated with the imperial ateliers, as well as individuals of other artistic backgrounds were able to examine and copy recently imported Chinese paintings. Full comprehension of the techniques that distinguished them, however, was difficult because of the limited number of original works and copies then available. Moreover, the actual application of these new techniques required the encouragement and support of patrons and connoisseurs.

The arrival of the Chinese Zen master Lanqi Daolong (Japanese: Rankei Dōryū; 1213–78) in 1246 marked an important turning point in the development of ink painting in Japan. Lanqi Daolong was invited to Japan by Hōjō Tokiyori (1227–63), the fifth regent of the Kamakura military government, and was installed as abbot of Kenchōji, a temple built in Kamakura with Tokiyori's backing. Three decades later the social and political turmoil that accompanied the Mongol takeover of China in 1279 encouraged other Chinese monks to flee to Japan. Among these refugees was Wuan Puning (Japanese: Gottan Funei; 1197–1276), who took up residence at Kenchōji at Tokiyori's behest and later became the regent's Zen master. These and other Zen monks prepared Japanese artists and connoisseurs for the appreciation of the spiritual and cultural underpinnings of Chinese ink painting.

The first decades of the fourteenth century saw a succession of Chinese Zen masters arriving in Japan and simultaneously a host of Japanese students departing for the study of Zen in China. Until this time Japanese artists, according to custom rarely signed their works, but by the middle of the century a number of distinctive personalities emerged. Their identities are known from the seals and signatures on their paintings as well as from accounts left by their contemporaries. Chief among them are Kaō (d. 1345), Mokuan Rei'en (fl. 1323–45), Ryōzen (fl. 1328–52), and Gukei Yūe (fl. 1361–75). Of these four painters only Ryōzen appears to have been trained as a professional artist. The others, all Zen monks, were talented amateurs. Mokuan may have had the opportunity of studying ink painting firsthand while in China, but Kaō and Gukei were familiar only with the paintings then available in Japan.

For these and other ink painters through the sixteenth century, Zen monasteries continued to serve both as training grounds and as patrons. Painting was encouraged as part of a monk's spiritual indoctrination, and the subjects of many paintings, such as portraits of Zen masters and portrayals of personalities from

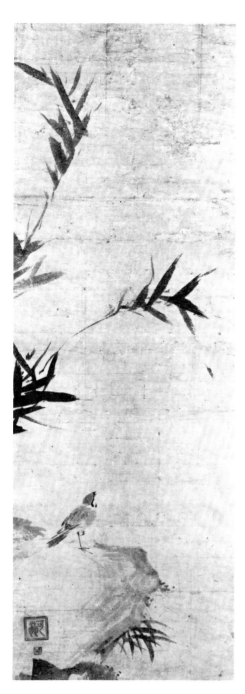

fig. 1
Kaō (d. 1345)
Bamboo and Sparrow
Mid-fourteenth century
Hanging scroll; ink on paper
90.6 x 30.3 cm (35 5/8 x 11 7/8 in.)
Yamato bunkakan
Important Cultural Property

Buddhist and Daoist legends, were directly related to Zen beliefs and practices. Paintings of birds and flowers, expressive of the distinctive Zen view of the natural world, also held an important place in early sumi-e in Japan.

Bamboo and Sparrow (fig. 1), a painting by Kaō, exemplifies the thorough mastery of the brush achieved by fourteenth-century Japanese ink painters. This hanging scroll reflects awareness of the Southern Song-Yuan Chan painting traditions. It shows a sparrow perched on one leg on a rock, gazing intently at a bamboo overhead, whose leaves appear to be rustling in the wind. This moving image of an insignificant, yet profoundly intense being has Zen overtones, though in the absence of an inscription it is difficult to be certain of its intended meaning. The modulated brush strokes and subtle tonal harmonies of the work testify to the consummate skill of a painter often regarded as the father of ink painting in Japan.

Early Ink Landscapes

Whereas in Japan sumi-e was introduced and fostered by the Zen sect, in China the relationship between Zen Buddhism and ink painting was more tenuous. There the outlook of Confucian intellectuals and poets also profoundly affected ink painting's philosophical basis. China, moreover, did not share Japan's emphasis on figural themes of Zen inspiration but prized landscape above all. In Japan, *dōshaku jinbutsu*, that is, portraits of Zen patriarchs and famous monks, as well as those of Daruma, Hotei, and Kannon, were the usual subjects. Bird-and-flower themes were painted occasionally, but landscapes were rarely rendered, although the traditional reverence for nature in Japan provided a fertile ground for the incorporation of landscape into the realm of sumi-e. Nothing in the native pictorial tradition, however, prepared Japanese artists for the representation of the vast mountain vistas that figured so prominently in Chinese landscape painting. Toward the end of the twelfth century, paintings of Shinto shrines that emphasized their architecture in detail rather than their topographical setting, began to appear. Chinese landscape painting, by contrast, was devoted to the depiction of places unfamiliar to the Japanese and was not intended to record the appearance of specific locales, but to evoke the vastness of the natural world. Not surprisingly, a long period was required before these foreign motifs and the outlook underlying them could be fully assimilated.

Landscape first became prominent in Japanese ink painting during the early part of the fifteenth century with compositions typically featuring a scholar seated in a rustic study. Such images representing idealized retreats offered spiritual refuge for monks living in the crowded, bustling Zen temples of Kamakura and Kyoto. Although technically they may be considered landscapes, these scenes are rather limited in scope and take up only a very small portion of the total length of the scrolls. The bulk of each scroll is filled instead with long inscriptions comprised of poems written by friends and acquaintances of the individual for or by whom the painting was created. Although landscape painting had achieved a greater measure of independence by the latter half of the fifteenth century, the close correspondence between painting and poetry remained a conspicuous feature in the development of painting through the Muromachi period.

Reading in a Bamboo Studio (fig. 2), thought to represent the style of the influential monastic painter Tenshō Shūbun (fl. 1423–43), typifies the elongated, vertical format and limited space allotted landscape in the ink painting of the first half of the fifteenth century. The picture is dominated by a pair of twisted pines, whose forms evoke a mood of solitary dignity appropriate to a painting of a reclusive scholar's study. The scholar, reading in a modest thatched hut, hidden in a

fig. 2
Attributed to Tenshō Shūbun (fl. 1423–43)
Reading in a Bamboo Studio
Before 1446
Hanging scroll; ink and light color on paper
134.8 x 33.3 cm (53 1/8 x 13 1/8 in.)
Preface (1447) by Jikuun Tōren
Inscriptions by five individuals
Tokyo National Museum
National Treasure

fig. 3
Attributed to Tenshō Shūbun (fl. 1423–43)
Color of Stream and Hue of Mountain
1445
Hanging scroll; ink and light color on paper
108.0 x 32.7 cm (42 1/2 x 12 7/8 in.)
Inscriptions by Shinden Seihan and two others
Fujihara Yūzō Collection, Tokyo
National Treasure

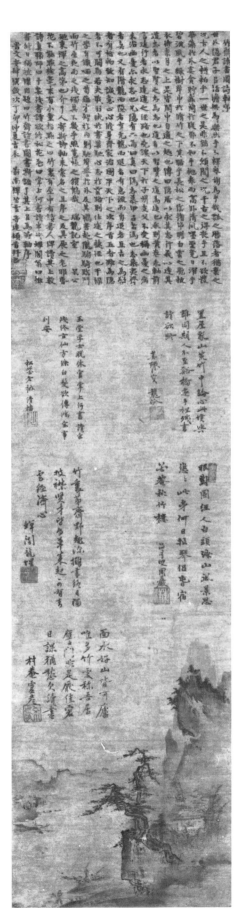

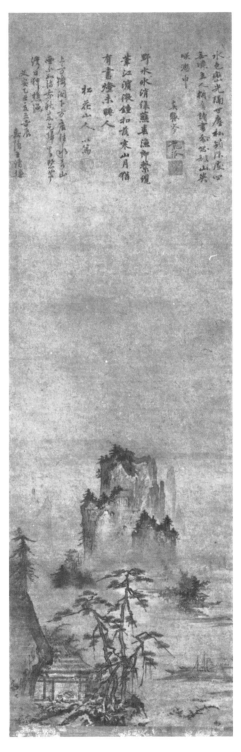

mist-shrouded bamboo grove (the source of the painting's title), is only faintly visible beyond the pines.

The strong asymmetry of this composition suggests derivation from works in the tradition of Ma Yuan (fl. late twelfth–early thirteenth centuries) and Xia Gui (fl. 1190–1225), members of the Imperial Painting Academy during the Southern Song dynasty. The pair of gnarled pines growing on a giant rock face is a motif that also finds its antecedents in the Ma-Xia tradition. While the representation of the trees is somewhat generalized, the use of graded washes and short, jagged, ax-cut strokes gives the rocks beneath them a more solid, three-dimensional appearance. Also consonant with the ideals of Southern Song academic painting is the artist's effort to create an evocative image of space. The twin pines — one growing straight up, the other, diagonally — emphasize the composition's height and guide the eye to the river that opens up beyond the hills. The sharp definition of the trees and more muted forms of the bamboo grove and distant mountains further enhance the sense of atmospheric space. Despite its small scale, this work admirably demonstrates the degree to which Japanese artists of the fifteenth century had assimilated the essentials of Chinese landscape painting.

Color of Stream and Hue of Mountain (fig. 3) prefigures the direction taken by ink painters in the second half of the fifteenth century. It can be dated to 1445 on the basis of three poems appearing above the picture and, like *Reading in a Bamboo Studio*, is also thought to be in the style of Shūbun. Although the prefatory remarks inscribed on *Reading in a Bamboo Studio* provide a terminus date of 1446, stylistically and compositionally it represents an earlier stage in the development of ink painting in Japan. *Color of Stream and Hue of Mountain* points to a growing interest in and understanding of atmospheric perspective: the straggling pines and well-kept hermitage oriented along the central axis in the foreground are brought extremely close to the picture's edge; behind them a broad, mist-covered lake is revealed; and still farther in the distance huge mountains soar into the sky. The sense of volumetric mass of the giant mountain, with its faceted sides, has a vigor that is in sharp contrast to the more restrained simplicity of the rock forms in *Reading in a Bamboo Studio*.

Sesshū (1420–1506) is the artist who perfected this system of spatial recession, in which a broad expanse of mist helps define foreground and background (see *Autumn Landscape* and *Winter Landscape*, figs. 4a and 4b). A work (*Landscape*, cat. no. 2) by Bunsei (fl. 1427–57) with a wide lake in the middle ground illustrates a similar three-part spatial sequence. Korean painting provided the models for Bunsei's work, but Sesshū, who traveled to China, learned directly from the Yuan and Ming paintings he saw there.

With Sesshū the transformation of Japanese ink painting was complete. His strong, centralized compositions and vigorous brushwork reveal the self-assurance and authority of a powerful personality. Sesshū's long life spanned a period of incessant warfare among rival lords. In a letter written near the end of his life to his disciple Sōen, Sesshū expressed his regret at having endured a period of such decadence and confusion. In spite of the difficulties of his time, Sesshū was able to maintain his integrity and the strength of his art.

The Kanō-school Contribution to Sumi-e

Whereas Sesshū spent much of his life serving local lords in the provinces, his contemporary Kanō Masanobu (1434–1530) remained in war-torn Kyoto in the service of the Ashikaga shogun Yoshimasa. Masanobu, the first in the line of Kanō artists, who dominated Japanese painting until the nineteenth century, firmly be-

lieved in the importance of maintaining an artistic tradition based on hereditary succession. The notion of a family-centered school was not new: painters traditionally had been organized along family lines, but generally leadership from one generation to the next was determined by artistic talent rather than lineage. In the Kanō school, however, leadership usually passed from father to son, and when a suitable descendant could not be found, a talented individual was adopted.

Although the Kanō school became closely identified with Chinese-style ink painting, it also produced paintings of native subjects in the colorful Yamato-e tradition. Masanobu himself is listed in the Kōfukuji temple archive (*Daijoin Jisha zoji ki*) as a follower of the Tosa school, the chief exponents of Yamato-e painting in the fifteenth century; and Masanobu's son Motonobu (1476–1559) married into the Tosa family. Moreover, according to notes on various artists written by the sixteenth-century painter Hasegawa Tōhaku, Motonobu claimed that in matters of ink painting he deferred to his contemporary Sōami.

Landscape (cat. no. 7) is one of Masanobu's earliest works. Said to be in the style of Sun Junze, a fourteenth-century practitioner of the Southern Song academic style, it depicts a waterfall thundering down from the sky. Unlike the paintings of Sesshū and other artists of the period, however, this composition is restricted in scope. The distant views and sense of atmosphere characteristic of their work have been suppressed in favor of more explicit, sharply defined forms. This painting does not invite the viewer to experience the landscape as Sesshū's rather naturalistic renderings do. Instead, it is a more decorative work conveying a tension that stimulates the eye.

During Masanobu's lifetime, Zen Buddhism lost its unchallenged position as a cultural force in Kyoto. Masanobu was an adherent of the Nichiren sect, and his painting lacks Zen overtones. Despite the fact that he received the Buddhist honorific title *hokkyō* and maintained close ties with Daitokuji, a prominent Zen temple, he was a professional, secular painter.

The Ami were another line of artists who were not originally affiliated with the Zen sect. While the Kanō served as the official painters of the Ashikaga sho-

guns, three generations of the Ami family — Nōami (1397–1471), Geiami (1431–85), and Sōami (fl. 1485–1525) — directed the shoguns' cultural activities. In their capacity as confidants and cultural advisors, they compiled catalogues of the shogunal collections and provided guidelines to the display and appreciation of ink painting. As painters the Ami evolved a distinctive style in which Chinese values were extolled. Through their treatment of form and space and their avoidance of color and gold, which differed from the Kanō, they were instrumental in shaping and directing ink painting into a medium of expression that was compatible with Chinese aesthetic ideals.

Sesson and the Kamakura Tradition

Although Kyoto was the principal center of ink painting during the entire Ashikaga period, other areas, such as Kamakura, came to prominence in the late fifteenth century. Ink painting in Kamakura had been fostered by the Hōjō regents in monasteries such as Kenchōji, where Lanqi Daolong resided. Despite the Hōjō's loss of power in 1333 and the subsequent transfer of the Ashikaga military headquarters to Kyoto, Kamakura remained an important Zen center. The ink painting tradition that developed there reflected the vigorous life-style and spirit of the warrior class.

Among the prominent artistic personalities of Kamakura was Kenkō Shōkei (fl. mid-fifteenth–early sixteenth centuries). Shōkei initially served as a monk at Kenchōji but later traveled to Kyoto, where he studied under Geiami. Another was Sōen, who had earlier studied with Sesshū in Yamaguchi Prefecture. The most distinguished of all the Kamakura painters, however, was Sesson Shūkei (c. 1504–89).

Sesson was born to a branch family of the Satake warrior clan and entered a monastery early in life. His work, like Sesshū's, bears the stamp of a powerful and highly individualistic personality. A pair of paintings entitled *Summer Landscape* and *Winter Landscape* (cat. no. 6) exemplify the beauty of ink and color in Sesson's work. Sesson has used ink and light color to convey the freshness of summer and broad, harsher ink washes to capture the cold of winter. Compared with Sesshū's paintings of a similar theme — autumn and winter — Sesson's show greater sensitivity to seasonal change.

In the instructions he left his disciples, Sesson describes painting as a form of magic. Although the significance of this statement is not entirely clear, it may allude to the importance Sesson placed on man's ability to reveal the processes of nature through brush and ink. The nervous energy that pervades his work demonstrates how Sesson himself transformed the natural world according to his unique vision. These rather serene and restrained compositions are especially valuable in illustrating the early dependence on Chinese models that preceded Sesson's development of a personal idiom.

Sumi-e in Castle and Temple Interiors

With the collapse of the Ashikaga shogunate at the end of the fifteenth century, Japan entered a period of provincial wars. Oda Nobunaga (1534–82) and Toyotomi Hideyoshi (1536–98), the leaders who emerged from this great upheaval, were a new breed of man, and they brought with them new values and tastes. Lacking the cultured background of their Ashikaga predecessors, they set new aesthetic standards through their construction of huge, multistoried castles, which they decorated with magnificent wall paintings. Painted on fusuma, which served as parti-

tions between rooms, these predominantly depicted secular themes and made extensive use of gold and color. The awestruck beholder, confronted with such a dazzling spectacle, was compelled to feel respect for the owner.

Ink painting, with its more contemplative quality, found little favor in the eyes of Nobunaga and Hideyoshi. The great castle at Azuchi, built by Nobunaga in 1576, had only a few ink paintings in its private chambers. Even the temples whose interiors were commissioned by Hideyoshi had paintings in the gold-and-color style. Many of the lords who served under these two leaders, however, had more conservative tastes and continued to favor paintings done in ink alone.

Kanō Eitoku (1543–90), the grandson of Motonobu, who had consolidated the Kanō style and workshop system, was the foremost painter of the Momoyama period. Motonobu had a son, Shōei (1519–92), to follow in his footsteps, but Shōei was less talented than the child prodigy Eitoku. Accordingly, Motonobu appears to have made Eitoku his successor.

The Jukōin, a subtemple on the compound of Daitokuji, built in the memory of a recently deceased Kyoto warlord, contains several mural compositions designed by Eitoku when he was only twenty-three. Unlike the intimate hanging-scroll format used by ink painters during the Muromachi period, painting on fusuma panels required that an artist conceive a composition that could be sustained across the expanse of a large room. The central room of the abbot's quarters in the Jukōin features a continuous fifty-nine-foot composition, *Birds and Flowers in the Four Seasons* (cat. no. 8), depicting a theme popular among artists of this era. The motifs include pine, plum, bamboo, and various small flora and fauna arranged in a seasonal sequence. The colossal, almost theatrical plum tree, whose branches span several panels, epitomizes the grandeur and vitality of Eitoku's early style.

Sections of an eight-panel mural composition from another room in the Jukōin illustrate another aspect of Eitoku's style. These panels, *The Four Accomplishments* (fig. 5), illustrate the pursuits of the Chinese lute (*qin*), chess, calligraphy,

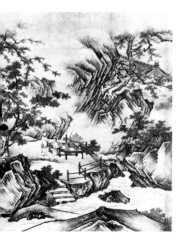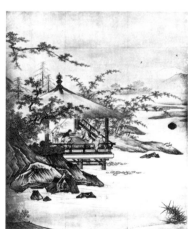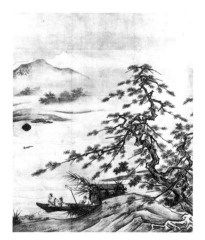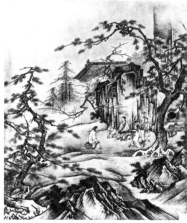

fig. 5
Kanō Eitoku (1543–90)
The Four Accomplishments
Circa 1556
Four fusuma panels from a set of eight; ink and light color on paper
Each 175.5 x 142.5 cm (69 1/8 x 56 1/8 in.)
Jukōin, Daitokuji, Kyoto

and painting, associated with the ideal of the cultivated gentleman. Although influenced by a composition on the same theme by Motonobu, Eitoku's version is less tautly organized and gives greater emphasis to foreground elements. The sense of restraint and detail of this work differs sharply from the tone of *Birds and Flowers in the Four Seasons*. In the latter, the motifs are monumental in scale and rendered in coarse, sweeping brush strokes. The dynamic, muscular style of this work, consonant with the spirit of the times, made Eitoku famous and was emulated by painters of the Kanō and other schools.

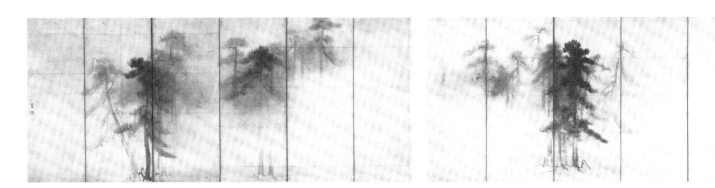

figs. 6a and 6b
Hasegawa Tōhaku (1539–1610)
Pine Forest
Late sixteenth century
Pair of six-fold screens; ink on paper
Each 156.0 x 347.0 cm (61 3/8 x 136 5/8 in.)
Tokyo National Museum
National Treasure

Because of the unprecedented prosperity of the Momoyama period, Eitoku and other talented painters, including Hasegawa Tōhaku (1539–1610), Kaihō Yūshō (1533–1615), Soga Chokuan (fl. 1596–1610), and Unkoku Tōgan (1547–1618), were granted many large-scale commissions. The demands of these projects invariably necessitated the collaboration of many assistants. But still further changes in the traditional practice of ink painting were required to speed production. Painters increasingly dispensed with deep distance and focused instead on foreground and middle ground. They used clouds and bands of mist to give the illusion of depth. In this way, the goal, stimulated by Song and Yuan painting, of creating atmospheric perspective, which had reached its apogee in Japan in the art of Sesshū, gave way to a more emphatic mode of expression.

This transformation is illustrated in the ink painting of Hasegawa Tōhaku. Like the Kanō family, he was a follower of the Nichiren sect. He received his early training as a professional, Buddhist painter and claimed also to have studied under Tōshun (fl. 1506–42), a disciple of Sesshū. The connection with the Sesshū school is unlikely however. Indeed, Tōhaku appears to have had little experience in the realm of ink painting before 1571, when he arrived in Kyoto from the provinces.

A series of fusuma panels designed in 1589 for Sangen'in (now in Entokuin) are among Tōhaku's first ink paintings. Their subjects and compositions are derived from paintings by artists of earlier generations, but Tōhaku's approach is more decorative and two-dimensional. Even more representative of the new outlook of the age is *Pine Forest* (figs. 6a and 6b), a pair of byōbu showing pines emerging from and receding into the mist. Although some sense of pictorial depth is achieved through the modulation of ink tones, there is no real differentiation between foreground and background. The distance is completely shrouded in mist; the remote mountains have been reduced to pale shadows. This elusive composition represents a natural scene, yet the manipulation of forms and play of solid and void give it the quality of a still life. It is more a nostalgic image than an image of nature observed. Tōhaku's transformation of the natural world and his distinctive personal interpretation foreshadows the direction taken by painters during the Edo period.

Sumi-e in the Early Edo Period

Kanō Sansetsu (1590–1651), Unkoku Tōeki (1591–1644), Soga Nichokuan (fl. 1656), and Kaihō Yūsetsu (1598–1677) were the leaders of their respective schools in the generation immediately following the Momoyama period. All lived to see the unification of the nation by Tokugawa Ieyasu (1542–1616), the founder of a military hegemony that lasted until 1868. Although they inherited many of the stylistic features found in their fathers' work, their treatment of traditional themes also reveals significant departures. Sansetsu, Tōeki, and Nichokuan in particular share

a generational characteristic, a narrowing of creative possibilities enjoyed by their Momoyama predecessors: a curious distortion of natural forms gives their work a tendency toward meticulous patterning and a dryness not found in earlier painting. Yūsetsu, who had been trained in the Kanō studio, remained faithful to that tradition.

Kanō Tan'yū (1602–74) was perhaps the most prolific and versatile painter of the early Edo period. As the official painter of the Tokugawa military regime, newly established in Edo (present-day Tokyo), he was also a most influential connoisseur. Tan'yū successfully established the Kanō family in Edo; he was followed by others eager to make their fortunes in the burgeoning city.

Tan'yū had studied under Kanō Kōi (c. 1569–1636), a talented painter who had been adopted into the Kanō family. Much of his training, however, came from firsthand study of the paintings in the collections of the Tokugawa shoguns and other collectors who turned to him for advice on quality, authenticity, and value. Tan'yū was conversant with Southern Song and Yuan landscape traditions as well as with Ming bird-and-flower painting. Although he especially admired Southern Song painting, he also developed a keen interest in the native style, Sesshū's above all. The Kanō school had turned to a brilliantly colorful and decorative style during the Momoyama period, but Tan'yū, through his involvement in traditional ink painting, contributed to its resurgence in Japan. In the art of Tan'yū, the Kanō school reached another peak.

Not all ink painters, however, were trained under Kanō tutelage. In this respect, Tawaraya Sōtatsu (fl. 1602–30) holds a unique position in the history of Japanese ink painting. A highly talented painter, believed to have been in charge of a fan shop, he contributed to a revitalization of native polychrome painting in the early Edo period. Whether he received formal training and from whom is not known, but there is no question that he had access to many fine narrative handscrolls of native subjects. In his fan and screen painting he copied and adapted many motifs he saw in such works.

In his ink painting, Sōtatsu preferred broad areas of ink wash to the use of lines. Often he applied wash in overlapping areas. By applying a second layer of ink while the first was still wet, he achieved a diffuse, puddled effect, known as *tarashikomi*, which became the trademark of the Sōtatsu tradition. The origins of this distinctive ink painting technique are not known. *Water Birds on a Lotus Pond* (cat. no. 35) is surely Sōtatsu's masterpiece. In rendering the lotus flowers bathed in morning mist, the glistening waves, and the water-soaked birds, Sōtatsu used the expressive potential of ink to its fullest.

The polychrome tradition of painting in Japan can be traced to the seventh century, thus antedating by many years the introduction of sumi-e. The use of brush and ink to outline forms has had a long history and many fine exponents in Japan. Not until Sesson and Sōtatsu, however, were the subtleties of ink wash appreciated to such a high degree. Sōtatsu's contribution to this phenomenon is paradoxical in view of the fact that he was not trained in Chinese-style ink painting. Perhaps the reason his unusual compositions are so appealing is that the art of ink painting has little to do with formal learning but is rather the expression of the personal character of the artist.

In 1635 the Tokugawa government, fearful that Westerners might undermine its authority, closed Japanese ports to trade with Western nations. One of the results of this isolationist policy was the rekindling of interest in Japanese customs and history and, concomitantly, the rise of genre themes within ink painting. Kusumi Morikage (fl. 1634–97), who was initially a student of Tan'yū, was one of the chief exponents of genre painting using ink and light color. Another was

Hanabusa Itchō (1652–1724). He too had studied under a Kanō master, but unlike Morikage's his work is often humorous.

Humor, an important feature in the painting of the Edo period, also distinguishes many of the compositions of Itchō's contemporary Ogata Kōrin (1658–1716). The son of a wealthy kimono merchant, Kōrin was a well-known personality in Kyoto society. His brushwork reveals the influence of early training in the Kanō studios, but he also studied and copied the painting of Sesshū, Sesson, and Sōtatsu, all of whom had made significant contributions to the development of ink painting in Japan. Kōrin's selective study of past masters is revealing of his tastes.

His wit is illustrated in a two-fold screen entitled *Bamboo and Plum* (cat. no. 38). Painted in monochrome ink on a gold foil ground, the compositon is filled with widely spaced stalks of bamboo and plum branches, all viewed from a very close vantage point. In the right panel, the even-paced movement and the strong rectilinear forms of the bamboo are interrupted by the zigzag of a plum branch. The abrupt shift in movement and tone is deliberately provocative and adds an element of surprise to an otherwise conventional theme.

After Kōrin's death, the world of Japanese painting changed dramatically. Through contact with the Chinese mainland, the influence of literati painting, known in Japan as *nanga* and *bunjinga* and in China as *wenren hua*, began to be felt. While its exponents, artists such as Ike no Taiga and Yosa Buson, were not bound by rigidly traditional rules, they prided themselves on their adherence to individualistic moral principles. As painters they completely rejected skillfulness as a criterion in painting, striving instead to give free expression to the unique aspects of their personalities. The emergence of literati painting marks the dividing line between early and late Edo.

LATE EDO-PERIOD SUMI-E

Satō Yasuhiro

The Edo period divides symbolically at the year 1716: Ogata Kōrin died; Yosa Buson and Itō Jakuchū were born. Painting in the eighteenth and nineteenth centuries departed markedly from trends set during the first half of the period. The Tokugawa regime's political philosophy in the early days of the Edo period had aimed at coercion by the demonstration of military strength. After the middle of the seventeenth century, however, the shogunal government switched to a policy designed to rule the country through ethical education and by law. Confucianism was the basis of the national administration and Confucian scholars were employed as officials. Confucianism and the related culture of China came to be admired among a wider strata of society centering around the samurai class. Scholars in increasing numbers engaged in composing Chinese-style poems and became devotees of the fine arts of China. Of greatest impact to artists were the importation of paintings and woodcut-printed painting manuals and treatises from China and the arrival in Nagasaki of emigre, Qing-period artists who fostered in their Japanese students a wider appreciation of Chinese art. European influence, manifested in a new awareness of linear perspective and in the effects of light and shade, was felt simultaneously in Japan.

The sumi-e of the late Edo period may be separated into two broad categories, although many highly individualistic artists of the period incorporated aspects of each category in their works. Those artists who drew their primary inspiration from Chinese painting, particularly landscapes, and who also composed poetry, practiced calligraphy, indulged in wine and music at gatherings of like-minded friends are classed as Nanga, or *bunjinga*, painters in the Chinese literati tradition. A second, more diverse group received their training in established academic workshops but broke away to explore fresh, often startling directions. They painted a great variety of subjects — eccentric figures, animals, birds and flowers, or genre themes in addition to landscapes — often in both polychrome and ink monochrome styles. Whether they incorporated fantastic subjects, strove for an increased naturalism, or stretched the expressive potentials of their media to the brink of abstraction, each artist created a truly idiosyncratic style.

More than that of any other era, the ink painting of the late Edo period ran the gamut from meticulous realism to monumental, expressionistic statements, all as a result of the remarkable variations in these artists' handling of brush and ink. As Japanese artists increasingly explored and developed individual styles, a new spirit of independence manifested itself in their works. Ink was employed in the form of dots or lines or as washes to fill broad surface areas. While blending harmoniously with light color, monochrome ink conveyed a palpable sense of substance. Yet the potential for bold playfulness always existed. This essay explores the subtle relationship between brush and ink in the work of the most important painters of the period.

Early Masters of Eighteenth-century Literati Painting

The major Nanga painters of the first generation were Gion Nankai (1676–1751), Sakaki Hyakusen (1697–1752), and Yanagisawa Kien (1704–58). Their styles, learned primarily from imported Chinese painting manuals — *Bazhong huapu* (Eight Kinds Painting Manual) or *Jieziyuan huazhuan* (Mustard Seed Garden Manual) — or directly from late Ming and early Qing painting, took a variety of forms. They adapted, for example, calligraphic brush methods for drawing plum, bamboo, orchids, or chrysanthemums, while rendering trees and rocks as clusters of dots and staccato lines drawn with a light touch. To some degree, experiments with these brush modes had begun in the Muromachi period, but their results were not

always aesthetically pleasing or successful. Although the ink paintings of this first generation appear to have progressed little further than repetitive imitations of minor Chinese paintings and printed copybooks, three significant technical contributions by these artists are noteworthy.

The first of these is Kien's innovations in *shitōga* (finger painting). Kien, in his bamboo paintings, frequently substituted his fingers for brushes, dipping them into the ink and applying them directly to the paper. Drawing with the hand, in fact, had precedents in the formative period of ink painting in eighth-century China. The *Tangchao minghua lu* (A Record of Famous Paintings of the Tang Dynasty) mentions Wang Mo (*mo* literally means ink), who painted while inebriated, splashing ink onto the painting's surface: "Then, laughing and singing all the while, he would stamp on the painting with his feet and smear it with his hands, while splashing ink and sweeping it with the brush."[1] Wang Mo's *pomo* (splashed ink) technique (Japanese: *hatsuboku*) prompted contemporary critics to place him in the *yipin* (Japanese: *ippin*) class, those artists whose brush-and-ink techniques or eccentric behavior stood them apart from the norm. Other painters, notably Zhang Zao and Wei Yan, also employed unusual brushwork as well as their fingers. These were in part performances, yet yipin artists sought, in deviating from traditional mastery of fine-line drawing, the freshness and spontaneity of the accidental.

Kien may have learned finger-painting techniques from an emigre Qing painter, but he did not necessarily think of himself as emulating the early Chinese eccentrics. Looking askance at the shallowness of contemporary Kanō-school painting, he probably found in finger painting an escape from stultifying academic techniques and an outlet for artistic indulgence.

The second significant technical contribution of the bunjinga artists, seen primarily in the work of Hyakusen, involved a vibrant pattern of dots and lines, the twin components of the new style, enriching the painted surface. In contrast to Nankai, who produced meticulous facsimiles from the woodcut painting manuals, Hyakusen, with his profound understanding of the dotting and texturing techniques of seventeenth- and eighteenth-century Chinese painting, adapted those techniques to a more abstract expression, whether by repeating tiny strokes or by wielding his brush in violent rhythms.

The third, and last, of the major contributions came in Hyakusen's paintings of Japanese scenery. In the handscroll *Famous Places of Ōmi and Kyoto* (c. 1748; fig. 7), he made extensive use of wash techniques, as well as the *tarashikomi* method of Sōtatsu and Kōrin, in which he floated different tones of ink onto a wet surface. This yielded a graphic depiction of Japan's dank atmosphere.

It was the second generation of Nanga painters, however, who brought these three methods of applying ink — with fingers, with patterns of dots and texturing strokes, with puddling — to a high level of artistic achievement.

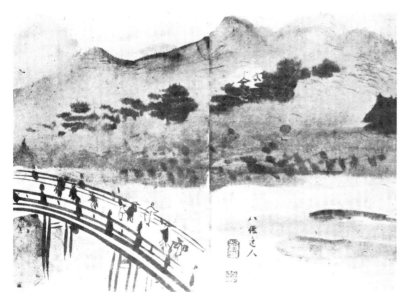

fig. 7
Sakaki Hyakusen (1697–1752)
"Higashiyama," from *Famous Places of Ōmi and Kyoto*
1748
Handscroll; ink on paper
36.4 x 606.0 cm (14 3/8 x 238 5/8 in.)
Formerly in Aimi Kōu Collection

Ike no Taiga

In his twenties Ike no Taiga (1723–76) often did finger paintings. Unlike Kien, who only used the technique to paint bamboo, Taiga used his fingers for painting birds

and flowers, human figures, bamboo and trees, and, less frequently, landscapes. A line drawn with a finger dipped in ink is different from a brushed line: a feeling of awkwardness arises from friction between finger and surface, resulting in changes in ink density and interruption in line (see *A Visit to Eastern Woods*, cat. no. 44). Taiga furthermore produced with his fingernails sharp lines that would have been impossible with a brush.

His manner of painting in a single sweep with ink-covered fingers astonished many and earned him acclaim. The breadth of his repertoire and the fact that he paraded his skills in front of audiences distinguished him from Kien, a samurai and an amateur. Taiga was, after all, a professional painter from an urban background. He apparently thought of himself as painting in the manner of the Chinese eccentrics. In his inscription on the 1755 scroll *Horse Market in a Mountain Village* (fig. 8), he quoted a famous reference about the artist Wei Yan drawing horses "with a dot for a head and a dash for a tail."[2] It is recorded in a poem by Miyama Rikkan (c.1754), entitled *Ike no Taiga wa Kyoto ni Kaeru no o ni okeru* (Concerning Ike no Taiga's Return to Kyoto), that during a visit to Kanazawa, in about 1749, Taiga painted while holding a cup of sake in one hand and a brush in the other, a description that resembles anecdotes about his eccentric predecessors.

If Taiga had devoted himself to eccentricity for its own sake, he would not have become an important painter. But his eccentricity led to bold and fruitful experimentation. His pupil Kuwayama Gyokushū (1746–99) wrote in *Gaen Higo* (Vulgarisms from the Garden of Painting): "Taigadō, who had earnestly desisted from the path of imitating other painters, is someone who tried all kinds of oddities." Objections had been raised to Taiga's brush methods, which seemingly were

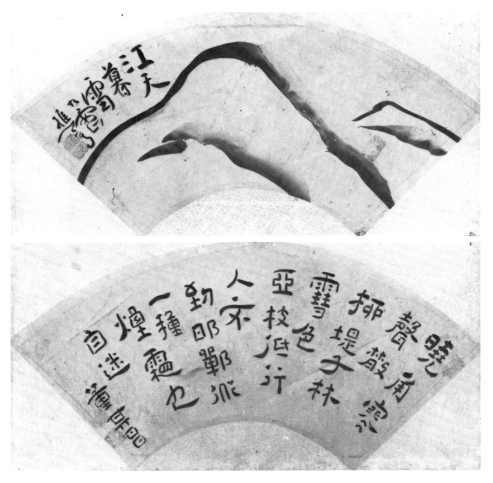

fig. 9
Ike no Taiga (1723–76)
"River and Sky in Evening Snow" from *Eight Views of Xiao and Xiang*
1770s
Album leaf with fan painting and matching inscription; ink on paper
20.0 x 52.5 cm (7 7/8 x 20 5/8 in.)
Private collection, Tokyo

fig. 8
Ike no Taiga (1723–76)
Horse Market in a Mountain Village
1755
Hanging scroll; ink and light color on paper
136.9 x 58.4 cm (53 7/8 x 23 in.)
Idemitsu Art Gallery, Tokyo

fig. 10
Yosa Buson (1716–83)
Fern Palms
Circa 1767
One four-fold screen of a pair; ink on paper
Each 162.0 x 363.0 cm (63 3/4 x 142 7/8 in.)
Myōhōji, Kagawa Prefecture
Important Cultural Property

derived from his finger-painting techniques. To enhance his peculiar line techniques, he also experimented with broad washes and puddled ink.

In his thirties, when he had all but abandoned finger painting, Taiga continued to strive in his brushwork for unexpected effects that echoed his earlier experiences. The characteristics of his later painting — fine lines that convey an impression of tightly stretched nerves, broad strokes that vary in thickness and density, or warm surfaces of light ink or color — can be linked to his earlier finger-painted works.

Among his contemporaries Taiga was foremost in building massive rock clusters through the application of ink or in creating vast, empty spaces. He also evinced a keen interest in the value of brush techniques with carefully controlled dots and lines. In other words, he was not as devoted a copyist of Chinese paintings as were the early Nanga artists, yet when he did make copies, he tended to follow his own physiological rhythms, transforming the brush modes of the original. Even in the paintings of his youth, he frequently added moss dots independently of their role in suggesting foliage to create vivid abstract patterns.

One immediately evident aspect of his style is his manner of depicting leaves. Drawn with a mixture of dots and short lines, the individual strokes vary in strength and direction. The resulting light and dark clusters produce an almost musical harmony characteristic of Taiga and unknown in the works of the first-generation Nanga artists.

When compared with Yosa Buson or Uragami Gyokudō, Taiga seems much more a painter of brush than of ink. Yet he did use ink wash effectively, especially in works where he sought to capture the true appearance of the Japanese countryside. In his 1749 handscroll *Wondrous Scenery of Mutsu Province* (cat. no. 42) or in *Twelve Famous Views of Japan* (cat. no. 47) , he followed Hyakusen's lead in using graded ink washes to convey atmospheric or seasonal changes. Among his late masterpieces is an album of fan paintings *Eight Views of Xiao and Xiang* (fig. 9). Hyakusen and Taiga thus rediscovered and transformed their heritage through their application of new ink techniques and literati sensibilities.

Yosa Buson

Unlike Taiga, Yosa Buson (1716–83) was a late-maturing painter, whose representative masterpieces date from his sixties. No finger paintings by him are known, but two works bear inscriptions indicating that they were "painted while [the artist was] intoxicated." One is a single screen entitled *Landscape in the Manner of Wang Meng* (cat. no. 48), dated 1760. The other is a pair of four-fold *byōbu* entitled *Fern Palms* (fig. 10), painted around 1767, while the artist was in Sanuki. Produced

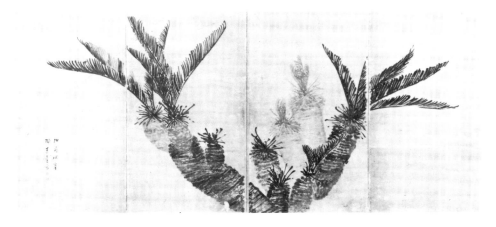

during a long period of experimentation, these two screen paintings stand out for the expressive power of their ink washes.

Of course, the wild side of Buson's ink painting cannot be attributed solely to the influence of Chinese yipin eccentrics. It resulted in part from lack of skill and from studying the followers of Shen Nanpin (1682–1780), a lesser Qing painter, who visited Nagasaki from 1731 to 1733. In other examples his style derived from his imitation of Zhang Lu and other Zhe-school painters who specialized in figures and landscapes and whose styles descended ultimately from Southern Song academic artists. The ink and brush methods of the Nanpin school, combined with the visual effects of ink wash, line, and the occasional rich tonal harmonies of Zhe-school masters, became the basis of Buson's late ink wash style.

In general, Buson's brushwork is stronger and more angular than Taiga's. Yet, like Taiga, he clearly tried through the sheer force of his brushwork to introduce new life into the patterns of line and dots he found in Chinese painting. That his accomplishments differed significantly from those of Taiga can be easily seen through a comparison of their characteristic foliage. Taiga created his form with distinct, regulated brush strokes (see cat. no. 46). Buson did not. Rather he forced the viewer to perceive texture in a merging of color and ground that comes from minute changes in the strength and density of his brushwork (see *Black Kite* and

figs. 11a and 11b
Yosa Buson (1716–83)
Black Kite and *Crows*
Circa 1780
Pair of hanging scrolls; ink and light color on paper
Each 133.5 x 54.3 cm (52 1/2 x 21 3/8in.)
Kitamura Bunkazaidan, Kyoto
Important Cultural Property

fig. 12
Yosa Buson (1716–83)
City under Night Sky
Circa 1780
Hanging scroll; ink and light color on paper
28.0 x 129.5 cm (11 x 51 in.)
Mutō Haruta Collection, Hyōgo Prefecture
Important Cultural Property

Crows, figs. 11a and 11b). Although Taiga shared something of this manner of grappling with the paper or silk ground as part of his expression, Buson concerned himself more deliberately with his materials.

Buson, for example, having seen seventeenth-century Chinese paintings on satin, experimented with this difficult surface. Perhaps his finest work in this medium is *Spring Glow after Rain* (cat. no. 49). Even as he brought the sheen of the satin ground to life, he fervently desired to depict the vast subtleties of the natural world.

Buson also treated paper to produce unusual effects. In his *City under Night Sky* (fig. 12), he first applied *gofun* (ground white shell) to paper as an undercoating. This specially prepared paper played a critical role in producing the whiteness of snow, the unique tone of the sky, and the dusky orange glow of lamplight in the houses. Buson's wonderful ink wash paintings could not have been realized without such experimentation.

Several masterpieces from his late years — *Black Kite* and *Crows*, *City under Night Sky*, *Peaks of Mount Omei* (figs. 13 and 13b), and *Mount Fuji over a Pine Forest* — employ the motif of a dark night sky, and two of them depict Japanese scenery. In these paintings, which look so carelessly drawn, Buson's quick, full lines describe their subjects succinctly. The broadly inked surfaces of night or snowy skies evoke the beauty of the ink wash itself. Snow or a moon left in reserve harmoniously join with the ink and light color, creating a surface of tonal richness. These expressions could not have been produced in any medium other than ink wash. Buson's manner of highlighting his subjects and the swiftness of his brush technique are characteristics not found in Chinese painting. Among ink paintings of the Edo period, *City under Night Sky* is one of the greatest achievements. Still, the similarity of this

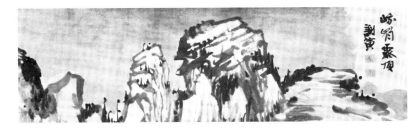

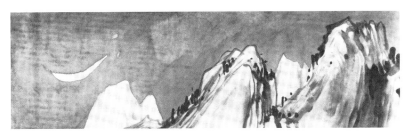

figs. 13a and 13b
Yosa Buson (1716–83)
Peaks of Mount Omei (details)
Circa 1780
Handscroll; ink and light color on paper
28.8 x 240.5 cm (11 3/8 x 94 5/8 in.)
Mizuno Fujiko Collection, Tokyo
Important Cultural Property

figs. 14a and 14b
Itō Jakuchū (1716–1800)
Grape Vines
1759
Two fusuma panels from a set of fifty fusuma
and wall panels; ink on paper
Each 170.0 x 95.0 cm (66 7/8 x 37 3/8 in.)
Rokuonji, Kyoto
Important Cultural Property

scroll to Hyakusen's handscroll *Famous Places of Ōmi and Kyoto* should not be overlooked.

Eighteenth-century Kyoto Individualists:
Itō Jakuchū

Itō Jakuchū (1716–1800) created a highly idiosyncratic style based on combining Kanō-school techniques, in which he was trained, and academic bird-and-flower painting of the Ming dynasty. In his earliest sumi-e he adopted a cliched Ming technique of applying ink wash so that flowers and leaves resemble flat metallic cutouts. He continued using this technique in his *Grape Vines* (figs. 14a and 14b), a monumental work consisting of fifty *fusuma* and wall paintings in the Rokuonji temple, dating to 1759. There he drew leaves without outlines; before the ink had dried he touched in veins in quick strokes to produce a blurred effect. The grapes show subtle contrasts of dense and light ink, departing completely from the somewhat inorganic quality of his Ming models. Despite his extraordinary mastery of ink, Jakuchū's brush technique remains the most noteworthy aspect of this work. In a later painting, *Lotus Pond* (cat. no. 74), dated 1790, he revived the technique, but by then the thrust of his experiments lay elsewhere.

In his ink paintings, more than in his works of brilliant polychrome, Jakuchū abbreviated and distorted the shapes of plants and animals. A pair of screens entitled *Birds, Flowers, and Vegetables*, dated 1759 (fig. 15), shows a new development in his increasing use of light and dark washes of ink and of sharp, angular brush strokes. These quick sketches were done on thin *gasenshi* paper, upon which ink easily runs and blurs; adjoining ink pools do not mix, leaving a white border in reserve in between. Jakuchu took advantage of this characteristic of the paper, creating a new method of painting each feather or petal separately. Most of

36

these late ink paintings are characterized by bold abstraction that articulates a sense of material substance of the animal or plant depicted.

The painting of plants and animals and various other subjects in ink wash had a long history in the repertoire of Chinese literati painters long before Jakuchū began his work. After Shen Zhou (1427–1509) extravagantly praised a handscroll depicting flowers and vegetables from life attributed to Muqi (Palace Museum, Beijing) and subsequently painted an album based on it, there was increased interest in this subject in Ming and Qing painting circles. Flowers drawn in ink wash, largely without outlines, had not interested Japanese Nanga artists until Jakuchū succeeded so brilliantly with the theme. Whether such paintings were inspired by works of Chinese artists, such as Xu Wei (1521–93), Zhu Da (1624–1705), or the eighteenth-century Yangzhou Eight Eccentrics, is unclear. Yet his achievement within the context of Edo-period sumi-e should be compared with theirs.

Soga Shōhaku

The fantastic, unrestrained paintings and unconventional behavior of Soga Shōhaku (1730–81) obliquely acknowledged the irreverent painting styles of Chinese eccentrics. The main body of his ink wash paintings are monumentally scaled with splattered ink and extremely violent brush strokes. Occasionally he used a towel dipped in ink instead of a brush, a method that Morishima Chōshi suggests in *Hanbaku zawa* (Tedious Conversations While Sitting at Ease) placed Shōhaku as a descendent of Chen Rong, a thirteenth-century Chinese painter of dragons. Morishima, a provincial literatus who had met Shōhaku as he wandered about Ise, compared him with the illustrious Tang painter Wu Daozi, and described his painting of the Zen eccentrics Kanzan and Jittoku (now lost) and recounted how Shōhaku, reversing the usual practice, began by drawing their feet and hands and ended with their heads.

Shōhaku first studied the painting methods of the Kanō school but soon found them ill suited to his restless spirit and turned to the antique style of the Soga school instead. While he was probably aware of the so-called depraved, or het-

fig. 15
Itō Jakuchū (1716–1800)
Birds, Flowers, and Vegetables (details)
1790
Pair of six-fold screens; ink on paper
Each 134.8 x 50.0 cm (53 1/8 x 19 5/8 in.)
Private collection, Hyōgo Prefecture

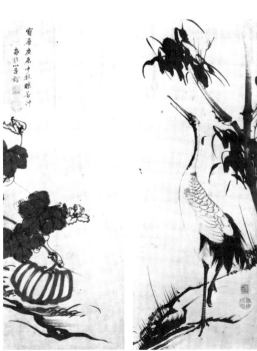
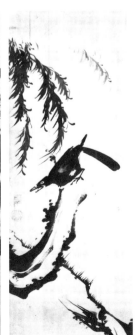
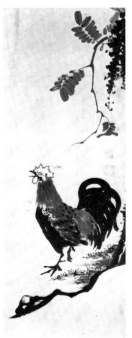

erodox, creations of some late Ming artists, he aggressively exploited extreme elements that were already latent both in Soga- and Unkoku-school paintings. He also may have adapted his method of drawing bold trees from Hyakusen's.

In Shōhaku's early works, fine, needlelike lines dominate, but in the 1760s his ink wash techniques matured, resulting in such representative works as the monumental *Dragon in Clouds* (Museum of Fine Arts, Boston) and *Chinese Lions* (cat. no. 76). In these and other paintings, through deceptively haphazard brushwork (seen also in Gyokudō's paintings), he captured paradoxically the essence of reality. For example, for Jittoku's clothing in the Kōshōji temple *Kanzan and Jittoku* (fig. 16), the artist provocatively smeared dense ink on top of lighter ink. This seemingly disordered brushwork transmits the feeling of coarse, filthy rags. Even in the wildest of paintings done in his thirties, however, the strange and daring brushwork does not obscure the meaning of details.

Such a precarious balance could not long survive. From about the 1770s the brushwork in Shōhaku's ink paintings returned to a style of powerful, rigid lines. The landscape panoramas of his late years, characterized by geometrical shapes and sharp contrasts of light and dark, resulted from his own reinterpretation of Muromachi landscape painting.

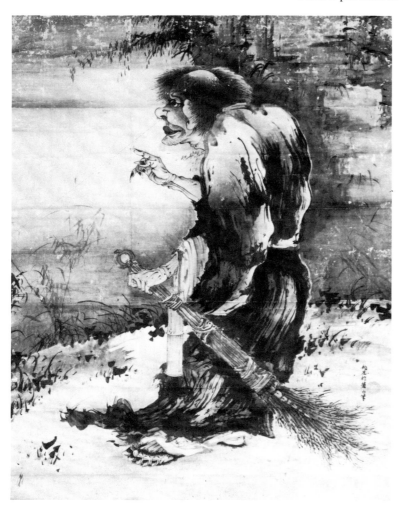

fig. 16
Soga Shōhaku (1730–81)
Jittoku
Mid-1760s
One hanging scroll of a pair ; ink on paper
74.0 x 135.0 cm (29 1/8 x 51 1/8 in.)
Kōshōji, Kyoto
Important Cultural Property

Maruyama Ōkyo

Maruyama Ōkyo (1733–95), like Jakuchū and Shōhaku, began his artistic career by studying Kanō methods. He also studied Japanese and Chinese paintings of many other styles and periods, assimilated the methods of perspective drawing from imported Chinese prints that were based on European compositions, and drew directly from nature. As a result, his painting style and that of the school he founded blended naturalistic and decorative qualities. Normally Ōkyo used ink to reproduce actual visual experiences. Even in those works where he used his brush liberally, he remained cautious about imparting expressive or abstract qualities to his lines or washes. He developed a characteristic technique of layering washes called *tsuketate*, in which a subtle balance between description and abstraction was displayed to marvelous effect.

Tsuketate was Ōkyo's response to traditional *mokkotsu* (boneless) painting, that is, painting without outlines. He invested every brush stroke with variations in density; when these varicolored brush strokes overlapped, they began to merge. It was an excellent method for drawing objects in shade.

Ōkyo's first bold use of tsuketate appeared in *Pine in Snow* (fig. 17), executed in 1765. In this hanging scroll on silk, Ōkyo suggested the mass of the tree trunk with a close, true-to-scale view. His sense of volume developed further in his screens *Dragons in Clouds* (1773; fig. 18), in which clouds and smoke emerge palpably from the richly graded ink wash. His finest use of tsuketate appears in another interpretation of snow-covered pine trees, *Pines in Snow* (fig. 19), one of a well-known pair of screens of the 1780s.

Bamboo (cat. no. 78) and *Wisteria* (fig. 20), two pairs of screens dating from

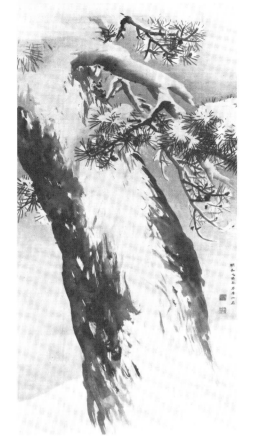

fig. 17
Maruyama Ōkyo (1733–95)
Pine in Snow
1765
Hanging scroll; ink on silk
123.0 x 71.6 cm (48 3/8 x 28 1/4 in.)
Tokyo National Museum

fig. 18
Maruyama Ōkyo (1733–95)
Dragons in Clouds
1773
One six-fold screen of a pair; ink and light color
on paper
Each 177.5 x 368.5 cm (69 7/8 x 145 1/8 in.)
Private collection, Gifu Prefecture
Important Cultural Property

1776, show yet another aspect of Ōkyo's ink wash painting. Of all of his works, these come closest to the realm of literati painting, even though Ōkyo opposed the subjectivity of the literati painting ideology through his advocacy of rational naturalism. In *Bamboo*, a bamboo forest sways gently in the wind and rain. Each stalk is defined in light or dark ink, rich in tonal nuance. The harmonious balance of light and dark in the rendering of the bamboo is precisely calculated, yet imbued with graphic, even calligraphic, qualities. In *Wisteria*, the vines drawn in light ink over the gold ground are more than mere vines: they are the traces of light, swift brush movements that meander across the surface, frequently changing direction. Of course, Ōkyo's emphasis on naturalism constrained his brush methods. Even so, only the medium of brush and ink could have allowed the expressive possibilities that so excited the imagination of Edo painters.

Nagasawa Rosetsu

Among Ōkyo's followers, Nagasawa Rosetsu (1754–99) went furthest in exploiting the potentials of the medium. It was during his 1786–87 travels in southern Kii Peninsula that Rosetsu began exhibiting the lively style that set his talent apart. In the nearly 180 fusuma and wall panel paintings produced for Kii temples, such as Muryōji and Sōdōji, his rapidly executed brush strokes evoked the excitement of his feverish vigor. He drew lively, close views and on occasion experimented with finger painting or painting while intoxicated. He defined triangular shapes in ink wash and juxtaposed broad expanses of black and white, exemplified by *Playful Monkeys on a Rocky Cliff* (cat. no. 81). After his Kii experiences Rosetsu continued to exploit the mysteries and beauty of dynamic linear movement, but in his late works he preferred a less improvisational technique that expressed his sensitivity to nature.

In a pair of superb byōbu entitled *Landscape* (fig. 21), Rosetsu experimented with ink lines and wash on gold ground. In the left screen a subtly varied gold ground penetrates the space left by the fantastic, cavernous rock formations drawn with wild brush strokes. This luminous ground seems to support the weight of the

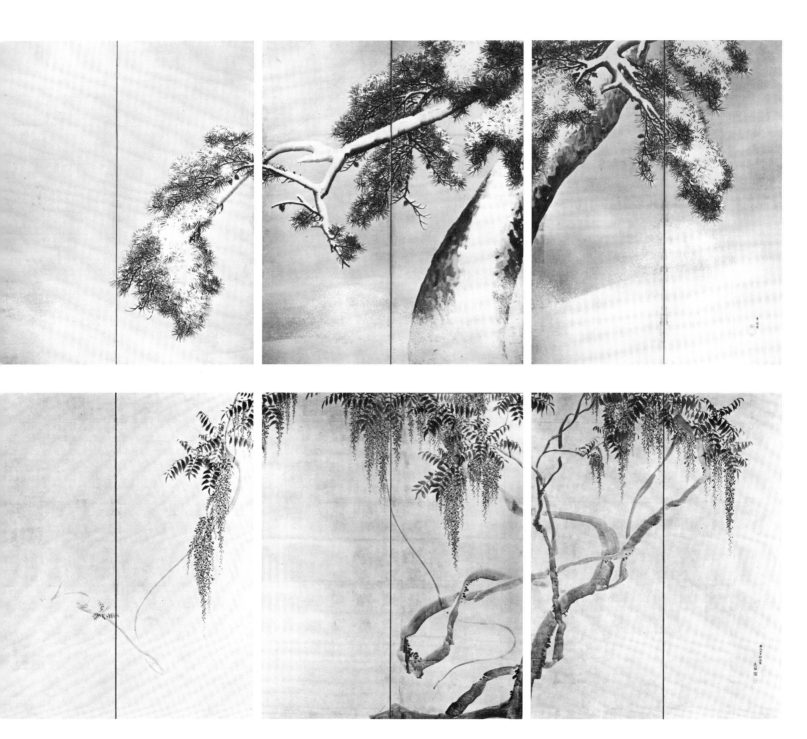

fig. 19
Maruyama Ōkyo (1733–95)
Pines in Snow
1780s
One of a pair of six-fold screens; ink and light
color on paper
Each 155.0 x 362.0 cm (61 x 142 1/2 in.)
Mitsui Hachiroemon Collection, Tokyo
National Treasure

fig. 20
Maruyama Ōkyo (1733–95)
Wisteria
1776
Pair of six-fold screens; ink, color, and gold foil
Each 156.0 x 360.0 cm (61 3/8 x 141 3/4 in.)
Nezu Art Museum, Tokyo
Important Cultural Property

strange rocks. By contrast, in the right screen the harmony of dense, bright ink in each of the trees makes the gold ground appear as a haze; pale ink spreads between the twigs to soften the gold. Thus in the left screen the rocks absorb the metallic quality of gold, while in the right screen the transparent light ink dissolves the gold into the atmosphere. While applying ink directly to gold foil flourished during the Edo period, Rosetsu's screens were surely the finest achievements in this technique.

Representative of his exquisite depictions of scenery are his album *Eight Views of Miyajima* (fig. 22), painted in 1794, and his hanging scroll *Moonlit Landscape* (fig. 23) of the late 1790s. In these compositions the Japanese countryside appears to float in the pale glow of dusk or stands silhouetted by the moon. Making subtle use of the mokkotsu technique, he achieved extraordinary pictorial qualities with bland understatement. The style of *Moonlit Landscape* prefigures the ink wash painting of the Meiji and later periods.

Nineteenth-century Literati Painters:
Uragami Gyokudō

Friendships and common stylistic sources united the early literati painters Taiga and Buson, but whether or not their styles were perpetuated in the works of third-generation literati painters in the early nineteenth century is unclear. Of the period's finest ink painter, Uragami Gyokudō (1745–1820), it can only be said that he independently pursued the relationship with Chinese painting.

Just as Taiga used accident learned from finger painting to enliven his brushwork, it seems Gyokudō transformed his painting through intoxication. Many of his works bear inscriptions affirming this.

Tanomura Chikuden (1777–1835) wrote of Gyokudō in his painting treatise *Sanchūjin Jōzetsu* (A Mountain Man Wags His Tongue):

> Some of the ancients borrowed the effects of drinking in their brushwork. Ki Gyokudō does this. Perhaps it is only when he drinks that he gains the divine favor that makes his works differ from those of ordinary men. When Ki indulges, he feels free to paint; dripping ink he is unable to rest. Once he sobers up he stops. To complete one painting he sometimes has to drink as many as ten times.

For Chikuden, the ancients must have included the early hatsuboku painters.

Elsewhere it is recorded that when Gyokudō was living in Kanazawa "he awoke early in the morning, drank sake, played his Chinese lute, and then enjoyed himself painting or composing poetry." Gyokudō's eldest son, Shunkin (1779–1846), wrote an inscription in 1811 on his father's *Album of Mist and Clouds* (c. 1806–10; fig. 24) which includes the word *hatsuboku* and mentions Wang Mo. Thus Gyokudō may have sensed that he was descended from the Chinese eccentric painters.

Gyokudō's uninhibited and highly individualistic style comprised a strange mixture of randomness and verisimilitude. In his paintings each and every brush stroke was applied freely, seemingly without following any particular sequence. In reality they were piled up deliberately, resulting in an image of limitless, changing scenery.

First in any consideration of his methods must be his use of the brush. In the works of the literati pioneers dots and lines were quiescent and without individuality. Taiga and Buson animated them, and their facility in drawing scenery made personal statements of their brushwork. Gyokudō too expressed his inner spirit freely in this medium. His brushwork, whether tumbling or thrashing or concealed

41

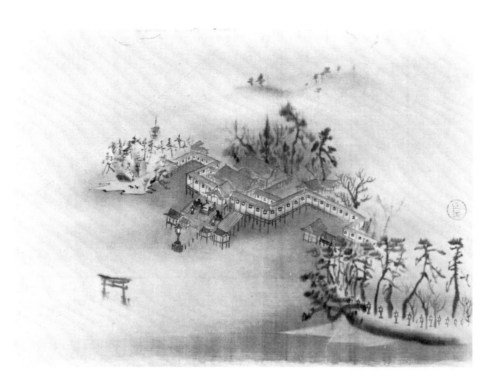

fig. 22
Nagasawa Rosetsu (1754–99)
"View of Itsukushima Shrine" from *Eight Views of Miyajima*
1794
Album leaf; ink and light color on silk
34.5 x 46.5 cm (13 5/8 x 18 1/4 in.)
Yasuda Chūzō Collection, Hiroshima Prefecture
Important Cultural Property

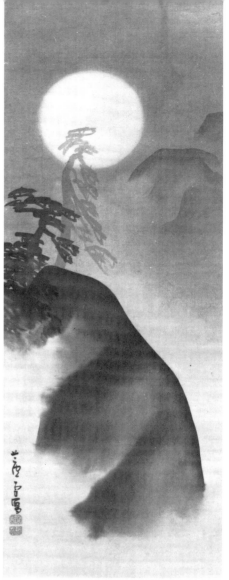

fig. 23
Nagasawa Rosetsu (1754–99)
Moonlit Landscape
Late 1790s
Hanging scroll; ink on silk
98.0 x 35.5 cm (38 5/8 x 14 in.)
Egawa Art Museum, Hyōgo Prefecture
Important Art Object

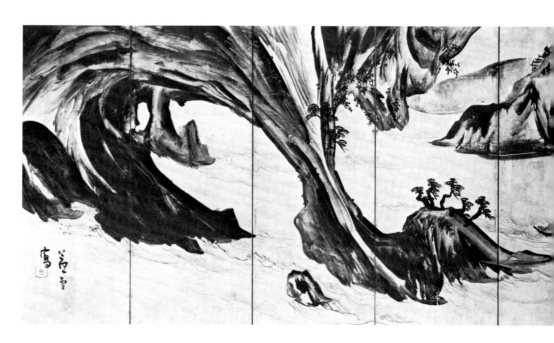

fig. 21
Nagasawa Rosetsu (1754–99)
Landscape
Late 1790s
Pair of six-fold screens; ink on gold foil
Each 155.0 x 355.2 cm (61 x 139 7/8 in.)
Metropolitan Museum of Art

42

in a spreading pool, forces the viewer to feel the energy at the moment of creation.

Gyokudō, like Buson, was a late-maturing painter, and his use of improvisational brushwork only began when he was already in his sixties, about the time of his *Album of Mist and Clouds*. This album is a free interpretation of compositions and motifs from an album of the same title (fig. 25) by an otherwise unknown artist, Li Heng, which Gyokudō acquired in 1806. Having reworked Li Heng's style and compositions, Gyokudō endeavored to improve his layering of horizontal strokes and attempted to recreate the atmospheric qualities of Li Heng's paintings. In Gyokudō's album, however, the saturated clouds and mist, contrasting light and shade, and separation of foreground and background seen in Li Heng's painting were eliminated. Uninterested in mere depiction of scenery, Gyokudō wielded his brush for the pure enjoyment of its movement. Thus Li Heng's album should be considered the spark that ignited Gyokudō's brush style.

Gyokudō's use of ink wash is particularly noteworthy. Hyakusen and Taiga had limited their use of broad ink washes, suggestive of light, shade, and atmosphere to depictions of famous Japanese sites. Buson created a completely new vision of ink wash painting in his late years by adjusting his brushwork and ink washes to the surface medium, bringing forth beautiful textures. Gyokudō made further advances in this direction, although his methods differed considerably. Chikuden wrote in *Sanchūjin Jōzetsu* that one of Gyokudō's merits was that his layering of washes and his horizontal texturing strokes penetrated to the back of the paper. "An excellent painting should be ambiguous and indistinct. Ancient masters, who strove for such an effect, painted on washed silk or on silk polished with fine-grained stones, making it receptive to ink. Gyokudō understood the significance of this." The depth that Gyokudō achieved through layering dry and wet, light and dark brush strokes created the richness of a patinated surface. In his paintings brushwork and ink are harmoniously united. Strokes that appear whimsical actually express the spirituality evoked by nature. Gyokudō carried the potentials of ink painting further than any other Japanese literati artist.

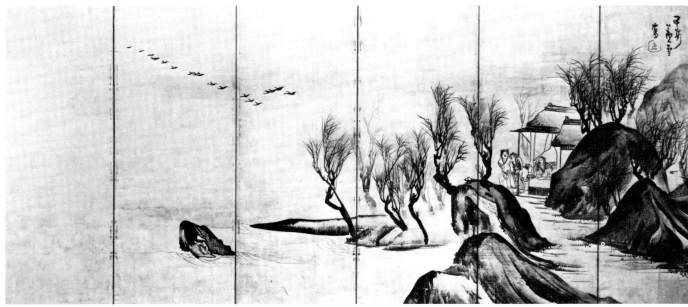

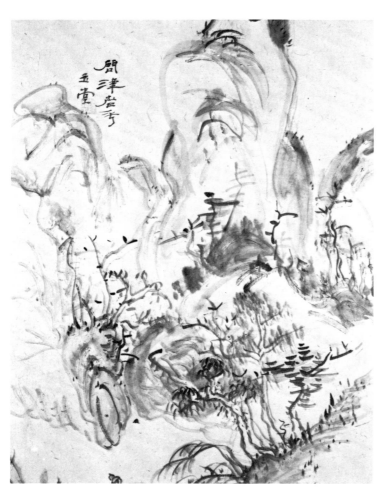

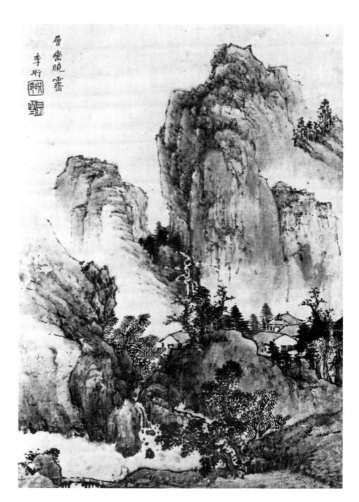

fig. 24
Uragami Gyokudō (1745–1820)
Album of Mist and Clouds
Circa 1806–10
Album leaf; ink and color on paper
29.1 x 22.4 cm (11 1/2 x 8 7/8 in.)
Colophons (1811) by Uragami Shunkin and
Tanomura Chikuden
Umezawa Kinenkan, Tokyo
Important Cultural Property

fig. 25
Li Heng
Album of Mist and Clouds
Circa 1800
Album leaf; ink and light color on paper
25.9 x 17.8 cm (10 1/4 x 7 in.)
Private collection, Hyōgo Prefecture

Nineteenth-century Nanga Masters

After Gyokudō there were few innovations in ink painting in the nineteenth century except perhaps for the Nanga artists in Mito. By that time orthodox Qing painting was well understood in Japan. Fine, delicately drawn depictions, using dot, line, and light color, dominated the work of mainstream artists, such as Tanomura Chikuden.

Okada Beinsanjin (1744–1820), a friend of Gyokudō, also enjoyed painting while intoxicated. Yet his paintings, if anything, advanced in the direction set by Taiga. Natural motifs, reduced to abstract forms and patterns, are drawn in brushwork overflowing with a feeling of power.

Aoki Mokubei (1767–1833) tried both finger painting and fine linework, but his forte, like Taiga's, lay in balanced compositions, in experimentation with pale colors, and in creating strong, dark accents over pale, graded mists.

Tani Bunchō (1763–1840) transplanted literati painting to the city of Edo. Although he occasionally worked in a splashed-ink mode, this had little effect on his landscape paintings. His successes in this technique are works depicting famous places, such as Matsushima (see *Dawn at Matsushima*, fig. 26) or the Sumida River. Of more importance is the linework found in his sketches of scenery and the improvisational brush strokes that reveal the unexpected beauty of nature. This style of drawing was also taken up by Watanabe Kazan (1793–1841; see "Kamabara," fig. 27), Tsubaki Chinzan (1801–54), and others. The sketches of these three artists, who used brush and ink as lightly as pencil, foreshadow the trends of the modern era.

Hayashi Jikkō (1777–1813) and Tachihara Kyōsho (1785–1840) were painters of the Mito region northeast of Edo. Although the expressive ink paintings of Japanese literati artists were primarily landscapes, these painters applied broad wash techniques to a variety of subjects. Jikkō did finger paintings and innovative creations stimulated by drunkenness. Kyōsho's masterful *Grapes* (cat. no. 69), painted while the artist was intoxicated, calls to mind the similarities between Chinese yipin painters of the eighth century and late Edo sumi-e artists.

fig. 26
Tani Bunchō (1763–1840)
Dawn at Matsushima
1826
Hanging scroll; ink on silk
42.0 x 125.4 cm (16 1/2 x 49 3/8 in.)
Private collection, Tokyo

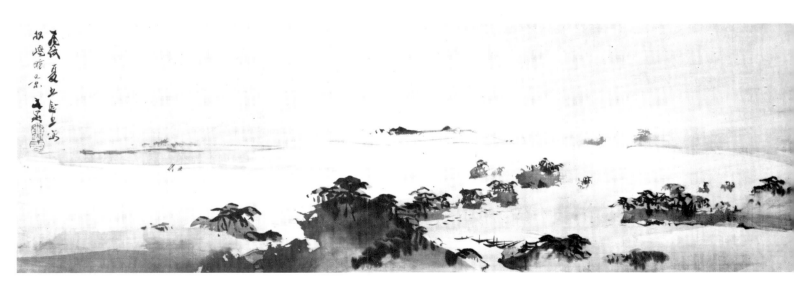

Most outstanding ink paintings of the late Edo period, with their experimental techniques and expression of individual painters' creative energies, embody a spirit of *bokugi* (ink play) derived ultimately from Chinese literati painting. In Japan, however, that spirit reached a more popular level of acceptance, where it was freely and vitally transformed. The sumi-e techniques refined in this period were transmitted to artists of the Meiji era, but the spirit of creative playfulness that enlivened late Edo painting was gone.

NOTES

1. Alexander C. Soper, trans., "T'ang Ch'ao Ming Hua Lu (The famous paintings of the T'ang dynasty) by Chu Ching-hsuan of Wu-chün," *Archives of the Chinese Art Society of America* 4 (1950): 20.
2. Taiga mistakenly wrote Wang Mo for Wei Yan in his inscription. This has been corrected for the essay.

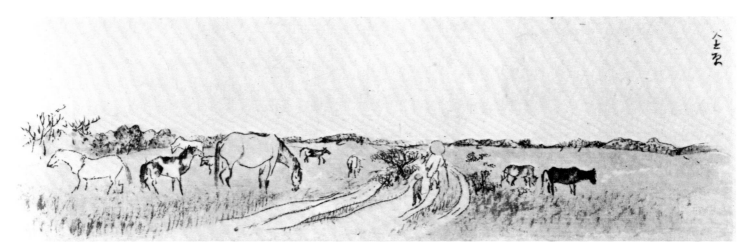

fig. 27
Watanabe Kazan (1793–1841)
"Kamabara" (detail) from *True Views of Four Provinces*
1825, with color added 1840
Second handscroll of a set of four; ink and color on paper
13.3 x 454.4 cm (5 1/4 x 178 7/8 in.)
Tanaka Heiroku Collection, Aichi Prefecture
Important Cultural Property

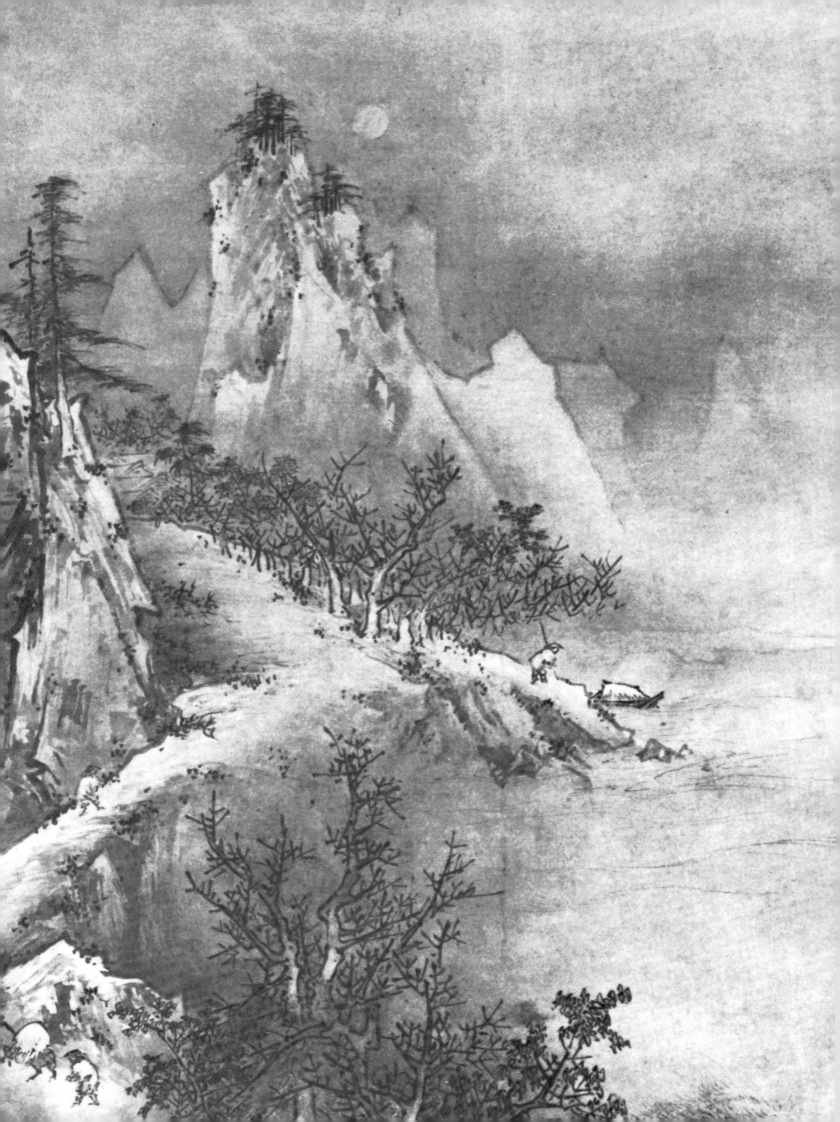

CATALOGUE OF THE EXHIBITION

Notes to the Reader

Japanese names have traditionally been rendered with the family name first, a custom that we have observed in this catalogue. An artist usually adopts the surname of his studio family, like Kanō or Soga, and in addition assumes innumerable pseudonyms, which he often uses in preference to his formal name. This practice began with courtier artists and Buddhist priests. Artistic noms de plume are frequently poetically beguiling phrases; nevertheless they can create problems of identification.

An artist's seal is usually added to his signature or at times replaces it. Occasionally there is a *kakihan* (cursive monogram), which is more often than not a challenge to decipher.

Poems are at times included as integral parts of ink paintings, where they function as sources of inspiration or dedications. Thus the three arts of poetry, calligraphy, and painting are often combined. Other inscriptions can be added by friends or admirers of the artist as encomia.

The heading information for each painting in this catalogue gives the signature or signatory inscription transliterated in Japanese. Longer inscriptions, which occasionally include dates of execution, are given in English translation. Dimensions are listed (height followed by width) in centimeters and inches.

Romanization of Japanese is constantly evolving. In the absence of a definitive system, we have incorporated what appears to be current practice in minimizing the use of hyphens. Apostrophes precede vowels that follow the letter *n* in order to clarify ambiguous syllabic divisions. Macrons are reproduced as they appear in Kenkyusha's *Japanese-English Dictionary*.

The Japanese have been classifying their cultural assets since the end of the nineteenth century. Today their finest art monuments are classified as National Treasures and Important Cultural Properties. Several grace this exhibition. In addition, there is an earlier, third-ranking category, Important Art Object, which is today being discontinued.

Winter Landscape
(detail, cat. no. 6)

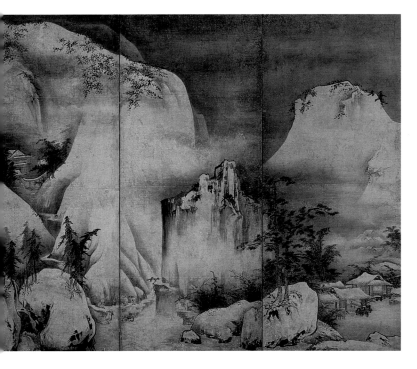
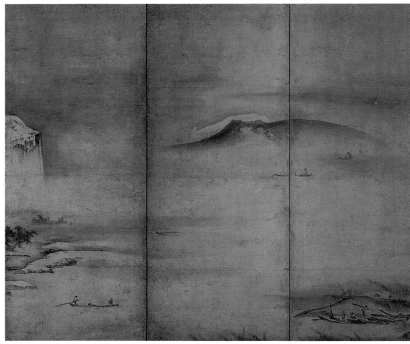

1 ANONYMOUS

Landscape of the Four Seasons
Late fifteenth century
Pair of six-fold screens; ink and light color
on paper
Each 151.5 x 355.0 cm (59 5/8 x 139 3/4 in.)
Tokyo National Museum
Important Cultural Property

The earliest ink landscapes painted in Japan were intimate views of scholars' studies, painted on vertical hanging scrolls. During the fourteenth century the demand grew for ink paintings on *byōbu* (folding screen) and *fusuma* (sliding door) panels. Artists adapted styles, motifs, and compositions from imported models and combined them with a traditional fondness for depicting seasonal and temporal change. For most Japanese painters unfamiliar with Chinese scenery, the painting of vast mountain panoramas or misty lakeside vistas became an imaginative exercise.

These screens had long been attributed to the elusive Zen monastic painter Tenshō Shūbun, but they are now thought to date to about a generation after his period of activity. They are among the finest examples of four-seasons screen compositions. Spring begins with the blossoming plum trees of the right screen, and the change of seasons progresses to the left. The towering cliff that stretches from near to middle ground disappears in the mist that connects it to the distant peak, giving an impression of fantasy. The painter contrasted the grandeur of nature with the insignificance of mankind. The figures in the painting, neither immortals nor lofty scholars, go about their everyday affairs. At the foot of the

cliff a fisherman casts his net, and travelers visit mountain cottages.

The focus of the summer scene is a lakeside pavilion under willows. A man rests, allowing his donkey to enjoy the cool breeze. In the left screen the full moon and a line of geese evoke countless Chinese and Japanese poetic associations of autumn. The winter scene, like that for spring, is a complex composition; its tightly connected mountains loom above a village. The contrasts of the darkened sky, the bright white snow, and the rich black ink of the trees are striking and fresh.

These screens include motifs common to paintings depicting the Eight Views of the Xiao and Xiang rivers, a popular theme in the Muromachi period (see cat. nos. 12, 15, and 31). Here, however, these references take second place to the well-integrated seasonal motifs; the artist has avoided fragmenting his overall composition. In many other Muromachi landscape screens the viewpoint is closer to the subject and decidedly lower, so that the viewer seems to be looking up into the scene. Here the viewer looks down from a distant vantage and enjoys the depth and serenity of the landscape.

Miyajima

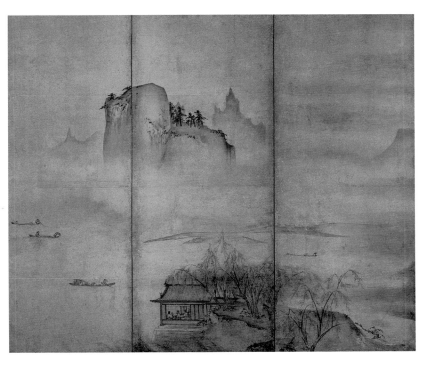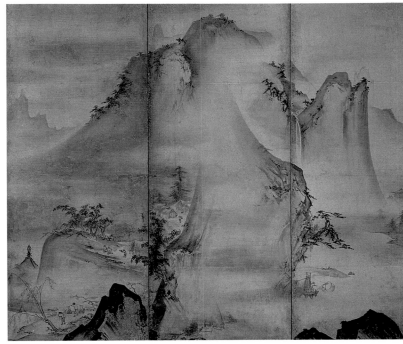

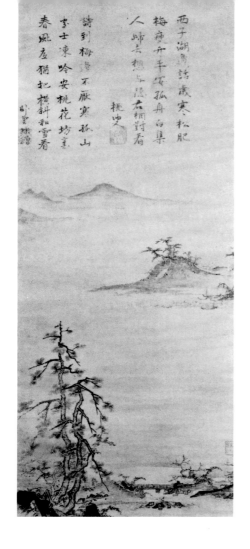

The poetic inscription by Ichijō Kanera identifies this lakeside vista as West Lake, a celebrated scenic location in Hangzhou. A broad expanse of sky and water merging into mist stretches from nearby shore to distant mountain, unifying the composition. Beyond the towering pines a traveler makes his way toward a bridge sheltered by bamboo and flowering plum trees. In the middle distance boats are harbored in the lee of Solitary Mountain, the island in the northern portion of West Lake.

Kanera's poem describes the wintry chill that envelops the scene:

> On the shore of West Lake we speak of the season's cold:
> The thick pine trunk, sparse plum blossoms, and bamboo at rest.
> The solitary boats collect as their occupants return home.
> How I long to join that hermit watching.

In the companion poem, the prominent Zen master and scholar Zuikei Shūhō mentions being at Kanera's Peach Blossom Studio, which was destroyed at the beginning of the Ōnin War in 1467. This painting

should thus predate that fire.

A seal at the lower right identifies the painter as Bunsei. At least six extant works by Bunsei are known. Two are portraits of Zen masters: Yōsō Sōi, inscribed by the sitter in 1452, and Yang Qi, a Tang dynasty monk, also inscribed by Yōsō (both at Daitokuji). Two others are also Buddhist in tone: *Three Laughers of Tiger Creek* (Powers Collection, New York) and an imaginary portrait of the Buddhist layman Yuima (Yamato Bunkakan), with a 1457 inscription. Only one other landscape exists, that in the Museum of Fine Arts, Boston.

Nothing else is known of Bunsei's life or career. Judging from his paintings, he was deeply involved in Zen circles and may have been a Zen monk himself. Since he used the character *bun* from Shūbun's name, he may have been a disciple. There is a theory that Bunsei is the same as another painter of the period whose name is written differently or that he was a Korean painter, but these problems cannot at present be resolved.

Miyajima

2 B U N S E I
(fl. 1427–57)

Landscape
Mid-fifteenth century
Hanging scroll; ink on paper
79.0 x 36.5 cm (31 1/8 x 14 3/8 in.)
Square relief seal: *Bunsei*
Inscription by Ichijō Kanera (1402–81)
signed: *Tōsō*
Square relief seal: *Kanera*
Inscription by Zuikei Shūhō (1391–1473)
signed: *Gaun Juso*
Square intaglio seal: *Zuikei*
Masaki Art Museum, Osaka
Important Cultural Property

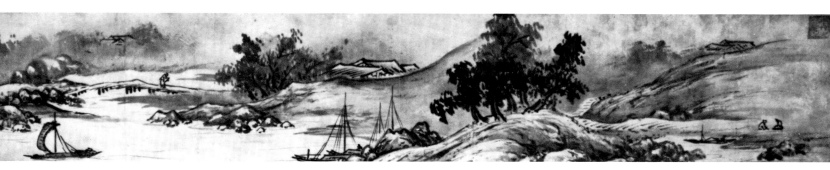

3 SESSHŪ
(1420–1506)

Landscape
Dated 1474
Handscroll; ink on paper
23.6 x 554.5 cm (9 1/4 x 218 1/4 in.)
Inscription signed: *Late in the first month of [1474], Sesshū, occupant of the first seat at Tiantong, Mingzhou, in Ming China*
Square relief seal: *Sesshū*
Colophon by Kinoshita Toshinaga (1648–1716) signed: *Toshinaga added this record based upon the recollections of his elders.*
Yamaguchi Prefectural Museum
Important Cultural Property

Although he entered the Shōkokuji Zen temple in Kyoto as a youth, Sesshū spent half his life outside the capital, in the far western province of Suō (now Yamaguchi Prefecture). There he received the patronage of the powerful Ōuchi family, who gave him his Unkoku Studio. As a member of the Ōuchi entourage, Sesshū accompanied the official Japanese delegation to Ming China in 1467. For nearly two years he visited famous Chan monasteries, sought out Chinese painters, and painted for his Chinese hosts. Upon his return to Japan, he found his own country still immersed in the strife of the Ōnin War, and thus he settled once again in Suō and in nearby Bungo.

Among Sesshū's disciples was Unpō Tōetsu, for whom he painted this landscape handscroll in 1474. The inscription reads in part: "On my travels to the south, I found that the style of many famous Chinese painters followed that of Gao Yanjing. Afterward I too painted landscapes in imitation of Yanjing, according to contemporary practice. When my follower Tōetsu asked for a painting, I did this and gave it to him."

The inscription mentions the Yuan artist Gao Yanjing (Kegong, 1248–1310), a landscape painter who employed moist ink dots and washes to build his mountains and describe his foliage. With this handscroll Sesshū gave Tōetsu a model to follow and furthermore indicated his approval of his disciple.

Unfortunately the latter (left) half of this scroll is a copy, as explained in the colophon by Kinoshita Toshinaga. According to his inscription, Toshinaga's grandfather Nobutoshi (1577–1642) saw the painting at the home of Hosokawa Tadaoki (1563–1645) when a poor, unnamed Hasegawa painter brought the scroll to sell. The painting was cut in two, with the first (right) half sold to Nobutoshi, the latter half kept by Tadaoki. Nobutoshi ordered the painter to copy the latter half to include Sesshū's inscription. The Hasegawa painter was probably a descendant of Tōhaku.

Miyajima

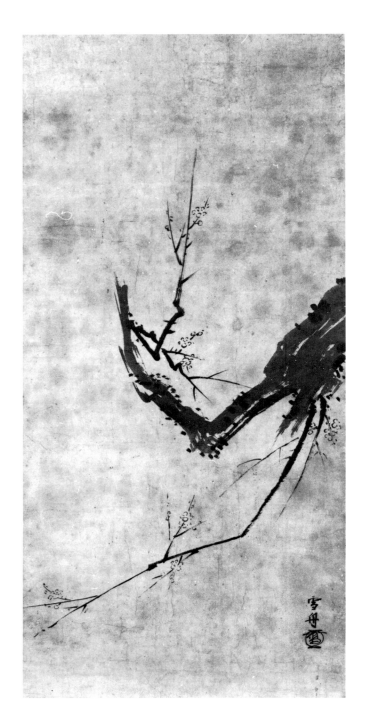

4 SESSHŪ
(1420–1506)

Plum Branch
Late fifteenth century
Hanging scroll; ink on paper
90.9 x 40.5 cm (35 3/4 x 16 in.)
Signed: *Sesshū*
Monogram
Tokyo National Museum

Unlike the luxuriant ink plums of four-teenth-century Chinese painters, this ancient plum has a forlorn appearance. Few blossoms remain on the twigs that grow from its decayed trunk. Yet the sim-ple composition is imbued with strength. The trunk, deliberately placed at the center of the paper, turns upward at a right angle. A thin twig shoots straight out, balanced by the long diagonal branch below. The form of this branch resembles a similar plum bough in the upper left corner of Sesshū's *Tenjin* [the deified Sugawara Michizane] *in Tang China*, painted when the artist was eighty-two. This plum painting may also date to Sesshū's late years.

Unusual in Sesshū's works is the inclu-sion of his *kaō* (monogram) beneath his sig-nature. The most reliable version of Sesshū's monogram appears on a letter (now in the Umezawa Kinenkan) to his disciple Sōen, written at age eighty. A comparison between the two monograms finds them similar in overall appearance, but this monogram is cruder, with slight differences in detail.

Although this painting cannot be se-curely authenticated, a Kanō Tan'yū (1602–74) copy proves that the traditional attribu-tion to Sesshū is fairly old. It is a work thor-oughly worthy of the aged Sesshū, who revealed his lofty spirit in the withered plum branch.

Miyajima

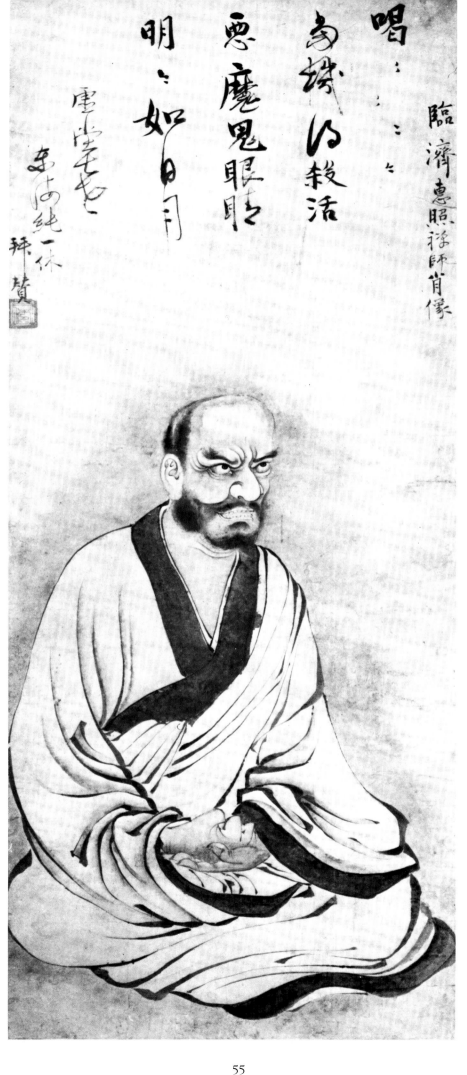

5　Attributed to
SOGA JASOKU
(Bokkei, c. 1415–73)

Portrait of Priest Linji
Late fifteenth century
Hanging scroll; ink and light color on
paper
95.0 x 40.3 cm (37 3/8 x 15 7/8 in.)
Title and inscription by Ikkyū Sōjun
(1394–1481) signed: *Seventh-generation fol-*
lower of Xutang, Tōka Jun, Ikkyū
Square relief seal: *Ikkyū*
Shinjuan, Daitokuji, Kyoto
Important Cultural Property

The subject of this portrait, Linji (Japanese:
Rinzai; d. 867), was the Chinese patriarch
of the Linji sect of Chan Buddhism. The
form of Chan espoused by Linji bordered
on violence. He was renowned for beating
or upbraiding his disciples to lead them to
enlightenment. In this painting, he shouts,
his right hand clenched in a fist. His
furrowed brow and piercing eyes echo the
words of Ikkyū's encomium, "His evil de-
mon's eyes, bright like the sun and moon!"
They seem to penetrate to the depths of the
viewer's soul.

　Portraits of Linji are rare. A closely re-
lated painting in the Yōtokuin subtemple
of Daitokuji is the left panel of a triptych
that has Bodhidharma, the Indian pa-
triarch of Chan, in the center.

　The first artist to be known as Soga
Jasoku received the name Bokkei from his
teacher, Ikkyū, at least by 1453, when the
artist painted the latter's formal portrait.
After Daitokuji burned during the Ōnin
War, Ikkyū took charge of the temple's res-
toration with the help of the Asakura clan,
whom Bokkei had served before becoming
Ikkyū's disciple. Although the painting
bears neither seal nor signature of the art-
ist, it is closely related to other works in the
Shinjuan, Ikkyū's memorial chapel at
Daitokuji. Bokkei's activities have fre-
quently been confused with those of his
descendants, who continued to paint for
Ikkyū's successors at Daitokuji.

Miyajima

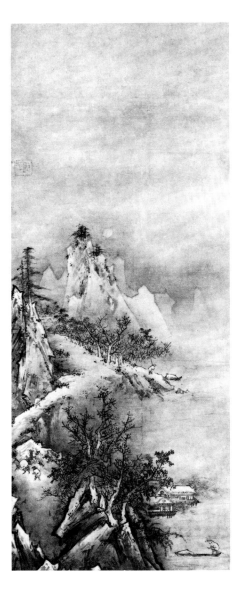

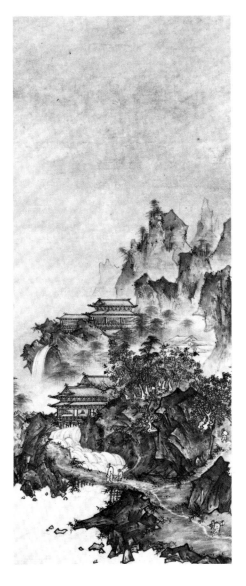

6 SESSON SHŪKEI
(c. 1504–89)

Summer Landscape and *Winter Landscape*
Middle sixteenth century
Two hanging scrolls; ink and light color on
paper
Each 102.0 x 40.5 cm (40 1/8 x 16 in.)
Square intaglio seal: *Sesson*
Kyoto National Museum

Sesson's life dates are uncertain, but inscriptions on various paintings indicate that he lived to be at least eighty-two, a life that spanned most of the sixteenth century. Although born to a warrior family, he took the tonsure to become a Zen monk and specialized in painting. He himself venerated Sesshū as his teacher, but the two artists' periods of activity and circles of associates were completely different. Sesson, brought up in the east, had no opportunity, in fact, to see Sesshū's paintings. Instead his primary efforts were devoted to copying Chinese paintings.

From their style and seals, these landscapes date to the artist's middle period, his forties or fifties. During this time Sesson was active in the Kamakura area, where he was able to see the many fine examples of Chinese and Japanese paintings that stimu-

lated his development as a painter. A hallmark of Sesson's work is his power to capture ever-changing nature, especially wind, rain, waves, or waterfalls. In these landscapes, however, the elements are used in moderation, and both paintings are calm. Trees in full leaf dot the summer landscape. A reddish tinge barely touches the mountain range, and the still, dark sky gives the impression of dawn. Sesson used pale blue color wash on the distant peaks. Moist black ink brilliantly transmits the damp chill of the atmosphere. Pale moonlight illumines the winter scene. A light dusting of snow reflects the moonlight, beneath which only the sound of the oars and the whinny of the pack horse can be heard.

Miyajima

7 KANŌ MASANOBU
(1434–1530)

Landscape
Late fifteenth century
Hanging scroll; ink and light color on silk
119.0 x 37.4 cm (46 7/8 x 14 3/4 in.)
Tripod-shaped intaglio seal: *Masanobu*
Poetic inscription by Ōsen Keisan (1429–
93) signed: *Kinka Keisan*
Square relief seal: *Keisan*; square intaglio
seal: *Ōsen*
Chōrinji, Tochigi Prefecture

Masanobu was the patriarch of the long-lived Kanō family of painters. Patronized by Ashikaga Yoshimasa (1436–90), he became an official painter to the shogun, a position that allowed him to build a foundation for the success of his sons and grandsons in the Momoyama and Edo periods. Although he was not born into a traditional family of painters, he succeeded in creating an individual style. A contemporary document relates that he studied with a member of the Tosa family, which suggests that his training was quite broad. At first his metier was polychrome painting, especially portraiture and Buddhist subjects, but he is more commonly identified as a painter of landscapes.

This painting belongs to the early period of Masanobu's landscapes. The waterfall plunging from the clouds and the stylized bubbles at the foot of the cascade are still experimental. Compared with the landscape panoramas of Shūbun followers (cat. nos. 1 and 2), Masanobu's claustrophobic sense of space reveals his own temperament.

The poem on this painting was written by the Zen monk Ōsen Keisan, who also inscribed a better-known waterfall composition by Geiami dated 1480.

> The mountain, lost in mist and clouds,
> changes from day to night.
> Bamboo crowds a thatched hut beside
> the precipitous mountain path.
> A thousand-foot cascade of snow
> descends beyond the pine.
> Could it be one trickle from the Milky
> Way?

Miyajima

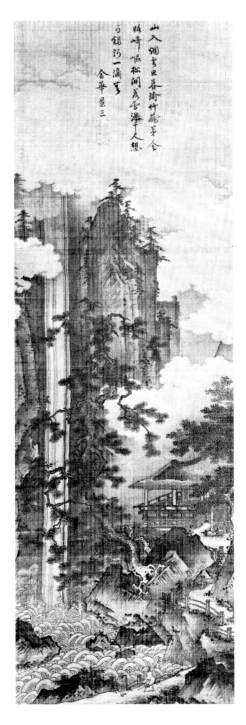

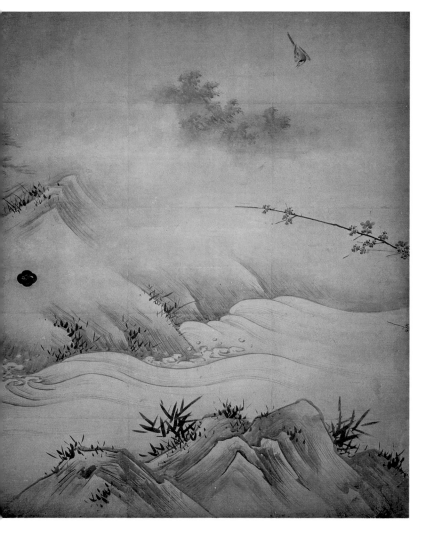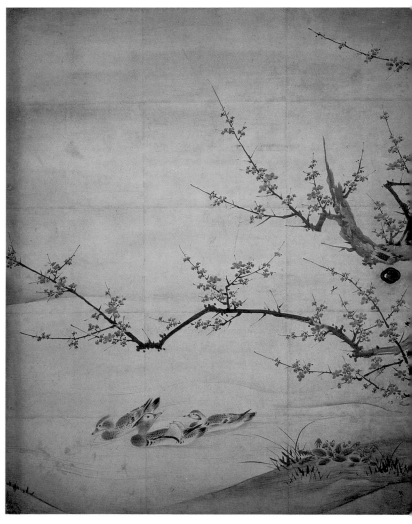

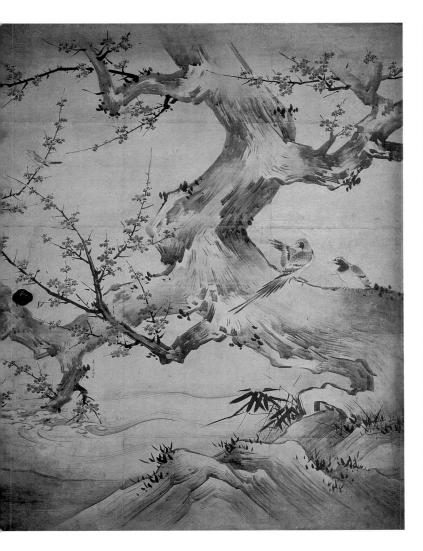
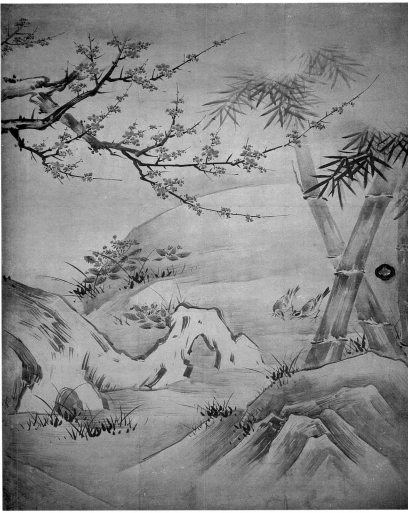

8 Attributed to
KANŌ EITOKU
(1543–90)

Birds and Flowers in the Four Seasons
Circa 1566
Four fusuma panels from a set of sixteen;
ink and gold on paper
Each 175.5 x 142.5 cm (69 1/8 x 56 1/8 in.)
Jukōin, Daitokuji, Kyoto
National Treasure

The most important room in the main hall of Jukōin, founded as a memorial chapel in 1566 for Miyoshi Chōkei (1522–64), is enclosed by fusuma panels depicting birds, flowers, and trees. Although these panels are unsigned, a temple tradition that Eitoku painted them is completely reliable. A great-grandson of Masanobu, Eitoku, a precocious youth, had executed them by age twenty-three.

These four panels begin the composition at the right with spring, while a flowing stream and river bank continue leftward into summer. The powerfully conceived, monumental red plum stretches its branches over the stream, partially dipping into the current below. The excitement of the small bird cavorting in midair attracts the notice of the two larger birds perched on the trunk of the plum and gives a feel-

ing of unity to the composition. No wonder the overall impression is one of strong, even youthful vitality.

Eitoku received the patronage of Oda Nobunaga, who employed the artist and his workshop to decorate the walls of Azuchi Castle in the late 1570s. During the next decade Eitoku took charge of painting for the interior of Toyotomi Hideyoshi's Osaka Castle and Jūrakudai mansion. The frantic pace and magnitude of these and other projects may have brought about the artist's premature death in 1590. Since all of his major commissions have long since been lost, the exuberant monumentality of this plum tree at Jukōin provides a rare glimpse of Eitoku's distinctive personal style.

Miyajima

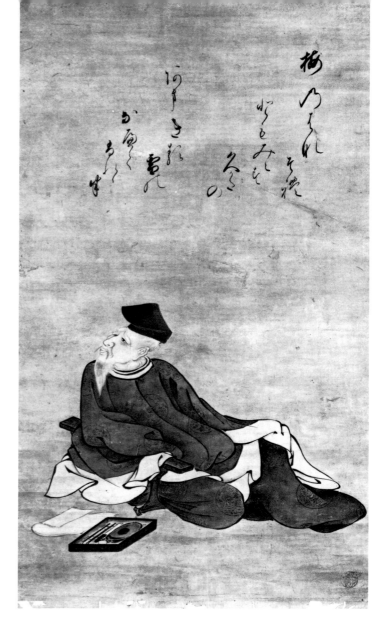

9 Attributed to
K A N Ō E I T O K U
(1543–90)

Imaginary Portrait of Kakinomoto Hitomaro
Late sixteenth century
Hanging scroll; ink on paper
83.5 x 46.5 cm (32 7/8 x 18 1/4 in.)
Tripod-shaped relief seal: (illegible character) *nobu*
Poem by Hitomaro (d. c. 729)
Gumma Prefectural Modern Art Museum

The court poet Kakinomoto Hitomaro had come to be revered as the patron deity of Japanese poetry by the early twelfth century. The oldest known portrait of him is included in the Satake version of Thirty-six Immortal Poets, dating from early in the following century. Hitomaro portraits may be divided into two lineages. One is exemplified by the Satake version, in which Hitomaro sits with a brush in one hand and a scroll of paper in the other. This portrait is representative of the other tradition, the earliest example of which is a late-fourteenth-century painting by Takuma Eiga, now in the Tokiwayama Bunko collection.

The seal in the lower right corner of the scroll is identical to the one on Eitoku's brilliantly colored *Scenes in and around Kyoto*. Because his seals are infrequently found, the authenticity of this one cannot easily be verified. Nevertheless the elongation of Hitomaro's face is characteristic of the artist's figural style.

Although this unusual painting was carefully executed without color, the subdued line and ink washes give the impression of polychrome. Iwasa Matabei strove for similar effects in his ink figures, but other examples of this style are rare.

Imaginary portraits of poets usually include a sample of their poetry, written in elegant Japanese script. The poem in this portrait (from a tenth-century anthology, *Kokinwakashu* [Collection of Ancient and Modern Poetry]) reads:

> The blossoms of the plum
> Do not appear to be themselves,
> For they are blanketed
> With clouds of falling snow
> That swirl from the distant sky.*

According to the contemporaneous inscription on the box, the poem was brushed by the first son of Emperor Ōgimachi, who became known posthumously as Yōkōin (1552–86). If he was indeed the inscriber, this painting can date no later than 1586, when Eitoku was at the height of his powers.

Miyajima

* Translation appears in Robert H. Brower and Earl Miner, *Japanese Court Poetry* (Stanford: Stanford University Press, 1961), p. 164.

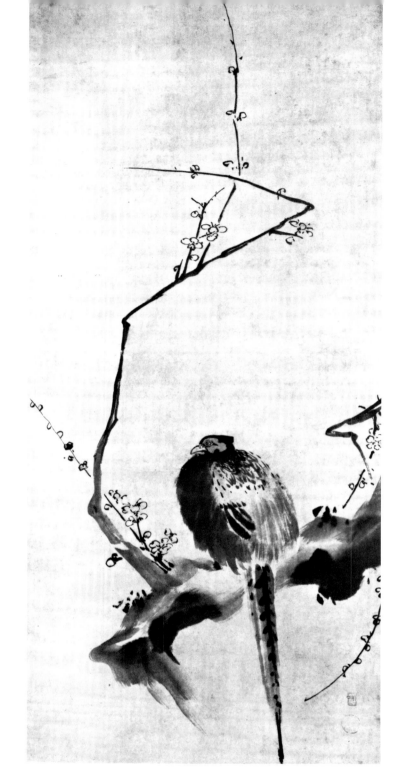

10 KANŌ SHIGENOBU
(fl. 1620–40)

Plum Blossoms and Pheasant
First half seventeenth century
Hanging scroll; ink and light color on paper
117.7 x 53.0 cm (46 3/8 x 20 7/8 in.)
Rectangular relief seal: *go*; tripod-shaped relief seal: *ji*
Private collection, Hyōgo Prefecture

According to one theory, Kanō Shigenobu was a member of the household of Kanō Sōshū (1551–1601), Eitoku's younger brother. He was also called Sōgen. At present six authentic works by the artist are known. *Thirty-six Immortal Poets*, a screen belonging to Tanzan Shrine (in Nara Prefecture), known to have been painted in 1621, provides the only date for the artist's career. Three brightly painted gold screens in the Idemitsu, Seattle, and Kimbell art museums all depict fields of poppies, subtly augmented by swaying stalks of bamboo or wheat. Red and white poppies, green leaves, and tall, straight stalks of bamboo and wheat arranged in rows are characteristic of early-seventeenth-century deco-

rative compositions. Although these three screens are the only examples of Shigenobu's work in this style to survive, screens like them must have been popular in their time.

Shigenobu is best known for his colorful screens. This painting and another, *Eight Views of Xiao and Xiang*, in the Suhara family collection are examples of his ink painting. Common to Edo-period Kanō-school ink painting are the gently brushed drawing of the branches. This simple composition of a branch of plum and a single pheasant nevertheless creates an inspiring impression.

Miyajima

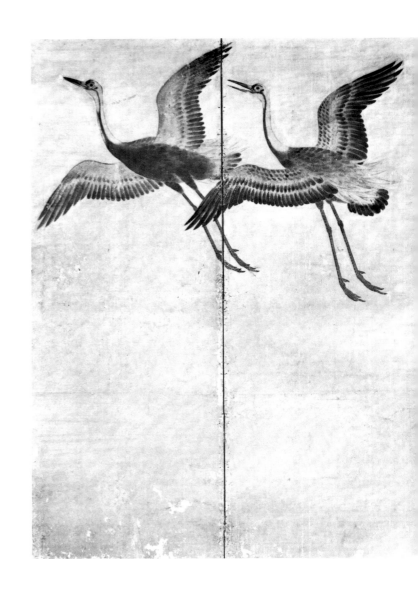

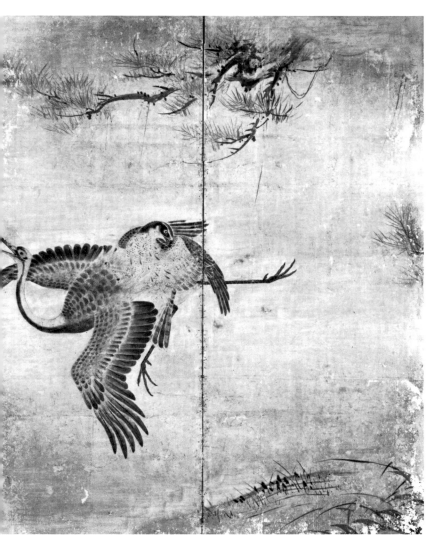
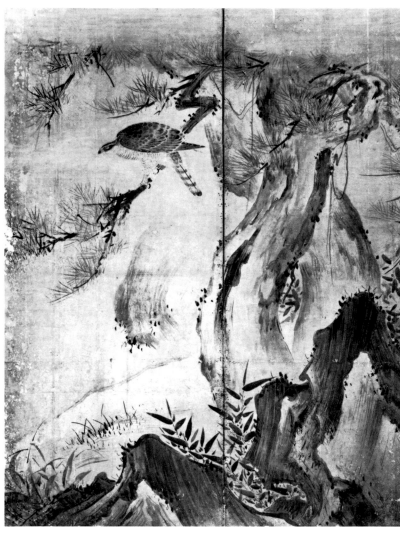

11 Attributed to
KANŌ MOTONOBU
(1476–1559)

Birds of Prey
First half seventeenth century
Six-fold screen; ink on paper
Each 153.4 x 358.8 cm (60 3/8 x 141 1/4 in.)
Tripod-shaped relief seal: *Motonobu*
Ii Family Collection, Shiga Prefecture

The Motonobu seal on these screens is probably a late addition. Texturing strokes on the rocks and the drawing of the pine tree resemble the style of Kanō Sanraku (1559–1635) more than that of Motonobu. Two versions of the subject by Sanraku survive: a screen in the Nishimura Collection and fusuma panels at Daikakuji.

Falconry was popular among the military elite of the late Momoyama and early Edo periods. The frequency with which the subject is found reflects that popularity, yet surprisingly few paintings depict the falconers. Such a composition almost certainly would have required a broad landscape of minute figures. Furthermore, paintings with birds alone seem to have been considered more evocative of military prowess than a genre version of the same theme might have been. Many versions of birds of prey survive. This painting of a hawk and an eagle pursuing their prey has remained in the collection of the Ii family, the former lords of the Hikone clan domain near Sanraku's birthplace.

Miyajima

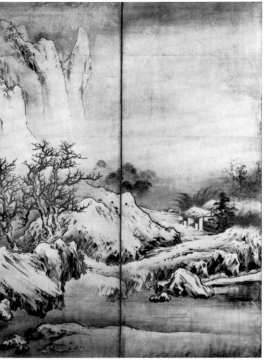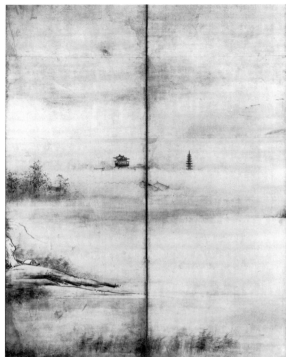

12 HASEGAWA TŌHAKU
(1539–1610)

Eight Views of the Xiao and Xiang Rivers
Late sixteenth century
Pair of six-fold screens; ink, light color,
and gold foil on paper
Each 158.5 x 352.6 cm (62 3/8 x 138 7/8 in.)
Square relief seal: *Tōhaku*
Bunkachō

The Chinese theme Eight Views of Xiao and Xiang refers to the scenery around the confluence of the Xiao and Xiang rivers and Lake Dongting in modern Hunan Province. The eleventh-century artist Song Di is credited with the earliest pictorial rendition of the theme, which became a source of inspiration for painters and poets in Southern Song China and, again, in Japan beginning in the fourteenth century. Handscroll paintings of the subject by such artists as Xia Gui, Yujian (mid-thirteenth century), and Muqi were owned by the Ashikaga shoguns during the fifteenth century and served as models for Japanese ink painters.

Each of the eight views came to be identified by a poetic title in four characters. In Tōhaku's composition the eight views show seasonal changes from spring to winter and temporal changes from early morning to late night. The right half of the right screen is entitled "Mountain Village after a Storm." The faint form of a boat on the horizon illustrates the phrase "Returning Sail off Distant Shore." "Night Rain over Xiao and Xiang" appears at the upper left edge, while "Fishing Village in Sunset Glow" overlaps the lower left edge and continues onto the left screen.

The remaining four scenes are found on the left screen. "Autumn Moon over Lake Dongting" and "Wild Geese Descending

to Sandbar," both in the right panels, signify autumn. A diminutive Buddhist temple in the center panels suggests "Evening Bell from a Distant Temple." The final scene, nearly equal in scale to the spring composition at the opposite end, is "River and Sky in Evening Snow."

Like most of Tōhaku's paintings, these screens were based on an earlier model, a pair of Eight Views screens attributed to Sōami at Myōshinji temple. Tōhaku's connection with Myōshinji began when his close friend, Nanka Genkō (1537–1604), was made abbot. Although Tōhaku must have known the Myōshinji paintings, there are significant differences nevertheless. The two flanking scenes, "Mountain Village" and "Evening Snow," occupy approximately the same space in the two compositions. In the Myōshinji screens, the remaining six views are more prominent, while Tōhaku devoted the center third of his composition to a vast watery expanse, considerably reducing the scale of the other views. Thus these screens by Tōhaku prefigure an Edo-period trait of making effective use of void space.

The square seal on these screens was used by Tōhaku before reaching age sixty-five. Because the style is delicately detailed, the work should date to the artist's fifties.

Miyajima

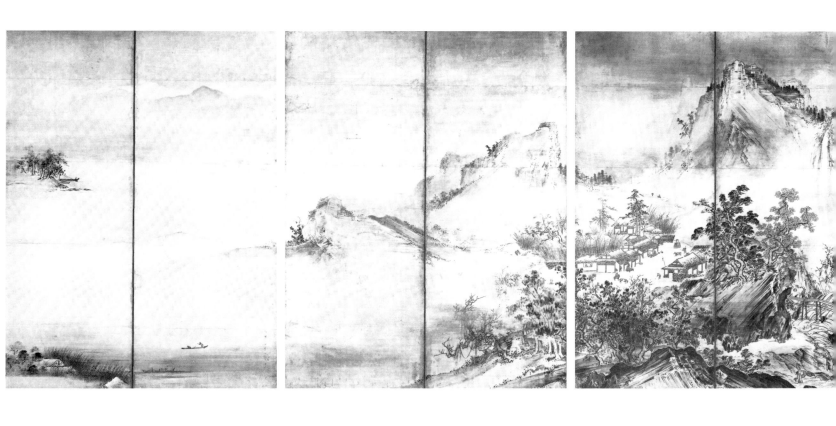

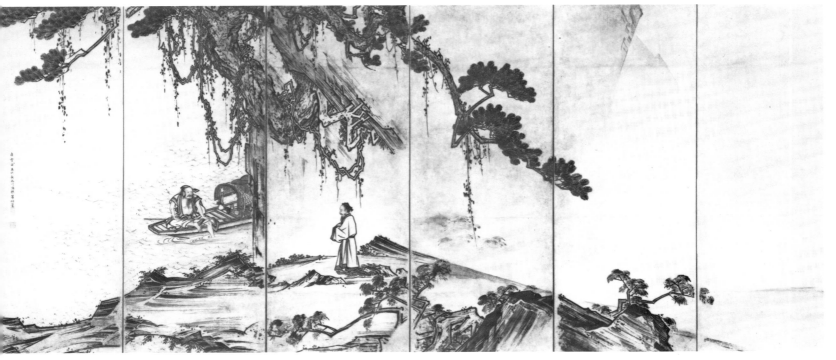

自雪舟五代長谷川法眼等伯筆

13 HASEGAWA TŌHAKU
(1539–1610)

Figures from Antiquity
Circa 1605
Pair of six-fold screens; ink and light color
on paper
Each 157.6 x 362.8 cm (62 x 142 7/8 in.)
Signatory inscription: *The fifth generation
after Sesshū, painted by Hasegawa hōgen
Tōhaku*
Double-bordered rectangular seal:
Hasegawa; square relief seal: *Tōhaku*
MOA Art Museum, Shizouka Prefecture

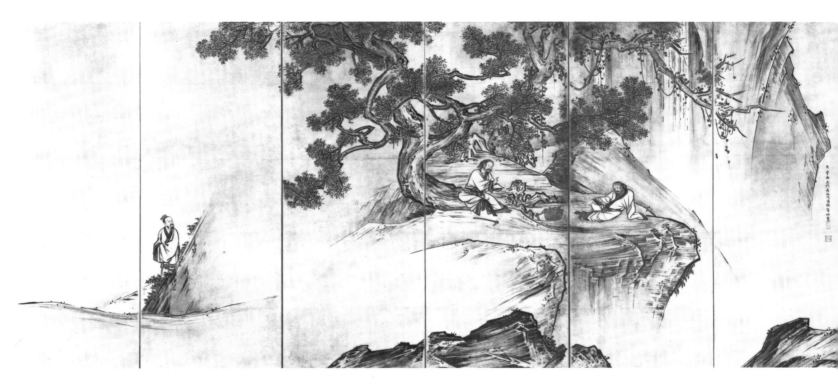

Each of these screens depicts legendary Chinese sages. The two recluses in the right screen are Boyi and Shuqi, brothers who lived at the time of the Zhou conquest of Shang (eleventh century B.C.), who were praised by Confucius for declining to serve the victorious King Wu. They retired to Mount Shouyang, subsisting briefly on ferns, but eventually dying of starvation. In the lee of the cliff stands a reverent observer. He may represent the Han dynasty historian Sima Qian (c. 145–90 B.C.), who eulogized the brothers in *Shiji* (Historical Records).

The subject of the left screen also appears in a lengthy *Shiji* biography. The statesman-poet Qu Yuan (fl. early third century B.C.) was banished to the Changsha region, a victim of court slander. As he was wandering despondently along the banks of the Yangzi River, he met a fisherman to whom he vigorously protested his innocence. Subsequently he wrote a poem (*fu*), entitled *The Fisherman*, describing this encounter, before drowning himself in the Mile River.

The original Chinese sources for Tōhaku's compositions are rarely found, but this painting is based upon a Ming original, entitled *Discourse between Qu Yuan and the Fisherman*, in the collection of the Sōjiji temple in Yokohama. Undoubtedly the coarse, Zhe-school style of the Chinese original influenced Tōhaku's brushwork as well as his composition. The striking amount of empty white space in Tōhaku's screen is the result of his effort to transform a vertical scroll composition into a horizontal format.

These screens have only recently come into the collection of the MOA Art Museum and were little known previously. The inscription reading "fifth generation after Sesshū" must postdate the artist's painting of a Parinirvāna (death of Buddha Sakyamuni) at Honpōji (1599). Tōhaku's use of the Buddhist rank *hōgen* dates this work as no earlier than 1605. A pair of dragon and tiger screens at the Museum of Fine Arts, Boston, bear similar inscriptions that append the artist's age, sixty-eight (1606). Thereafter, Tōhaku customarily included his age. Consequently, these screens should date to about 1605.

Miyajima

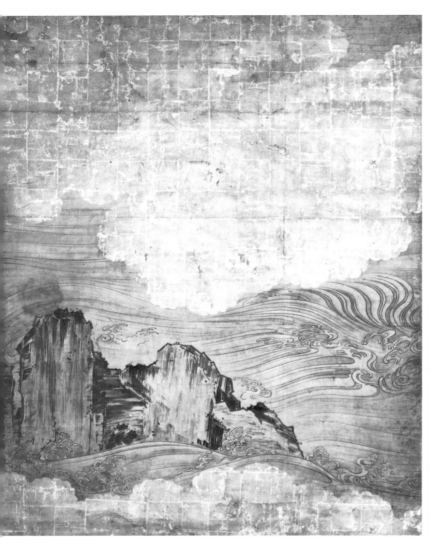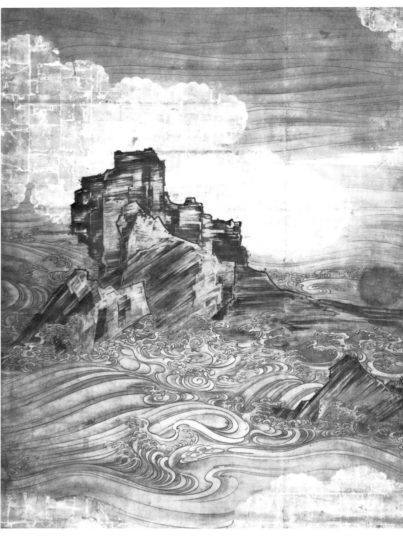

14 HASEGAWA TŌHAKU
(1539–1610)

Waves
Early seventeenth century
Four hanging scrolls from a set of twelve;
ink and light color on paper
Each 185.0 x 140.5 cm (72 7/8 x 55 3/8 in.)
Zenrinji, Kyoto
Important Cultural Property

These hanging scrolls were originally the fusuma panels for the most important room in the abbot's quarters at Zenrinji. The subject is waves breaking against a rocky shore. A passage in *Tōhaku gasetsu* (Tōhaku's Treatise on Paintings), mentions that the artist once painted a pair of screens after a composition of waves by Wang Wei (699–759). These panels of violently swirling waves may also derive from some distant Chinese source. The sharp, crystalline shapes defining the rocks are characteristic of Tōhaku, while the overwhelming strength and power of the painting epitomizes the Momoyama aesthetic.

Zenrinji experienced a period of renewal in the late sixteenth century, which culminated in the completion of the main hall in 1607. These panels probably date from that period and are thus examples of Tōhaku's late and most ambitious work. Zenrinji is a Buddhist temple of the Pure Land sect, and because it is unusual to find works by Tōhaku in that context, they were probably a gift to the temple. Both Toyotomi Hideyoshi and his son, Hideyori (1593–1615), aided Zenrinji's renewal effort, and either one of them might have commissioned and donated the work.

Miyajima

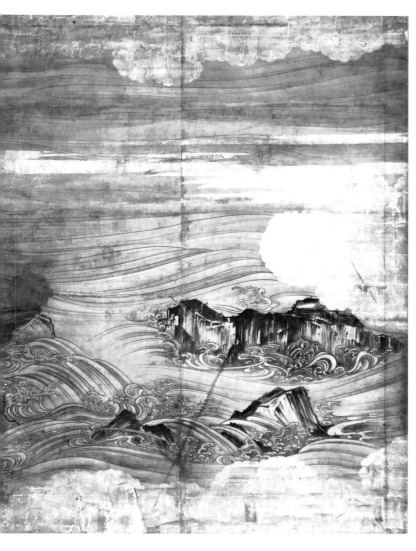

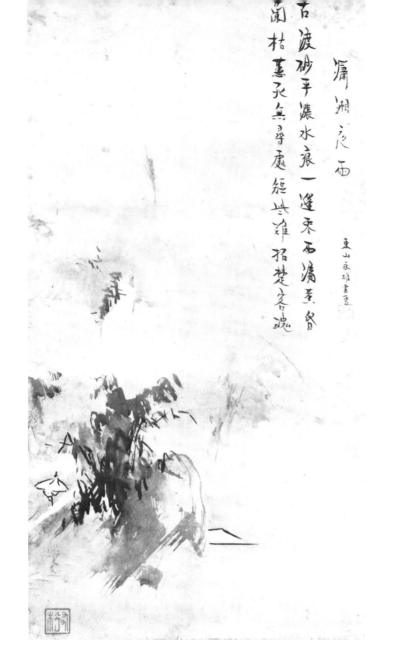

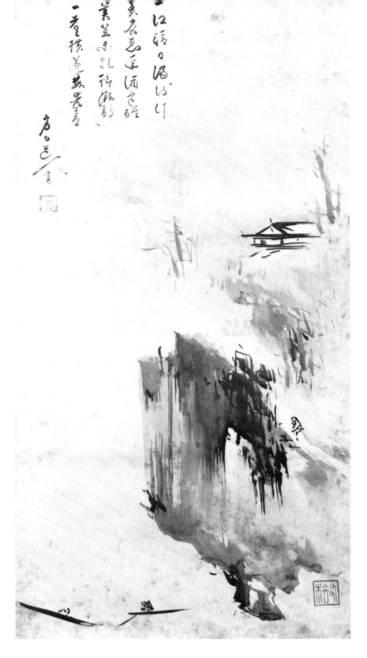

15 KAIHŌ YŪSHŌ
(1533–1615)

"Fishing Village in Sunset Glow" and
"Night Rain over Xiao and Xiang" from
Eight Views of Xiao and Xiang
Late sixteenth–early seventeenth centuries
Pair of hanging scrolls from a set of eight;
ink on paper
Each 72.3 x 37.0 cm (28 1/2 x 14 5/8 in.)
Square relief seal: *Yūshō*
"Fishing Village"
Poetic inscription by Nanka Genkō signed:
Kyohaku dōjin
Square relief seal: *Genkō*
"Night Rain"
Title and poetic inscription by Eiho Eiyū
(d. 1602) signed: *Written by Eiho of
Higashiyama*
Square intaglio seal: *Yū*
Gumma Prefectural Modern Art Museum

These two scenes from *Eight Views of Xiao
and Xiang* were originally pasted onto an
eight-fold screen. All eight scenes have
been remounted individually as hanging
scrolls and are now dispersed among sev-
eral Japanese collections.

Yūshō's tendency to render his subjects
distinctively with coarse brushwork can be
seen in the rocks, trees, buildings, and fig-
ures of these two paintings. The brush
technique used here, known as *haboku*
(splashed ink), follows in the style of the
thirteenth-century painter Yujian. These
scrolls are quite close in style to Yūshō's
fusuma panels in Kenninji, dated to 1599.

The inscriptions on this set of scrolls are
by seven Zen monks. They are the same
poems that appear on Yujian's Eight Views
handscroll, once in the shogunal collection,
of which only three fragments survive.
Eiho Eiyū, who inscribed "Night Rain,"
died in 1602; thus these paintings must date
before that year.

Miyajima

70

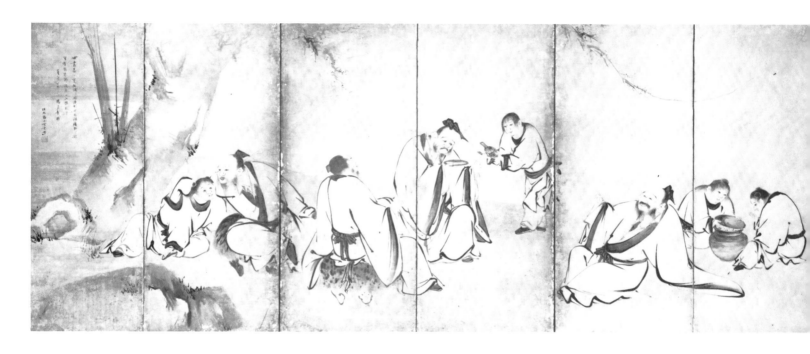

16 KAIHŌ YŪSHŌ
(1533–1615)

Eight Immortals in Drunken Revelry
Dated 1602
Six-fold screen; ink on paper
143.5 x 359.0 cm (56 1/2 x 141 3/8 in.)
Inscription signed: *The third day of the tenth month of [1602], painted by Kōhoku Kaihō Yūshō*
Square relief seal: *Yūshō*
Kyoto National Museum
Important Cultural Property

A poem by Tang dynasty poet Du Fu (712–70) about eight poets who enjoyed drinking inspired this painting. Four of the eight immortal poets are depicted here with their serving boys. The placement of the tree and the artist's inscription in the upper left corner indicates that this screen was originally the left half of a pair.

Kaihō Yūshō, son of a warrior, entered a Zen monastery as a young man. He went on to become a member of Kanō Eitoku's workshop and later established an independent studio. His distinctive personal style is evident in this screen. Fluid lines suggest the loose, flowing garments of the figures and stand in sharp contrast to the indistinct, soft brushwork of the rocks and trees. Yūshō's style inspired many imitators, even among artists of the Kanō workshops.

This screen is one of but two dated works by the artist. According to the inscription, the general Kamei Korenori (1557–1612) commissioned this painting as he did a pair of landscape screens by Yūshō now in the MOA Art Museum.

Miyajima

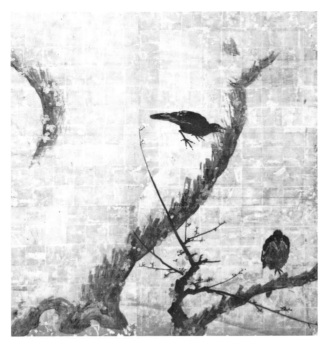 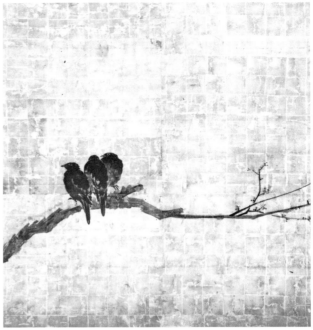

17 Attributed to
UNKOKU TŌGAN
(1547–1618)

Crows on a Plum Branch
Late sixteenth century
Two fusuma panels from a set of six; ink
and light color on gold foil
Each 166.5 x 156.6 cm (65 1/2 x 61 5/8 in.)
Kyoto National Museum

On a gold ground, a brush saturated with ink built the trunk of this plum tree layer upon layer. Powerful, straight brush strokes describe the lesser twigs. Counterbalancing the coarse, quick strokes of the tree, the ink wash bodies of the five crows appear softly warm and rounded. The fresh contrast between ink and gold was heightened by the addition of white paint for snow and green for moss. Red pigment used for the plum blossoms has largely rubbed off. The empty spaces both small and large, produced through careful placement of the crows and branches, define striking silhouettes. These two panels form the central section in a set of six sliding doors. When all six are placed side by side, the viewer fully experiences the vitality of the empty spaces.

These fusuma panels are said to have been painted for the audience hall of Myōjima Castle, built by the warlord Kobayakawa Takakage (1533–97) in 1588. The awe-inspiring air of these panels is especially suitable for a warrior's mansion. Although Tōgan served Mōri Terumoto (1553–1625), he was also Takakage's nephew, so the attribution of these doors to Tōgan should be reliable.

Miyajima

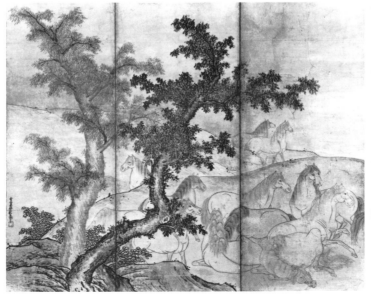 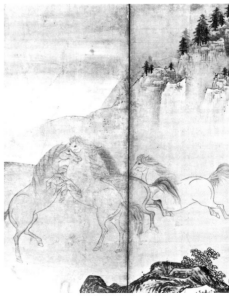

18 UNKOKU TŌGAN
(1547–1618)

Wild Horses
Before 1611
Pair of six-fold screens; ink and light color
on paper
Each 149.4 x 360.0 cm (58 7/8 x 141 3/4 in.)
Signatory inscription: *Painted by Tōgan,
descendant of Sesshū*
Round intaglio seal: *Unkoku*; square in-
taglio seal: *Tōgan*
Kyoto National Museum

Tōgan's landscapes, painted under the in-
fluence of Sesshū, are characterized by
tranquility. His other works, however,
appear as forerunners of later painters of
Chinese subjects, such as Kanō Sansetsu or
Soga Nichokuan, who experimented with
eccentric models. What Tōgan lacked in
refinement as a provincial painter he bal-
anced with a rustic vitality as in this paint-
ing. Trees grow rootless from cliffs shaped
like ancient palisades. On this broad, eerie
plain a herd of wild horses gathers.
Whether or not this subject stems from a
certain rusticity in the Unkoku school, it
seems to have been well received. Several
other versions by Tōgan, as well as exam-
ples by his son Tōeki, are known.

Judging from the combination of seals
and from the fact that the square Tōgan
seal shows little wear, these screens must
date relatively early in the artist's career. A
painting of Bodhidharma, dated no later
than 1611, bears a worn impression of the
same seal.

Miyajima

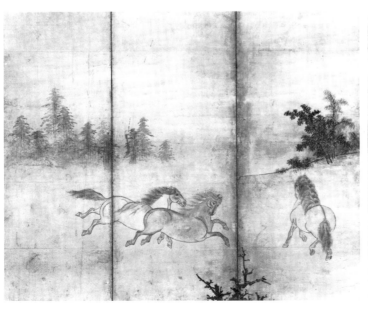
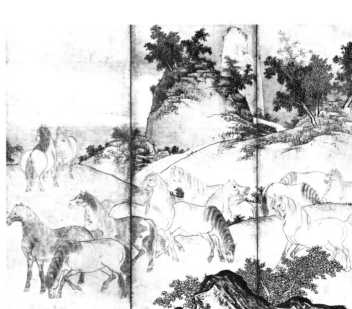

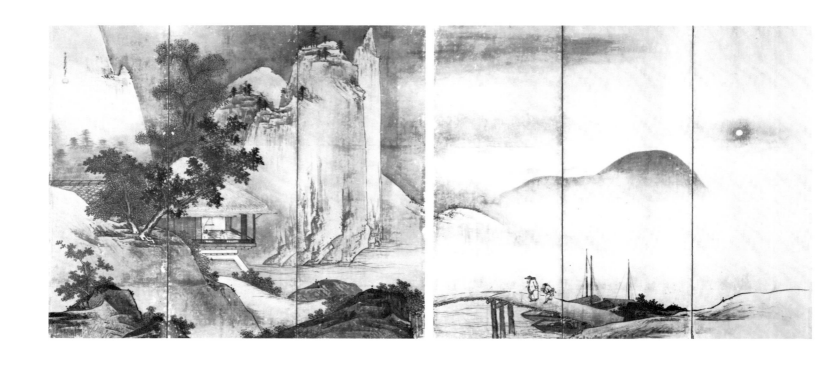

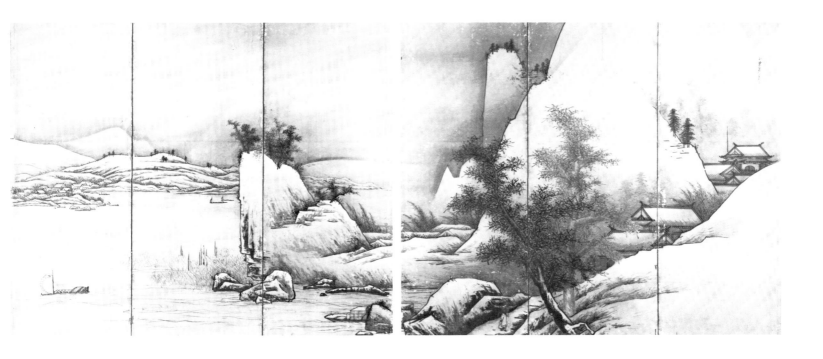

19 UNKOKU TŌGAN
(1547–1618)

Pavilions in a Mountain Landscape
Early seventeenth century
Pair of six-fold screens; ink and light color
on paper
Each 153.0 x 358.0 cm (60 1/4 x 141 in.)
Signatory inscription: *Painted by Tōgan, descendant of Sesshū*
Gourd-shaped intaglio seal: *Unkoku*; fan-shaped intaglio seal: *Tōgan*
Kumaya Art Museum, Yamaguchi Prefecture

Several documents handed down in the Mōri family verify Edo-period histories of painting that claim that Unkoku Tōgan studied either with Kanō Eitoku or Kanō Shōei. In 1569 on his way to the Kyushu residence of the provincial lord Ōtomo Sōrin, Kanō Shōei stopped at Itsukushima Shrine to donate a painted wooden plaque. The twenty-three-year-old Tōgan may have met Shōei at that time. A more significant factor in Tōgan's career was Mōri Terumoto's gift in 1593 of Sesshū's famous, long landscape scroll. Terumoto also gave Tōgan Sesshū's old residence, the Unkoku Studio. Tōgan diligently copied the scroll and called himself descendant of Sesshū as he labored to preserve the style of the master he never knew. Whatever Tōgan's ties to the Kanō tradition, these screens clearly reflect his debt to Sesshū.

After Tōgan began calling himself Unkoku, he used various combinations of seals. Their chronological significance is now clearly understood. The fan-shaped Tōgan seal used here appears on very few works and is believed to date from a short period just prior to his death. The style of these screens also affirms that they are from his final period.

Miyajima

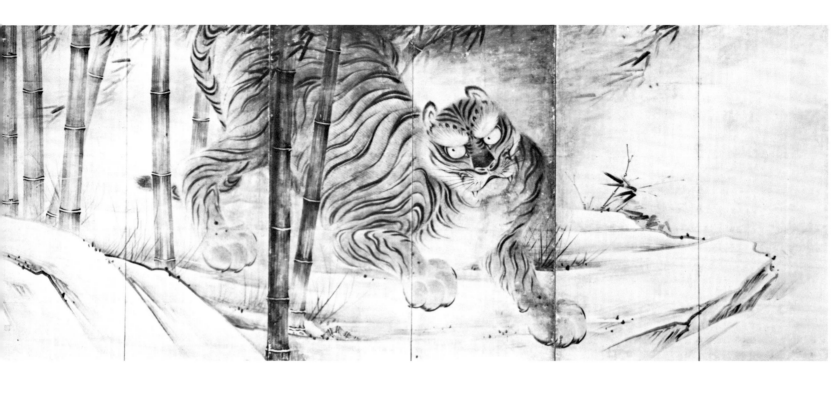

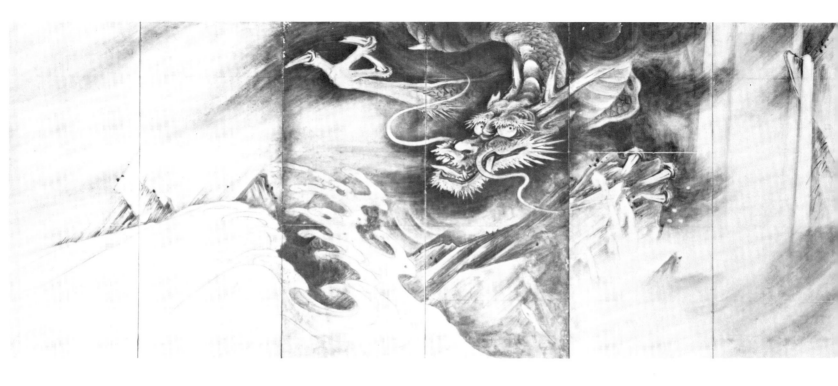

20 SOGA CHOKUAN
(fl. 1596–1610)

Dragon and *Tiger*
Early seventeenth century
Pair of six-fold screens; ink on paper
Each 153.0 x 364.5 cm (60 1/4 x 143 1/2 in.)
Square relief seal: *Taira Chokuan*
Tokyo National Museum

The bravura of the dragon and tiger sub-ject appealed to warlord patrons of the Momoyama era. Hasegawa Tōhaku, Kanō Sanraku, Kaihō Yūshō, and other leading painters all tried their hands at painting the theme. Chokuan placed his dragon at the foot of a waterfall, amidst the turbulent bubbles, its sharp, white claws clutching an upthrust rock. By blowing ink across the painting's surface, the artist managed to convey the cold, blustery atmosphere. The tiger of the left screen emerges from a bam-boo forest but backs off in angry surprise upon confronting the viewer.

The broad texture strokes that describe the cliff and rocks of these screens lack the density found in other Chokuan paintings. Straight, thick stalks of bamboo, a trait of Kanō artists active in Edo, may indicate that this is a late work by the artist. Alternatively, a painting of hawks by Nichokuan, the second Soga Chokuan, in the Museum of Fine Arts, Boston, has a waterfall that closely resembles the one in this dragon screen. It is conceivable that this pair is actually the early work of the son.

Only nine works by Chokuan are known, and only four of those are datable: a pair of hanging scrolls at the Myōshinji subtemple of Rinkain, which must date before 1604, when their inscriber Nanka Genkō died, and two painted wooden plaques (*ema*) at Kitano Shrine, donated in 1610 by Toyotomi Hideyori. From this scanty evidence, one phase of Chokuan's period of activity may be deduced. A pair of screens depicting roosters in the four sea-sons (in Hōkiin) displays a rather frag-mented composition similar to that in screens produced by the youthful Hasegawa Tōhaku; the two artists may have been contemporaries. Like Tōhaku, Chokuan seems to have been in contact with Genkō and the Toyotomi family. In contrast to Tōhaku, who sought to con-tinue Sesshū's style, Chokuan deliberately chose the Soga name and claimed to be a descendant of Soga Jasoku. He also called himself Shin'yo, adopting the character *yo*, which had been used by earlier Soga-school artists.

Miyajima

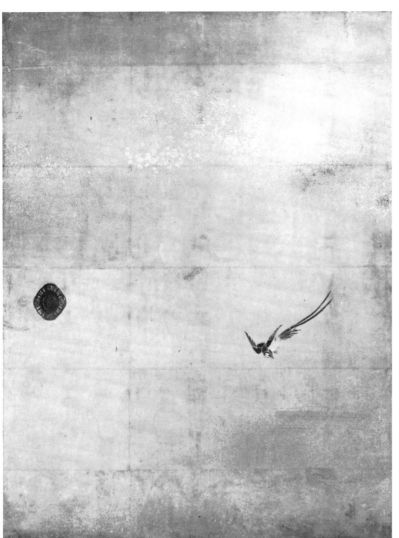
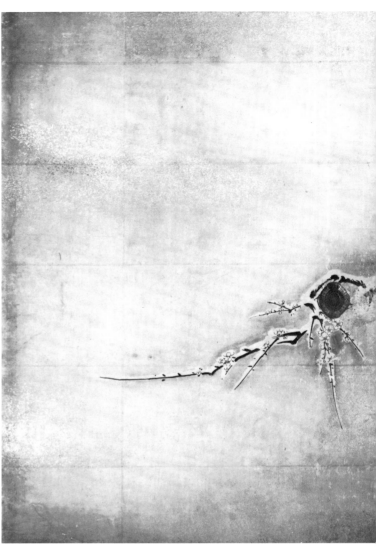

21 KANŌ TAN'YŪ
(1602–74)

Birds and Flowers of the Four Seasons
Datable to l634
Four fusuma from a set of eighteen; ink,
light color, and gold on paper
Each 192.0 x 165.0 cm (75 5/8 x 65 in.)
Nagoya Castle, Aichi Prefecture
Important Cultural Property

In 1634 a guesthouse for the third Toku-
gawa shogun, Iemitsu, was built within the
grounds of Nagoya Castle to serve as an of-
ficial resting place on the road from Edo to
Kyoto. These four fusuma panels of birds
and seasonal flowers come from one of
three rooms painted by Kanō Tan'yū. The
subjects of the remaining two rooms were
Model Chinese Emperors and the Four
Accomplishments.

This plum tree should be compared with
a version of the same subject attributed to
Eitoku at Jukōin (cat. no. 8). Eitoku was
Tan'yū's great-grandfather, and in the sev-
enty years that separated these two artists
great changes had taken place in Kanō-
school painting. In Eitoku's composition

the trunk of the plum tree thrusts beyond
the upper edge of the painting, so large that
its full extent is unclear. By contrast,
Tan'yū's plum twists in a downward curve
never reaching the upper edge. Empty
space, rather than background scenery,
stretches over twelve of the panels. This
treatment emphasizes the freshly snow-
covered bamboo and plum. At far left the
gliding, long-tailed bird, turning in midair,
is placed perfectly to balance the extended
twig. If Eitoku's painting brims with ten-
sion and vitality, Tan'yū's conveys an at-
titude of refined ease.

Miyajima

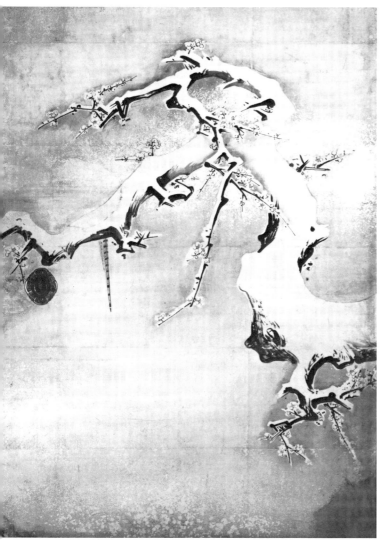
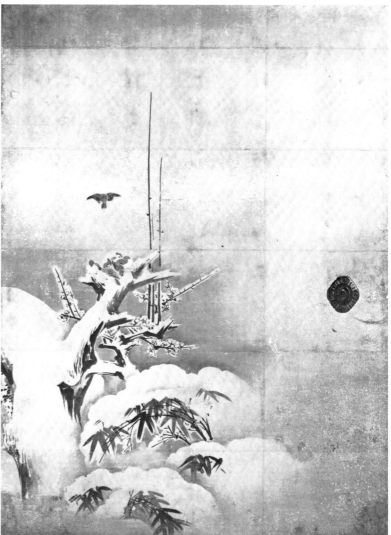

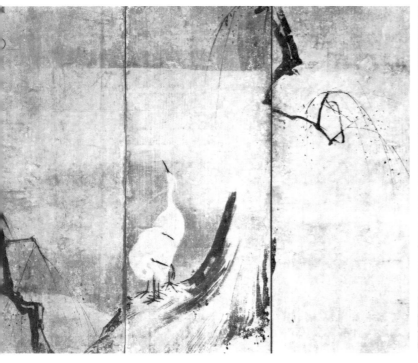

22 KANŌ TAN'YŪ
(1602–74)

Sparrows in Bamboo and *Herons under Willows*
Circa 1635–38
Pair of six-fold screens; ink, light color, and gold on paper
Each 140.3 x 336.2 cm (55 1/4 x 132 3/8 in.)
Signatory inscription: *Painted by Kanō Uneme Tan'yūsai*
Rectangular relief seal: *Tan'yūsai*; round relief seal: *Uneme*
Seiryōji, Kyoto

The date of these screens can be deduced from the signature. Because they are signed Tan'yū and that name was only bestowed in the twelfth month of 1635 by Kōgetsu Sōgen, a Zen monk of Daitokuji, they must have been painted after that date. Moreover, in the twelfth month of 1638 Tan'yū received the honorary rank hōgen, which he then included in his signature.

Tan'yū, still in his thirties, had already experimented with empty space as an aspect of his personal style. Rendered with sparse brushwork, the bamboo, plum, reeds, and willow tree do not appear in their complete forms. Unlike four-seasons compositions of the Momoyama period, here the seasons do not progress gradually one to the next. Rather each is symbolized by a single motif: the plum, spring; the moon, summer; reeds, autumn; while the heron on the ancient willow symbolizes winter. The depiction of small birds playing directly over the white moon is most unusual.

Miyajima

80

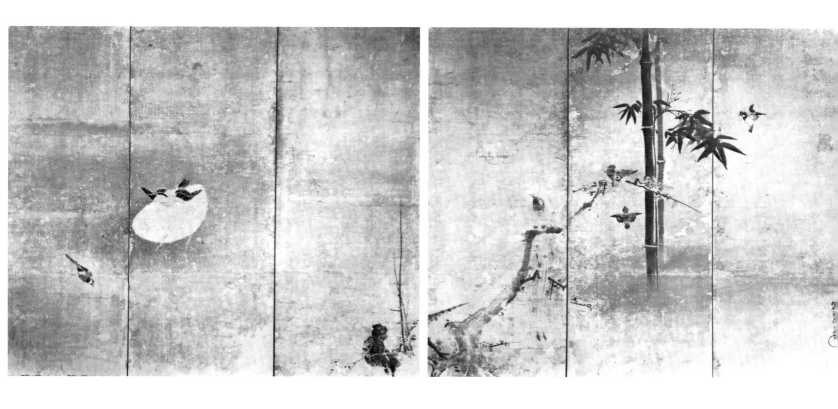

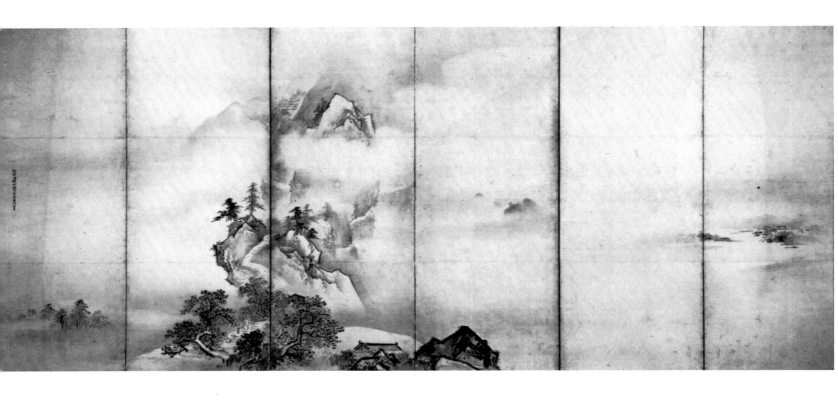

狩野法眼探幽齋藤原守信筆

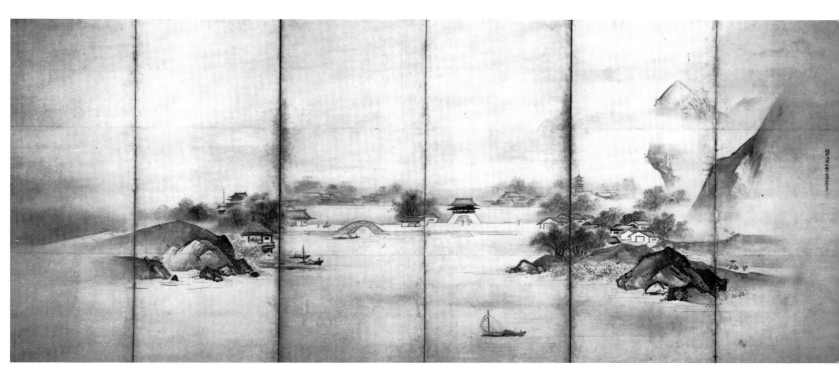

23 KANŌ TAN'YŪ
(1602–74)

Landscape
Mid-seventeenth century
Pair of six-fold screens; ink and light color
on paper
Each 157.7 x 361.8 cm (62 1/8 x 142 1/2 in.)
Signatory inscription: *Kanō hōgen*
Tan'yūsai Kanō Morinobu
Gourd-shaped relief seal: *Morinobu*;
square relief seal: *Tan'yū*
Tokyo National Museum
Important Art Object

These screens appear to represent summer. Willow leaves in the right screen have already grown long and dense, while in the left screen a bluish color wash also suggests dense growth. It is rare indeed for a pair of screens to show no seasonal change, but here Tan'yū varied his compositions instead of altering the seasons. The right screen is a low, horizontal view. Two roads approaching from opposite sides meet toward the center before a city gate. Beyond the wall tiers of roofs create a stable, level recession. In the left screen, the artist piled rocks and peaks precipitously. A tortuous path leads the viewer's eye upward. Tan'yū thus contrasted horizontal with vertical distance. In each case he clearly plotted the spatial recession. His assiduous study of past masters, such as Sesshū, enabled him to revitalize earlier compositional techniques ignored by contemporary painters of decorative screens. Here his vision of landscape incorporates vast stretches of empty space.

Because Tan'yū used the honorary title hōgen in his signature, these screens must date after 1638 but before he received the superior rank *hōin* in 1662. From the style and signature, they were probably done toward the end of that period.

Miyajima

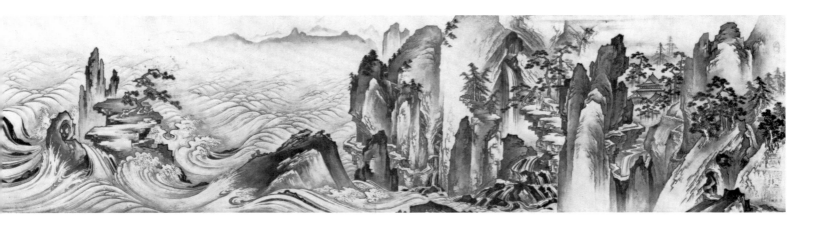

24 KANŌ SANSETSU
(1590–1651)

Pangu Valley
First half seventeenth century
Hanging scroll; ink on paper
31.1 x 122.5 cm (12 1/4 x 48 1/4 in.)
Oval intaglio seal: *Kanō*; tripod-shaped relief seal: *Sansetsu*; square intaglio seals:
Jasokuken and *Tōgenshi*
Private collection, Tokyo

Li Yuan, who lived during the Tang dynasty, retired to the Pangu Valley in the Jiyuan district of northern Henan Province. The event was described in a poem by his friend Han Tuizhi:

His dwelling nestles deep in the shade,
Where nature is most rugged.
How suitable a place it is
For a hermit to wander in.

A pavilion is sheltered by deeply layered mountains and valleys. On a high, flat ledge before a waterfall two scholars and a servant crane their necks to watch the river flowing below. Near this spot the Qin River flows into the Yellow River, and so the violent waves at left may be intended to suggest the actual view, which, curiously, the artist had never seen. Mountains are barely visible in the distance.

A distinctive aspect of Sansetsu's style is his talent for contrasting directional movements within a single composition. He excels furthermore in rendering dreamlike visions. At the lower right corner he impressed four seals side by side, making it likely that this painting was originally a handscroll.

Miyajima

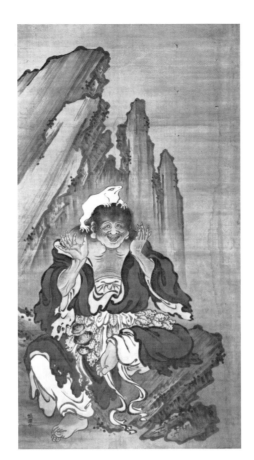
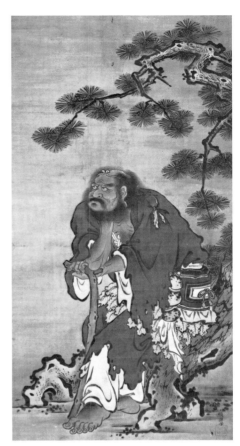

25 KANŌ SANSETSU
(1590–1651)

The Daoist Immortals Tekkai and Gama
First half seventeenth century
Pair of hanging scrolls; ink and color on silk
Each 173.0 x 88.6 cm (68 1/8 x 34 7/8 in.)
Signatory inscription: *Tōgenshi*
Square intaglio seal: *Sansetsu*
Sennyūji, Kyoto

The subjects of this pair of scrolls are the two Chinese immortals Tekkai (Chinese: Li Tieguai) and Gama (Chinese: Liu Haichan). The former, through his magical powers, sent his soul on distant journeys. On one such occasion, when his soul was out visiting an old gentleman, Tekkai's body was cremated. Upon returning, his soul was forced to inhabit the corpse of a beggar. Afterward Tekkai always appeared in this guise, carrying an iron staff. The second immortal, Gama, lived during the Three Kingdoms period in the kingdom of Wu. His name comes from his attribute, the beloved *gama*, a three-legged toad, which he taught to perform magic. The iconographic source for this subject is the pair of paintings by the Chinese artist Yan Hui in Chionji. The faceted rocks behind Gama nevertheless betray Sansetsu's hand.

Sansetsu was a pupil of Kanō Sanraku, who adopted him as official second-generation heir to the Kyoto branch of the Kanō school. Many of Sansetsu's works survive in Kyoto; the most important are fusuma panels painted for the Tenkyūin subtemple at Myōshinji. These two hanging scrolls are owned by Sennyūji, the temple where many Kanō-school artists are buried. A dragon ceiling painting in Sennyūji's Relic Hall bears further witness to the long and continuing relationship between the Kanō family and that temple.

Miyajima

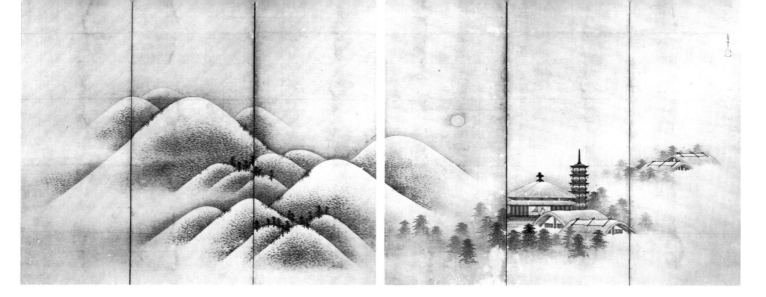

26 UNKOKU TŌEKI
(1591–1644)

Landscape
First half seventeenth century
One six-fold screen of a pair; ink and light
color on paper
153.5 x 355.6 cm (60 3/8 x 140 in.)
Signatory inscription: *Painted by Unkoku*
Tōeki
Gourd-shaped intaglio seal: *Unkoku*;
square relief seal: *Tōeki*
Osaka Municipal Museum
Important Art Object

Although Unkoku Tōeki was the second son of Tōgan, the death of his elder brother, Tōoku, in 1615 left him heir to the Unkoku family workshop while he was still in his twenties. He lived in the far western castle town of Hagi, under Mōri family jurisdiction. So distant from Kyoto and Edo, he felt little influence from other schools of painting. Tōeki labored faithfully to preserve his father's style but managed nevertheless to incorporate something of his own personality into his work. This screen, with its extremely stable composition, shows him at his best. The unusual use of Mi-style dots to describe the rounded hills is especially noteworthy. With this technique Tōeki subordinated the depiction of nature to experiment with the painting surface, a trait also seen in Kanō Sansetsu's work. Tōeki did not go to Sansetsu's extreme, however, maintaining a comparatively relaxed painting style.

Miyajima

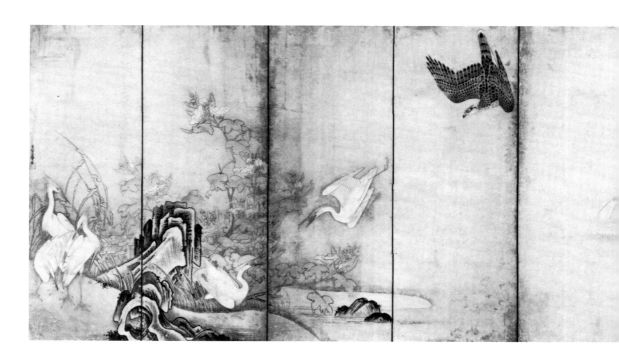

27 SOGA NICHOKUAN
(fl. mid-seventeenth century)

Falcons
Mid-seventeenth century
Pair of six-fold screens; ink and light color on paper
Each: 146.5 x 322.1 cm (57 5/8 x 126 3/4 in.)
Signatory inscription: *Painted by Soga Chokuan*
Square relief seal: *Kanetane*
Tokyo University of Arts

A flowering plum, insignificant behind a twisting pine, identifies the right screen as spring. Carp and catfish swim blithely unaware of a falcon gazing intently from its perch on a rock. The drama intensifies in the left screen. A white heron flies to shore to escape a descending predator and creates a noisy disturbance among the herons hiding behind the reeds and flowering rose mallow.

The signature Soga Chokuan was used by two artists. These screens are unmistakably the work of the second generation (Ni) Chokuan, whose real name was Sahei Jun'yō. The eccentric, knobby forms of the pine branches and the iciclelike wave crests characterize his style. Falcons became his specialty, appearing in many of his paintings. One, *Hawks among Pine, Bamboo, and Plum*, dated 1656 (in Hōryūji), is signed "sixth-generation descendant of Soga Jasoku." Since the Hōryūji painting is Nichokuan's only dated work, all other paintings must be compared with it. Judging from the rather free quality of the signature and brushwork in these screens, they may postdate the Hōryūji painting.

Miyajima

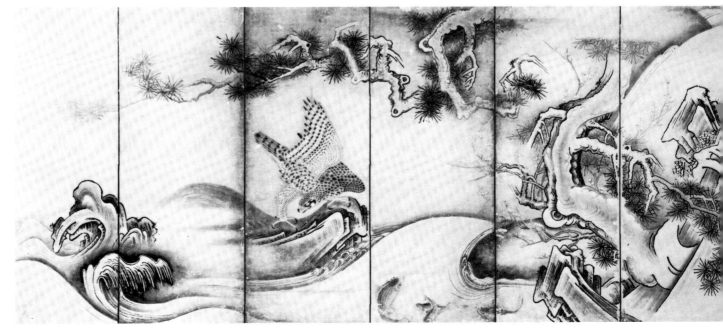

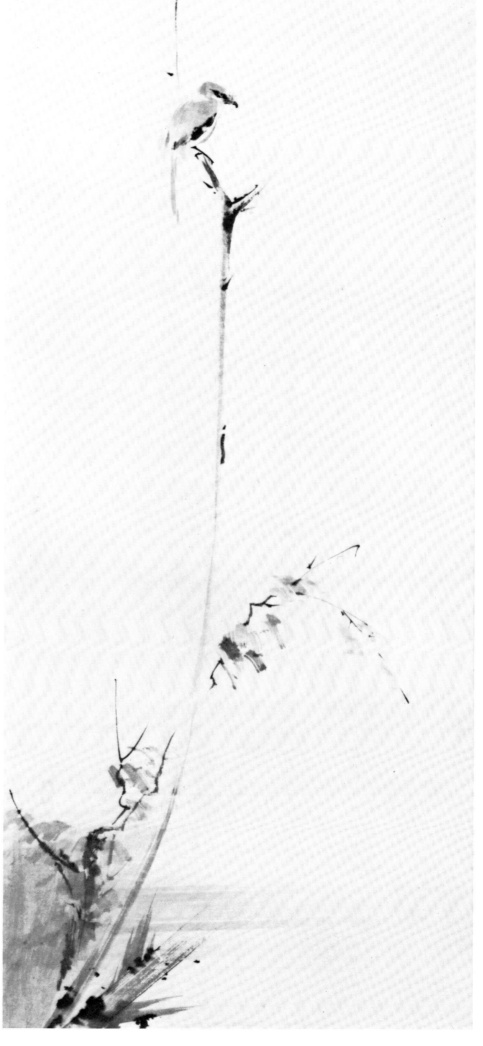

28 MIYAMOTO MUSASHI
(1582–1645)

Shrike on a Withered Branch
First half seventeenth century
Hanging scroll; ink on paper
126.0 x 54.5 cm (49 5/8 x 21 1/2 in.)
Intaglio seal: *Musashi*
Kubosō Memorial Museum, Izumi City
Important Cultural Property

A watchful shrike perches atop a withered, thorny branch. Just at midpoint a caterpillar inches upward. Whether or not the shrike is yet aware of this readily available meal, the caterpillar is about to lose its life.

Miyamoto Musashi (Niten) was a samurai warrior well versed in military tactics. Many members of the military class, beginning with the shogun Ashikaga Yoshimochi (1386–1428), practiced ink painting at their leisure; Musashi was among the last of this group. Amateur samurai artists tended to paint subjects less popular than those painted by professional artists who came from military families, such as Tōgan, Yūshō, and Sanraku. Musashi's work included numerous depictions of Bodhidharma or Hotei since it was his practice of Zen that introduced him to ink painting. Bird-and-flower compositions such as this one are equally prominent among his paintings.

He wrote of his beliefs in a book entitled *Dokkōdō* (The Way of Solitude). There he speaks of owning nothing and of refusing to participate in any worldly activity; he devoted himself to military tactics, fearless of death. This painting seems to embody Musashi's spirit faithfully. Although the stern expression of the shrike may be a metaphor of Musashi's demeanor, perhaps it is the slowly crawling caterpillar that best expresses his attitude toward life.

Miyajima

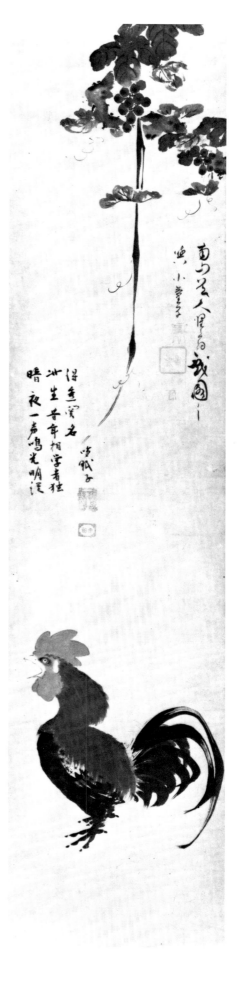

29 SHŌKADŌ SHŌJŌ
(1584–1639)

Rooster below a Grapevine
Late 1630s
Hanging scroll; ink and light color on paper
113.8 x 27.5 cm (44 3/8 x 10 7/8 in.)
Signatory inscription: *The old man of the southern mountains, Shōjōō, playfully painted this for a child.*
Tripod-shaped relief seal: *Shōjōō*; square relief seal: *Shōjōō*; relief seal: *Ryō*
Poetic inscription by Gyokushitsu Sōhaku signed: *Tominshi*
Relief seal: *Gyokushitsu*; square relief seal: *Sōhaku*;
Hasegawa Jirobei Collection, Mie Prefecture

Gyokushitsu Sōhaku (1572–1641), the 147th abbot of Daitokuji, composed the prefatory poetic inscription on this scroll:

> One crow of the rooster on a dark night
> And bright light floods his being.
> In former years we studied together,
> But you alone attain fame for penetrating the barrier.

With its comment on the rooster's — and Shōjō's — enlightenment, the inscription, calls to mind a thirteenth-century painting of a similar theme by the artist Luo Chuang (in the Tokyo National Museum). Shōjō's rooster differs, though, from Luo Chuang's, whose expression is rather severe. Although Shōjō's brushwork brims with gaiety, there is nevertheless a stridency to his rooster's expression. He has not really painted as lighthearted a work as his inscription would have the viewer believe.

In 1637 the ailing Shōjō, a monk from Otokoyama, the Shingon monastery at Iwashimizi Hachiman Shrine in the hills south of Kyoto, built himself a retreat, which he named Shōkadō (Pine Flower Hall). Since the artist refers to himself as the "old man of the southern mountains" in his inscription, this painting must date later than 1637.

Shōjō has long been counted as one of the three most famous calligraphers of his age, a peer of Hon'ami Kōetsu (1558–1637) and Konoe Nobutada (1565–1614). One theory suggests that he studied painting with Kanō Sanraku. When Sanraku's association with the Toyotomi clan forced him into hiding with the downfall of Hideyori in 1615, he fled to Otokoyama and Shōjō's protection. While Shōjō's landscape paintings do follow in Sanraku's style, his figures and other subjects are derived instead from the style of Liang Kai.

Miyajima

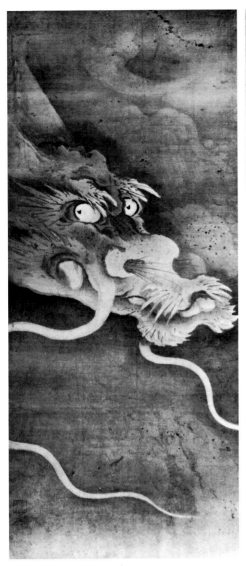
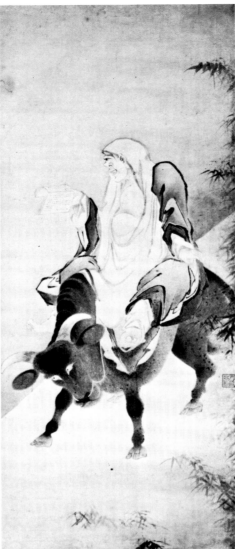
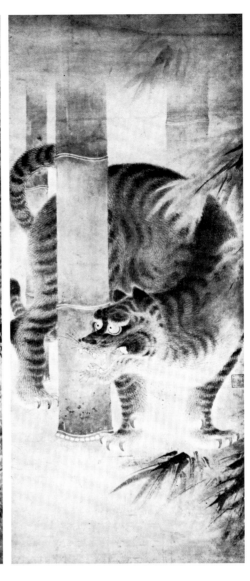

30 IWASA MATABEI
(1578–1650)

Tiger, *Laozi*, and *Dragon*
First half seventeenth century
Three hanging scrolls; ink on paper
Each 133.0 x 54.5 cm (52 3/8 x 21 1/2 in.)
Square intaglio seal: *Hekishōkyūzu*
Tokyo National Museum

Born the son of Araki Murashige (d. 1596), a supporter of Oda Nobunaga, Matabei was separated from his father, who had defected to Nobunaga's enemies. His family fled, but most were eventually executed. Young Matabei escaped to Kyoto, where he grew up in a subtemple of Nishi Honganji. Later he lived perhaps as many as twenty years in Fukui.

Although these three hanging scrolls appear to form a triptych, they were originally pasted onto the panels of a pair of six-fold screens handed down in the Kanaya family of Fukui Prefecture. They were given to the Kanaya family by Matsudaira Naomasa (1601–66), son of the lord of Fukui Castle, who had been entrusted to the family as a child.

Matabei saw himself as a latter-day descendant of Tosa Mitsunobu (1434–1525), a court painter of traditional Japanese themes. While he did, in fact, select subjects from classical Japanese literature and painted scrolls in rather shocking colors,

the basis of much of his work was actually Chinese. This deliberate eclecticism was characteristic of many seventeenth-century painters.

Each of these panels depicts a traditional Chinese or Japanese subject, as famous figures from the *Tale of Genji* mingle with Chinese folk heroes. The depictions of Laozi riding a bull and the dragon and tiger themes are thoroughly Chinese in subject, yet all are superb examples of Matabei's lively characterizations and brisk humor. His portrayal of Laozi derives from a Ming printed book entitled *Xian fo qi zong* (Strange Traces of Immortals and Buddhas), a source once used by Sōtatsu as well. A letter written by the merchant, literatus, and book publisher Sumi no kura Soan (1571–1633), mentioning a visit he intended to pay Matabei, to whom the book had been given, confirms that the artist knew the original Ming volume.

Miyajima

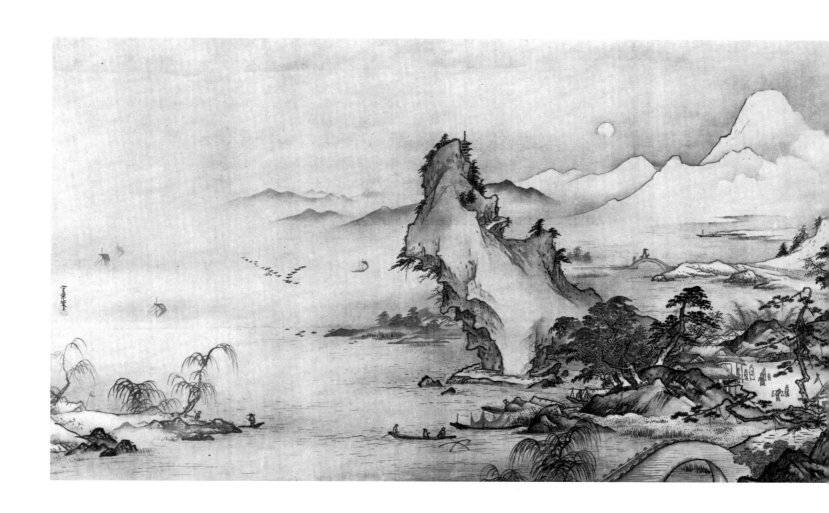

31 KUSUMI MORIKAGE
(fl. 1634–97)

Eight Views of the Xiao and Xiang Rivers
First half seventeenth century
Hanging scroll; ink and color on silk
55.5 x 95.8 cm (21 7/8 x 37 3/4 in.)
Signatory inscription: *Painted by Morikage*
Rectangular relief seal: *Kusumi*
Egawa Art Museum, Hyōgo Prefecture

Painted versions of the Eight Views of Xiao and Xiang theme are ordinarily found on fusuma panels, screens, hanging scrolls, or even fans, though few are wholly successful. In Hasegawa Tōhaku's pair of screens (cat. no. 12), for example, the balance between the scenes is sacrificed for the total composition. Morikage's ability to knit all eight scenes seamlessly into a single small composition takes the viewer by surprise. The eight views claim equal attention and space, while maintaining a unified viewpoint. Subtle color enhances the beauty of Morikage's vision.

A vast, level distance may be entered via the stone bridge in right foreground. The road winds toward a small village, which illustrates the motif "Mountain Village after a Storm." The road then follows the base of the central cliff back to the distant white mountains of "River and Sky in Evening Snow." "Autumn Moon over Lake Dongting" appears just to the left of the snow-covered peaks. A tall pagoda high atop the center peak represents "Evening Bell from a Distant Temple." A few houses, nestled beyond and pelted by a storm, are depicted in "Night Rain over Xiao and Xiang." Motifs of geese flying over the lake and sailboats making their way to shore are illustrated in "Wild Geese Descending to Sandbar" and "Returning Sail off Distant Shore." The final view, "Fishing Village in Sunset Glow," is suggested by the fishermen under willows at lower left.

Miyajima

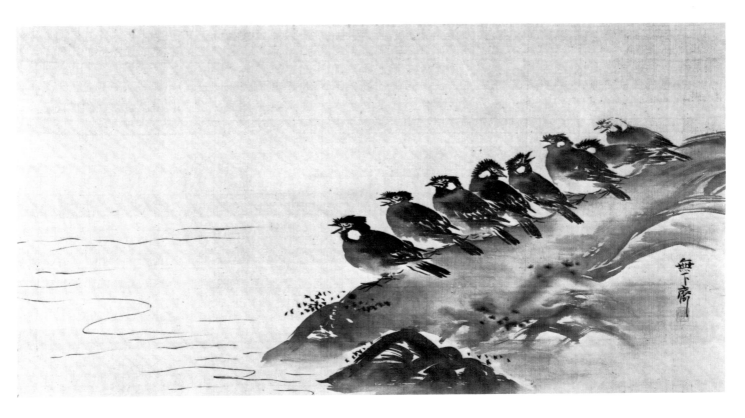

32 KUSUMI MORIKAGE
 (fl. 1634–97)

Magpies
Mid-seventeenth century
Hanging scroll; ink on silk
31.0 x 47.2 cm (12 1/4 x 18 5/8 in.)
Signatory inscription: *Mugesai*
Rectangular relief seal: *Kusumi*
Osaka Municipal Museum

Kusumi Morikage married a niece of Kanō Tan'yū and was counted among Tan'yū's four major disciples. Although landscapes predominate in his extant works, his most highly praised and characteristic paintings are gracefully drawn genre scenes. The subject of seasonal activities, especially connected with rice planting, traces its origins to China but achieved popularity in Japan during the late Muromachi period. Morikage fully succeeded in transforming the theme to Japanese country life.

This small painting, a rare subject in Morikage's oeuvre, exhibits his stylistic idiosyncrasies. Flowing water, described in simple, curving lines, contrasts with rough, sketchy strokes and puddled washes that describe the shore. There eight well-mannered birds sit in a row. Three look forward, while five squawk in protest at something beyond the scene. Their varied expressions break the potential monotony of the composition.

Miyajima

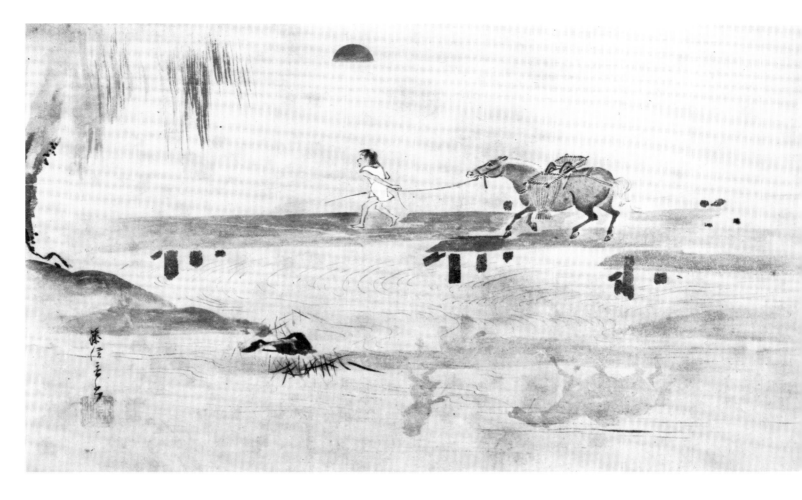

33 HANABUSA ITCHŌ
(1652–1724)

Pulling a Horse at Dawn
Late seventeenth century
Hanging scroll; ink and light color on
paper
30.6 x 52.0 cm (12 x 20 1/2 in.)
Signatory inscription: *Painted by Tō
Nobuka*
Square intaglio seal: *Chōko*
Seikadō, Tokyo

A boy wearing a paper garment pulls his horse across a bridge. The empty packs on the horse's back suggest that the two are hurrying off to begin a day's work. The shadows reflected in the river and the long, still willow leaves convey the feeling of a cool summer morning.

Born in Kyoto to the Taga family, Itchō as a child moved to Edo, where he studied traditional Kanō-school painting with Yasunobu (1613–85). Like many artists before and after him, Itchō determined to break free of his Kanō training and to establish his own artistic style. He was inclined toward depictions of folk customs as well as of city life: the so-called *ukiyo* (floating world) subjects — the Yoshiwara and theater districts — and the styles of Iwasa Matabei and Hishikawa Moronobu

(c. 1618–94) appear frequently in his early works. Itchō also became a poet and painter of humorous subjects.

In 1698 he was banished to Miyakejima, off the coast of the Izu Peninsula, for ridiculing the shogun's favorite concubine. Pardoned in 1709 and allowed to return to Edo, he began using the name Hanabusa Itchō. Now an old man, his former friends gone, he lost his enthusiasm for the pleasure quarters. He returned to older styles and subjects, which he drew with more attention to refinements in brush and ink. Although Itchō used the Chōko seal both before and after his period of exile, the carefree expression of this painting certainly belongs to his earlier period.

Miyajima

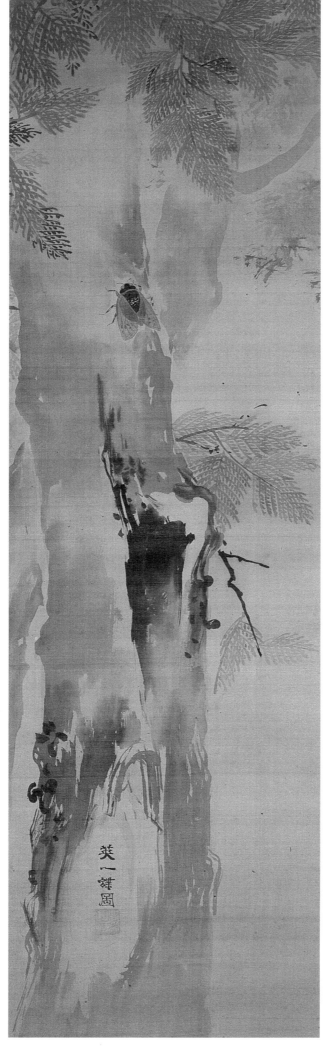

34 HANABUSA ITCHŌ
(1652–1724)

Cicada on a Cypress Tree
Early eighteenth century
Hanging scroll; ink and color on silk
84.1 x 24.7 cm (33 1/8 x 9 3/4 in.)
Signatory inscription: *Hanabusa Itchō*
Square relief seal: *Nobuka no in*
Ogino Kyūjirō Collection, Okayama
Prefecture

Within a narrow format, Itchō depicted a close view of the trunks of two Japanese cypresses, while suggesting that the viewer is actually in the middle of a forest. Coarse strokes in black ink, more wash than line, define the trunks; the needles, by contrast, are carefully and minutely drawn in color. A lone cicada perches on the trunk. Itchō boldly signed his name in a space deliberately left white on the trunk, a technique that is centuries old. The Hanabusa Itchō signature indicates that this work dates from the artist's late years.

Miyajima

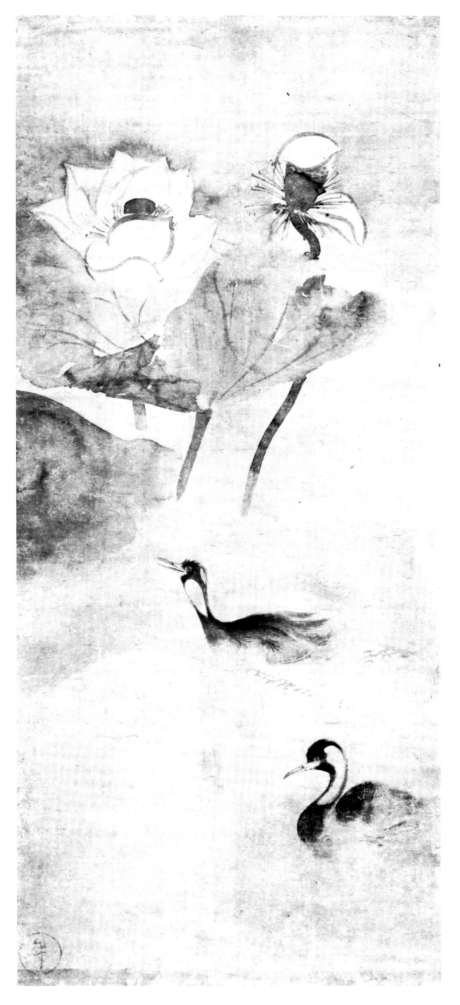

35 TAWARAYA SŌTATSU
(fl. 1602–30)

Water Birds on a Lotus Pond
First half seventeenth century
Hanging scroll; ink on paper
119.0 x 48.3 cm (46 7/8 x 19 in.)
Round relief seal: *Inen*
Kyoto National Museum
National Treasure

Sōtatsu, who appeared at the end of a long
period in which Chinese subjects and styles
held sway, freely revitalized familiar Japa-
nese subjects with his peerless sense of
design. Initially a painter of fans and deco-
rated papers for poetry, he went on to paint
brilliantly colored, golden screens, such as
the *Tale of Genji* pair in Seikadō and *Wind
and Thunder Gods* in Kenninji. Even in his
monochrome ink paintings, Sōtatsu dem-
onstrated a unique, vibrant freshness not
seen in the works of other painters using
Sino-Japanese styles.

The origins of the lotus pond theme lay
in China; examples were imported to Japan
as early as the thirteenth century. Because
lotus symbolizes the Buddha, his teachings,
and his Pure Land paradise, many lotus
paintings have remained in Buddhist tem-
ples. Although Sōtatsu could have seen
Chinese examples of waterfowl and lotus in
ink, he may also have painted directly from
the heart with the styles of such Chinese
artists as Muqi serving as no more than
vague models.

Here Sōtatsu avoided depicting the
dense vegetation found in Chinese ver-
sions. Instead he strove for simplicity. One
lotus blossoms. Another has dropped its
petals. Fallen leaves lie on the surface of the
water. One bird cries out, while the other
swims placidly among the lotuses at
twilight.

Miyajima

36 Attributed to
TAWARAYA SŌTATSU
(fl. 1602–30)

Sankirai
First half seventeenth century
Hanging scroll; ink and light color on
paper
100.0 x 35.5 cm (39 3/8 x 14 in.)
Signatory inscription: *Sōtatsu hokkyō*
Round relief seal: *Taiseiken*
Tokyo National Museum

Sankirai (English: smilax) is a member of
the lily family, well known because of the
medicinal use of its roots. Rarely does it
appear in painting however. (A slightly ear-
lier example can be found in a minutely
drawn album by Tosa Mitsunori [1583–
1638] in the Tokyo National Museum.)
Sankirai usually symbolizes spring. The
artist stretched the vine almost the entire
length of the painting. The fan-shaped
leaves and clusters of round berries serve as
points of interest. The bird perched on the
vine may be a bush warbler (*uguisu*). The
apparently marginal placement of the bird
helps integrate the composition.

Several paintings of this size and shape
by Sōtatsu survive. Most were probably
intended to be pasted onto screens. Succinct
details from nature or from common folk-
loric themes predominate. A unique fea-
ture of Sōtatsu ink paintings is the sparing
application of gold and green color.

Miyajima

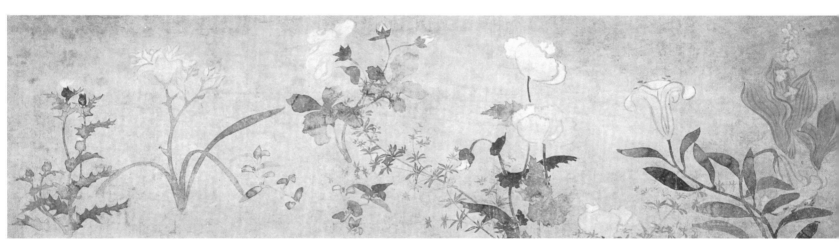

37 OGATA KŌRIN
(1658–1716)

Flowers of the Four Seasons
Dated 1705
Handscroll mounted as four hanging
scrolls; ink and light color on paper
Each 36.2 x 131.2 cm (14 1/4 x 51 5/8 in.)
Signatory inscription: *Hokkyō Kōrin*
Round relief seal: *Dōsū*
Private collection, Chiba Prefecture

Seasonal flowers, among them peony, hol-
lyhock, hydrangea, thistle, chrysan-
themum, bush clover, and narcissus, suc-
ceed one another in this horizontal
composition, formerly a handscroll. Kōrin's
scroll takes earlier decorated papers by
Sōtatsu as its point of departure. Here ink
wash and light color replace Sōtatsu's gold
and silver. Leaves are rendered in a com-
bination of *mokkotsu* and *tarashikomi* tech-
niques, while pale gray lines describe the
petals of white and pink flowers. In works
of Sōtatsu's followers, especially those who
continued to use the Inen seal, believed to
have been an identifying symbol of his
workshop, light color is occasionally

applied with ink wash techniques. For in-
stance, Kitagawa Sōsetsu, who may have
been Kōrin's contemporary, also used the
mokkotsu technique to describe flowers
and grasses. Yet Kōrin's style is at once
more delicate and richly expressive.

When this handscroll was remounted, a
dated inscription was discovered hidden on
the original roller: "Hōei second year, sixth
month, third day, Nakagawa Seiroku."
Nakagawa Seiroku may have mounted the
original scroll. Since few works by Kōrin
are dated, this painting has become a
benchmark for understanding his career.

Miyajima

38 OGATA KŌRIN
(1658–1716)

Bamboo and Plum
Early eighteenth century
Two-fold screen; ink on gold foil
65.8 x 181.5 cm (25 7/8 x 71 1/2 in.)
Signatory inscription: *Hokkyō Kōrin*
Square relief seal: *Masatoki*
Tokyo National Museum
Important Cultural Property

Bamboo was long a favorite subject of Chinese literati painters. Even so, relatively few examples of bamboo painting survive in Japan. Kōrin did not depict the density of a bamboo forest but instead transformed his subject into a decorative pattern. Such a composition was not Kōrin's invention. Contemporary Kanō-school artists had been experimenting along similar lines, but Kōrin added a freshness and lyricism seldom encountered in Kanō-school works. Here the bamboo stalks vary from thick to thin, dark to light. Although the white plum tree, with its branches splayed in all directions, interrupts the harmony of the rigid bamboo stalks, it does not destroy the overall balance of the composition.

This screen must have been painted after Kōrin received the honorary *hokkyō* title in 1701. From the style of the signature it appears to date after his 1705 handscroll of flowers and grasses as well.

Miyajima

101

39 YANAGISAWA KIEN
(1704–58)

Waterfall
Mid-eighteenth century
Hanging scroll; ink and color on silk
96.1 x 35.4 cm (37 7/8 x 13 7/8 in.)
Square relief seal: *Kien*; square intaglio
seal: *Ryū Rikyō azana Kōbi*
Tokyo University of Arts

Yanagisawa Kien was born and raised in
Edo but moved with his family to Kōri-
yama in Nara Prefecture at age twenty-one.
He began studying Kanō-school painting
but later claimed that by age twelve or thir-
teen he had already perceived its shallow-
ness and determined to find a teacher of
Chinese painting from Nagasaki. Kien was
a literatus of many talents, and his journal,
Hitorine (Sleeping Alone), is well known to
students of Edo literature.

In subject and style, this painting of a
waterfall stands alone among Kien's works.
Although in *Hitorine* he criticized blurred
ink washes by Kanō-school artists as "light
and coarse," their use here for the rocks
proves that he had thoroughly assimilated
Kanō ink methods. Kien also blew *gofun*
(ground shell) across the painting surface to
indicate spray, a technique also used in his
bird-and-flower paintings. Combined here
with decoratively patterned waves modeled
after native designs, such techniques are
not seen in conjunction elsewhere. Kien is
noted for his finger paintings of bamboo
ink, and the finely drawn lines in white are
additional evidence that Kien was follow-
ing his own fanciful, yet tasteful instincts as
a literati artist.

Satō

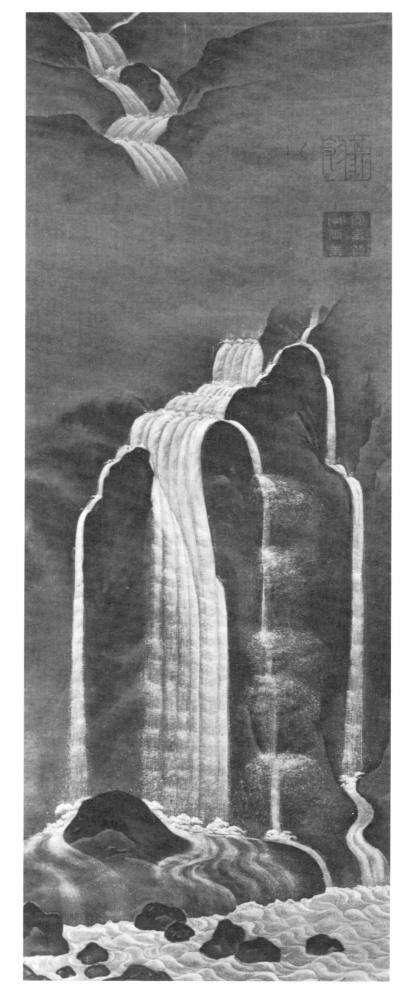

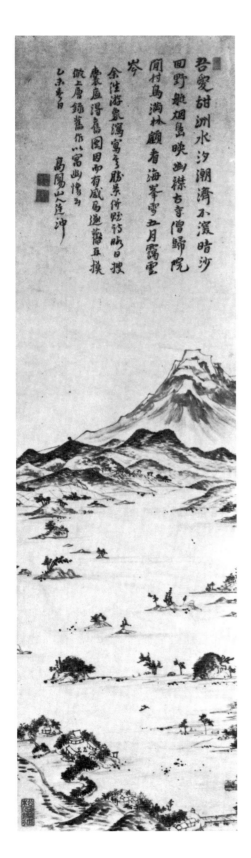

40 NAKAYAMA KŌYŌ
(1717–80)

View of Kisakata Bay
Dated 1775
Hanging scroll; ink on paper
103.5 x 38.4 cm (40 3/4 x 15 1/8 in.)
Signatory inscription: *On a spring day in [1775], Kōyō sanjin, Teichū*
Rectangular relief seals: *Shōseki* and *Shōsekisai*; square intaglio seals: *Chū Teichū in* and *Shiwa*
Kanmanji, Akita Prefecture

Born to a merchant family of Tosa (now Kōchi Prefecture), Kōyō was active mainly in Edo. Although formally a student of Sakaki Hyakusen, he also studied Chinese painting theory, woodblock-printed manuals, and late Ming painting, creating at last an eclectic style of his own.

To escape the great Edo fire of 1772, Kōyō traveled for seven months in northern Honshu. He seems to have followed the route taken by Bashō (1644–94) as recorded in the latter's famous travel diary, *Oku no hosomichi* (The Narrow Road to the North). Kōyō's own diary indicates that he visited Kisakata on the twentieth day of the fifth month. From his boat he sketched the view. In his diary he compared the sights of Matsushima and Kisakata with the works of two famous Chinese painters: Matsushima became a large, brilliantly colored landscape by the Tang artist Li Sixun (651–716), and Kisakata, a vast handscroll in light color by Dong Yuan (d. 962). The notion of a real scene reminding a painter of the works of past masters may also be found in the writings of the Ming theoretician and painter Dong Qichang (1555–1636). Since Kōyō wrote the first painting treatise in Japan that discussed the Northern and Southern school theories of late Ming, his attitudes very likely were formed through his reading of Dong Qichang and other Ming writers.

It seems Kōyō saw the style of Dong Yuan, an early master of the Southern School of Chinese literati painting, as suitable for depicting Kisakata, for in his 1772 version of the subject he made an atypical use of light color and ink dots. Compared with that painting, this composition is more tightly intergrated, and the deep, level distance is rendered in soft brushwork. The distant peak is Chōkaisan. The temple at the lower left, Kanmanji, now owns the scroll.

Satō

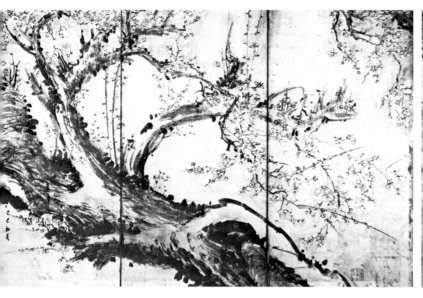
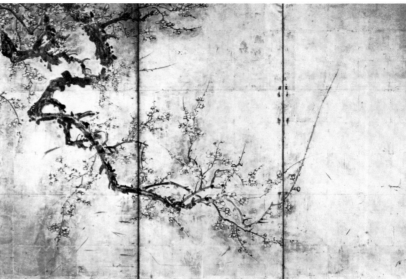

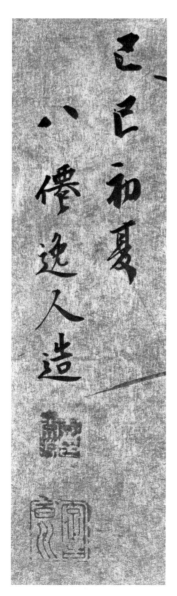

41 SAKAKI HYAKUSEN
(1697–1752)

Plum Trees
Dated 1749
Pair of six-fold screens; ink on gold foil
92.5 x 271.0 cm (36 3/8 x 106 3/4 in.)
Right screen
Signatory inscription: *Painted by Hōshū*
Rectangular relief seal: *hokkyō*; square intaglio seal: *Hō Shin'en in*; oval relief seal:
Sake o tsūin shi risō o yomu (Drunk with
sake, I read the tragic story of [Qu Yuan].)
Left screen
Signatory inscription: *Made by Hassen
Itsujin in early summer [1749]*
Square relief seals: *Hō Shin'en in*, *azana
iwaku Hyakusen*, and *Gozu wa ei no tame ni
arazu fūryū isasaka kō ni kau* (I paint not for
glory; elegance is little substitute for
diligence.)
Sumitomo Kichizaemon Collection, Kyoto

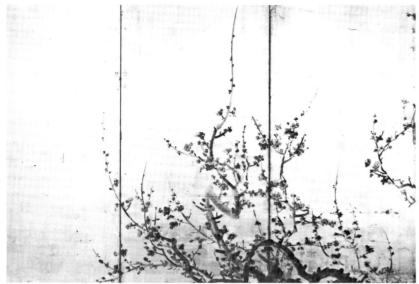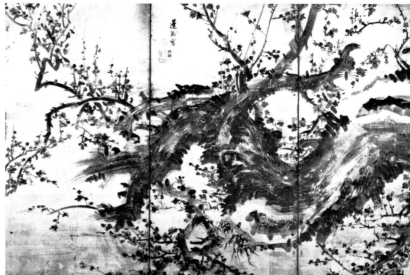

Hyakusen's style of plum painting was inspired by the Ming artist Liu Shiru (first half sixteenth century), especially his *Liu Xuehu [Shiru] meipu* (Liu Xuehu's Manual of Plum Painting). These screens are the earliest of his plum paintings. They are characterized by lively composition, comparatively soft forms, and bark smoothly built up in layered brush strokes, altogether an excellent embodiment of first-generation Nanga plum painting. The differences between the two plum trees suggest that the right screen is a red plum, and the left screen, a white plum.

The three prime examples of Hyakusen's plums, done as a group in his last years, are large-scale paintings in which the thick tree trunks are painted in rough, Ming-derived brush strokes. Yet Hyakusen may also have intended to emulate the large tree compositions found in Japanese screens.

Born in Nagoya, but active in Kyoto, Hyakusen irrefutably exercised great influence on his fellow Kyoto painters. In response to his two-fold screen of the same subject dated 1750, Ike no Taiga in 1753 painted a two-fold bamboo screen to form a pair with Hyakusen's plum painting. Hyakusen's panels painted for the Suhara House (in Nara Prefecture) in 1751 are believed to have served as models for Soga Shōhaku. The plum in Shōhaku's screen portrait of Lin Heqing of 1760 (Mie Prefectural Museum) is, in fact, similar to the plum in the right screen here.

Satō

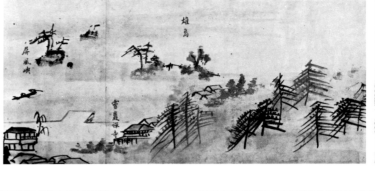

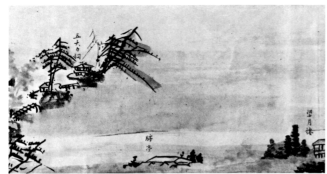

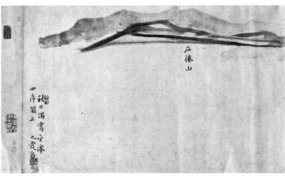

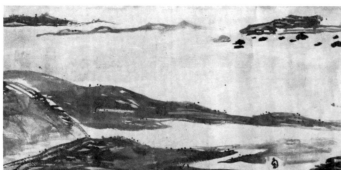
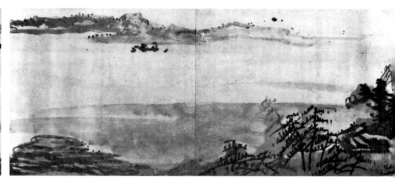

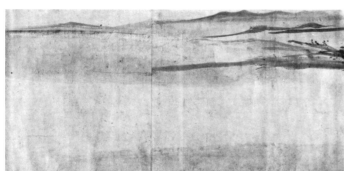
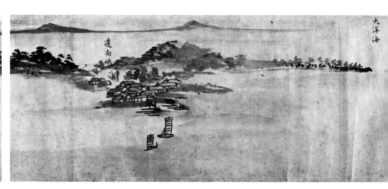

42 IKE NO TAIGA
(1723–76)

Wondrous Scenery of Mutsu Province: View of Matsushima
Dated 1749
Handscroll; ink and light color on paper
31.6 x 242.1 cm (12 1/2 x 95 3/8 in.)
Signatory inscription: *On an autumn day, Kyūka Tsutomu casually painted this at the Shijo Villa in Kanazawa.*
Rectangular relief seal: *Joitsu*; square intaglio seal: *Taiga no dō*; square relief seal: *Shūhei*
Title and artist's epilogue inscribed by Kō Fuyō (1722–84)
Shimosaka Nichinan Collection, Tokyo
Important Cultural Property

Taiga's close friend, the seal-carver Kō Fuyō, inscribed the four-character title that opens this handscroll as well as Taiga's epilogue. Therein the artist describes the events that led to its creation. In 1748 he left Kyoto for Edo. En route he climbed Mount Fuji, then proceeded to Nikkō, and finally to Matsushima, one of Japan's most celebrated scenic locations. The following year he crossed Japan to visit Kanazawa, where he enthusiastically described his earlier sojourn. Although many in Kanazawa had seen Fuji, few had been to Matsushima. Kobori Nagayori (1684–1765), a retainer of the daimyo of Kanazawa, begged Taiga to paint the sites he had described. Taiga complied; this handscroll was created at Nagayori's retreat, the Shijo Villa.

While ink wash is inherently suitable for the depiction of actual scenery, this painting is not an on-site sketch. Rather, like Kōyō's *View of Kisakata Bay* (cat. no. 40), it is a landscape based on earlier landscape styles. In the process of delineating what he had seen at Matsushima, Taiga adapted his study sketches and alluded to the traditional Eight Views of Xiao and Xiang, utilizing the concise ink wash methods usually associated with them. Here he blended pale color with the wash to create his impressive vision. This painting is uncharacteristic of the work he was doing in his twenties, as fine line, rather than ink wash, dominates most of his paintings from that period.

Satō

下走去歳遊東都三次
登芙蓉拜日光旁探奥
之勝地塩竈松島里海
三魁也煙興雲崎風渚
月浪三景香范滂古蛤鸞
天壤中有若茲三美兪今
年接末丁賀金澤眼至先
説芙蓉松島昏蓋莫茲

也佳、多登攀者故其奇
滕牛在世三口碑指奥地
其路絶遠而罕窺云鏡
三人也日
亀山君善其難窮者
命余描耐観松蔦三大
君余不堪解濃淡随手
潑洒以圖云第一云
寛延巳巳七月
栗東高籍書
平安池勤識

*Wondrous Scenery of Mutsu Province: View of
Matsushima*
(inscriptions and seals, cat. no. 42)

108

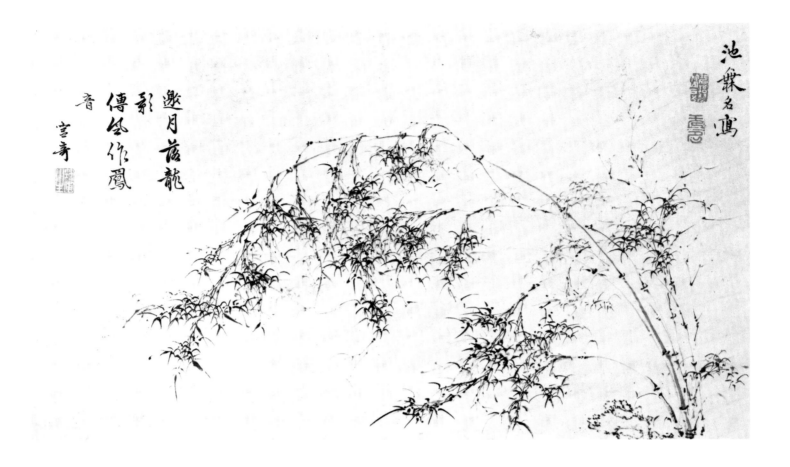

43 IKE NO TAIGA
(1723–76)

Bamboo and Rock
1750s
Hanging scroll; ink on paper
24.8 x 41.8 cm (9 3/4 x 16 1/2 in.)
Signatory inscription: *Painted by Ike Mumei*
Rectangular intaglio seal: *Hekigo sui chiku sanbo*; rectangular relief seal: *Mumei*
Inscription by Miyazaki Inpo (1717–74)
signed: *Kyūki*
Square intaglio seal: *Inposei*
Tomioka Masutaro Collection, Kyoto

Bamboo emerged as a popular theme for literati painters in eleventh-century China for several reasons. It was appreciated as a symbol of enduring character, and significantly, it was a subject that anyone, even amateurs, with training in calligraphy could paint. As a result, ink bamboo sometimes exhibit weaknesses in creativity. Although superb compositions may be found, there is a tendency among connoisseurs to gloss over defects in renderings of the subject.

This painting, done while Taiga was in his thirties, is free of such weaknesses. The supple stems of the bamboo are drawn out like silk threads. Leaves, rendered in quick, sprightly strokes, breathe fresh air into the long history of bamboo ink painting. Although a small work, it impresses the viewer with its refinement.

In his inscription Miyazaki Inpo, a Kyoto Confucian, who himself painted ink bamboo, pays tribute to this eternal symbol of gentlemanly virtue:

A welcomed moon casts a dragon's
 shadow
Turning in the wind, the call of a
 phoenix sounds.

The modern literati painter Tomioka Tessai (1836–1924) treasured this painting.

Satō

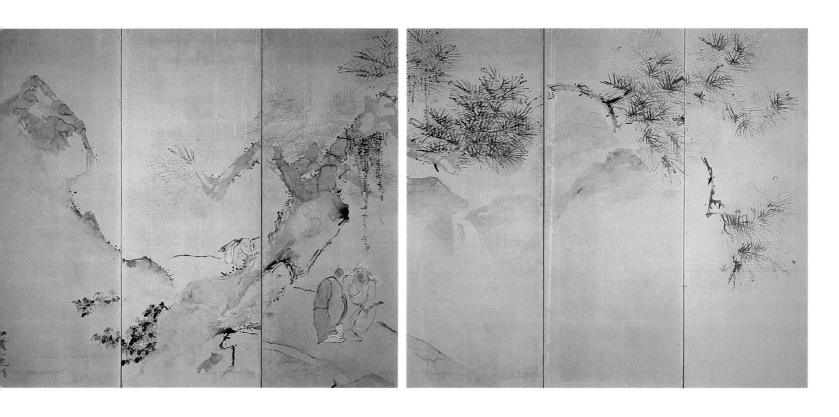

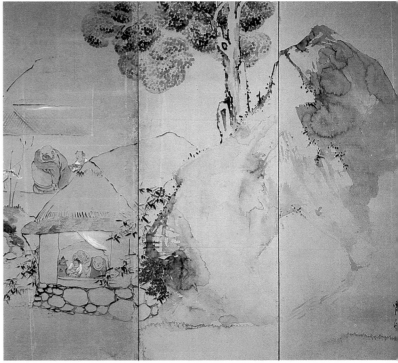

44 IKE NO TAIGA
(1723–76)

A Visit to Eastern Woods
Circa 1760
Pair of six-fold screens; ink and color on
paper
Each 165.5 x 362.6 cm (65 1/8 x 142 3/4 in.)
Right screen
Signatory inscription: *Kashō*
Left screen
Signatory inscription: *Painted by Kyūka
Sanshō*
Both screens
Square intaglio seals: *Tōzan itsusō* and *Ike
Mumei in*; square relief seal: *Gyokkō kōanri*
Bekka Hiroaki Collection, Shimane
Prefecture

The monk seated at his cottage window in
the right screen is Huiyuan (334–416), the
famous recluse of Donglinsi (Eastern Wood
Temple) on Mount Lu. The two sages
approaching on the path in the left screen
are the poet Tao Yuanming (c. 365–417)
and the Daoist Lu Xiujing (c. 406–77).
According to an allegory describing the
unity of Buddhism, Confucianism, and
Daoism, these three men met at Huiyuan's
temple on Mount Lu. Later, Huiyuan, bid-
ding his guests farewell, inadvertently
crossed Tiger Creek, the boundary of his
retreat, thereby breaking a vow never to
leave Donglinsi. The three men laughed at
the folly of imposing such artificial limits
on man's spirituality.

The craggy white plum of the right
screen connotes spring, while the red-
leafed ivy and blooming yellow chrysan-
themums, Tao Yuanming's favorite flower,
affirm that the left screen depicts autumn.
The major motifs, concentrated at the ends
of the composition, leave a central expanse

of empty space. The stiffness of the white
plum's branches and the bold use of satu-
rated, light ink wash for the waterfall show
that Taiga was influenced by the post-
Tan'yu Kanō-school style. Puddles of ink,
learned from Rinpa-school artists, define
rocks and tree trunks. Despite adopting the
traditional compositional and technical
means of his predecessors, Taiga applied
ink with his fingers, fingernails, and the
palm of his hand and dotted in color
accents or lines to create this vibrant and
expansive scene.

Because the style of these screens is
unique, they cannot easily be dated by
comparison with other works. According
to a record of questionable reliability, Taiga
may have painted these screens while trav-
eling to Izumo in 1755 while in his early
thirties. The maturity of the artistic vision
displayed here, however, shows greater
affinity with sensibilities of his forties.

Satō

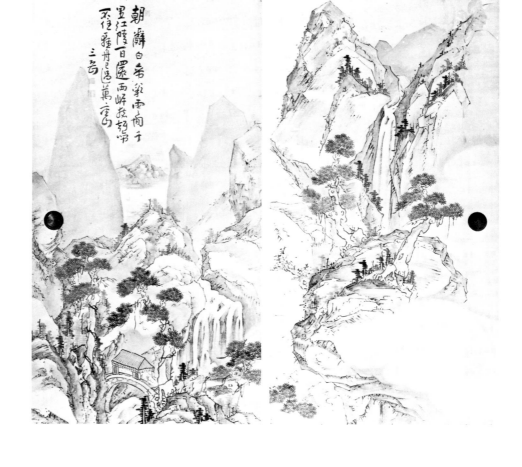

45 IKE NO TAIGA
(1723–76)

Landscape after Li Bo's Poem
Mid-1760s
Two fusuma panels; ink on paper
Each 166.5 x 89.5 cm (65 1/2 x 35 1/4 in.)
Poem by Li Bo inscribed by the artist and
signed: *Sangaku*
Rectangular intaglio seal: *Taiga*; square in-
taglio seal: *Ike Mumei in*; square relief seal:
Gyokkō kōanri
Maruoka Muneo Collection, Tokyo

Early morning, we depart Baidi, which
 is surrounded by tinted clouds,
Although it is a thousand *li* to Jiangling,
 we arrive in a day.
From the riverside cliffs the laments of
 gibbons fail to hold us back.
Our light boat has already passed ten
 thousand peaks.

The subject of these panels is apparently
this poem entitled "Leaving Baidi at

Dawn" by Li Bo, the famous Tang poet. *Tōshisen* (Compilation of Tang Poems), an anthology of Tang poetry widely read during the Edo period, included Li Bo's poem along with others describing the scenery depicted here. The images, however, evoked by this poem about precipitous mountains seen from a river boat would not result in these panels. The landscape scene of distant mountains seen from a lofty peak is from another Li Bo poem, also in *Tōshisen*, entitled "Sending Off Meng Laorang to Yangzhou." Taiga's compositional skill revealed in these paintings reflects the knowledge gained from studying Chinese paintings and illustrated books. The monumental presence of this work results from his wide-ranging travels, his experiences with nature and the stimulus of Western painting.

The composition and texturing of rocks in these panels fall midway between a pair of screens of Chinese themes, dated 1763, and the *Sages in a Landscape* fusuma panels

at Henshōkōin, dated a few years later. The present panels, in somewhat damaged condition, do not quite attain the harmonious blending of dot and line, light and dark ink, or breadth of palpable space found in the Henshōkōin doors, yet the ink builds forms in much the way a sculptor might; the hand of the master is everywhere evident.

These panels have been preserved in a residence at Niwase, a travelers' way station on the road to Izumo. Like *A Visit to Eastern Woods* (cat. no. 44), they provide evidence of Taiga's travels to the region. The style of these paintings is later than Taiga's supposed 1755 journey to Izumo; together with evidence in works done while the artist was in his forties, they suggest a second journey.

Satō

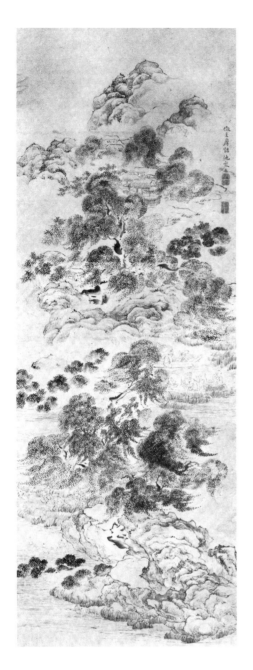

46 IKE NO TAIGA
(1723–76)

A Fisherman's Pleasure
1760s
Hanging scroll; ink on paper
152.0 x 54.0 cm (59 7/8 x 21 1/4 in.)
Signatory inscription: *In imitation of Wang Mojie, Ike Mumei*
Double semicircular relief seals: *Kashō*; rectangular relief seal: *Zenshin sōba Hō Kyūkō*
Kyoto National Museum
Important Cultural Property

Fishermen in their boats scattered throughout this high-angle glimpse of a river village enjoy the cool offshore breezes and raise their wine cups in toast. Children at the lower left frolic in the stream. Fine lines animate these figures. Swaying willows lend a feeling of fluid movement through the rhythms of light and dark ink dots.

The solitary fisherman provided a particularly significant theme for Chinese literati painters. For scholars and for officials embroiled in politics or mundane matters, fishermen or woodcutters out of doors became symbols in poetry and painting for their own eremitic yearnings. Taiga's painting of fishermen is a scene of merry pleasures and brims with his bright sense of humor.

Taiga's lighthearted transformations of this Chinese theme also stems from his drawing methods. The undulating movement in this zigzag composition may have derived from late-Ming landscape painting, since Taiga learned his methods of drawing trees and texture strokes from Chinese painting manuals and imported paintings. He completely transformed them, however, into an idiom of his own well suited to a bouyant sense of the sunny scenery at river's edge.

In his inscription the artist declares that he was imitating the eighth-century poet and landscape painter Wang Wei (Mojie). Taiga, who could not have seen any actual examples of Wang Wei's painting, must instead have imitated a Ming rubbing or printed composition after Wang Wei's famous handscroll *Wangchuan Villa*. By replacing the relief contour lines with ink brush strokes, Taiga's version of Wang Wei stresses fine, even lines. The thicker, oblique brushwork of tree trunks and pointillistic willow leaves are characteristic of Taiga's screen paintings of *Eight Views of Xiao and Xiang* (Hamaguchi Collection) and *Children under a Willow* (Taiga Museum). This painting has thus been placed as a work of Taiga's mature phase, when the artist was in his forties.

Satō

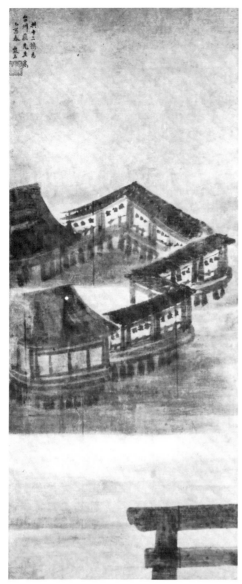
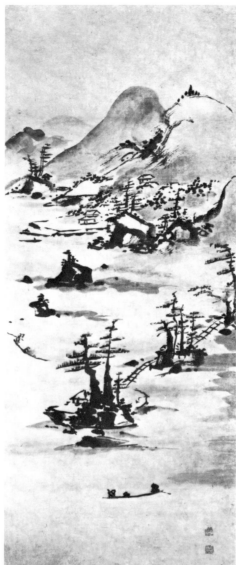
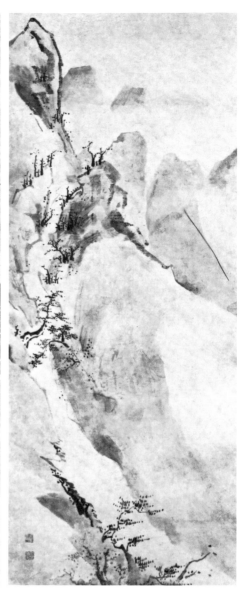

47 IKE NO TAIGA
(1723–76)

Twelve Famous Views of Japan
Dated 1765
Six hanging scrolls from a set of twelve;
ink on paper
Each 128.0 x 50.0 cm (50 3/8 x 19 5/8 in.)
"Miho no ura"
Signatory inscription: *Mumei*
Rectangular relief seal: *Sude ni senri no*
michi o yukedomo imada bankan no sho o
yomazu (I have already walked one thou-
sand miles but have not read ten thousand
books.)
"Miyajima"
Signatory inscription: *All twelve sheets were*
painted for Mr. Ogi of Taishū in the spring of
[1765], by Mumei.
Square relief seal: *Ike Mumei in*
Middle four panels
Square intaglio seals: *Sangaku dōja* and *Ike*
Mumei in
Kawabata Yasunari Kinenkan, Kanagawa
Prefecture

Twelve hanging scrolls illustrating famous
views of Japan were originally pasted to the
panels of a pair of six-fold screens. The two
inscribed scenes — "Miho no ura" and
"Miyajima" — must have bracketed the
series, so that the artist's signatures
appeared at opposite ends of the composi-
tion. The original order of the remaining
ten paintings is uncertain. Furthermore,
only five of the scenes — "Miho no ura,"
"Matsushima," "Kintaikyō," "Funabashi,"
and "Miyajima" — can be positively
identified.

Many of his so-called *shinkeizu* (true
views) incorporated his knowledge of dif-
ferent styles of ink painting. Each of these
twelve views, for instance, represents his
summation of Muromachi- and Sōtatsu-
school techniques. In a revealing letter
written by the artist in 1764 to a member of
a Korean delegation visiting Kyoto, he dis-
cussed Japanese methods for painting

Mount Fuji and inquired about the
texturing methods of Dong Yuan and
Juran (fl. 960–80). Taiga begs the Korean to
sketch Fuji from his ship as a sample of
these techniques. Thus did Taiga strive to
reinvigorate Japanese traditions.

Taiga's love for his native land undoubt-
edly grew from his frequent travels, yet it
may have been the owner of the screens,
Ogino Gengai (1737–1806), who, along
with his friends, chose the sites to be
depicted. Whatever the case, the artist
selectively abstracted each scene and varied
his vantage point. Each composition, boldly
epitomized in deep black or light ink, is
imbued with acute emotion. His insatiable
interest in technique gave him a repetoire
of means to express any artistic idea. For
Taiga method was more important than
accurate representation.

Satō

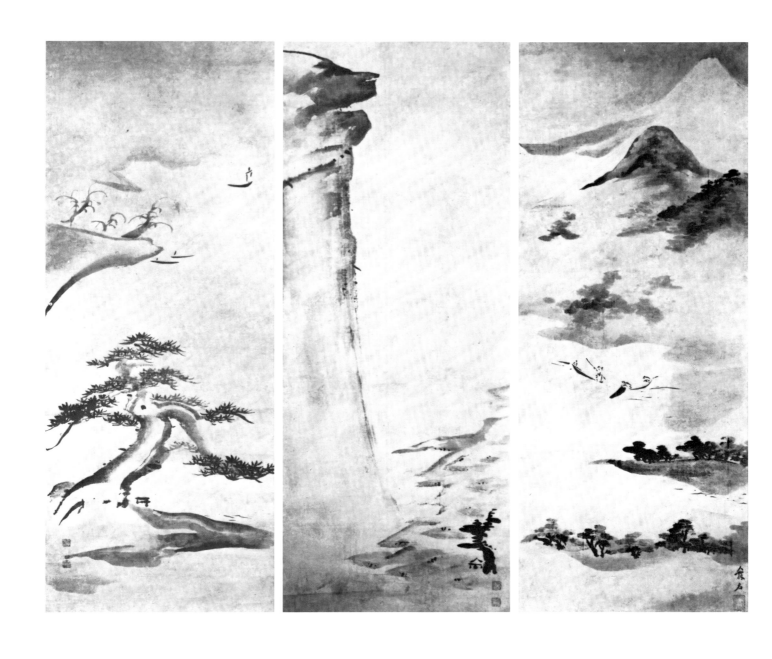

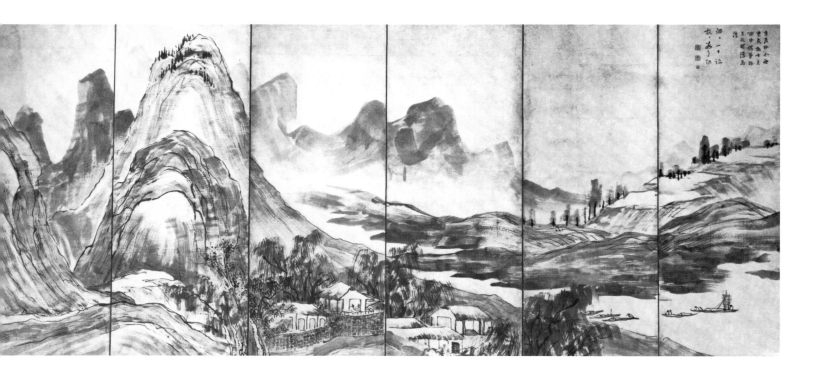

48 YOSA BUSON
(1716–83)

Landscape in the Manner of Wang Meng
Dated 1760
Six-fold screen; ink and light color on
paper
144.0 x 339.5 cm (56 3/4 x 133 5/8 in.)
Signatory inscription: *In the twelfth month,
on the day of the full moon in [1760], Tōsei,
Sha Chōkō, casually imitated the spontaneous
painting methods of Wang Shuming [Meng].
One day intoxicated can outshine several
months of practice.*
Square intaglio seals: *Shunsei, Sha Chōkō
in*, and *Sanka shujin*
Kyoto National Museum

This screen originally formed a pair with
Landscape in the Manner of Mi Fu (Los An-
geles County Museum of Art). The pair is
said to have come from a residence con-
nected with Tōji temple in Kyoto. In *Land-
scape in the Manner of Mi Fu*, Buson
employed Mi-style dots in a composition
reminiscent of Mi Youren's (1074–1153)
handscroll *Cloudy Mountains* (Cleveland
Museum of Art).

Only the fine, somewhat shaky lines of
these screens suggest the style of Wang
Meng (1308–85). The final phrases of the
inscription, quoted from a comparison of
the artists Wu Daozi (eighth century) and
Li Sixun (651–716), reveal, however, that
Buson's interest may have lain in experi-
menting with the uninhibited brush style
brought on by an inebriated state. Wu, in
just such a state, is said to have painted a
landscape on the palace walls of the Tang
emperor Xuanzong (602–64) in a single
day, while Li Sixun, a painter of equal re-
nown, took several months to complete a
similar commission.

After three years spent in Tango, Buson
returned to Kyoto in 1757. There he studied
the style of Shen Nanpin and from about
1763 painted screens in fine line and color.
This screen, painted in 1760, is in a rather
strong and fluent style for the period. The
broad strokes in varied ink tones seem to
prefigure the later painting style.

Satō

Yosa Buson (1716–83)
Landscape in the Manner of Mi Fu
Circa 1760
Six-fold screen; ink on paper
145.1 x 332.7 cm (57 1/8 x 131 in.)
Los Angeles County Museum of Art
Gift of the Frederick Weisman Company

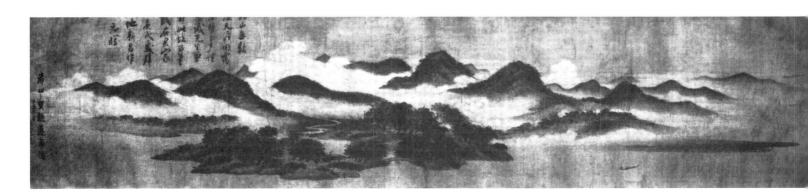

Mi Youren (China, 1074–1153)
Cloudy Mountains
1130
Handscroll; ink, lead white, and light color
on silk
43.4 x 194.3 cm (17 1/8 x 76 1/2 in.)
Cleveland Museum of Art

49 YOSA BUSON
(1716–83)

Spring Glow after Rain
Circa 1780
Hanging scroll; ink and light color on satin
28.5 x 32.0 cm (11 1/4 x 12 5/8 in.)
Signatory inscription: *Shain*
Paired rectangular seals: *Chōkō Shunsei*
Matsushita Kōnosuke Collection, Hyōgo
Prefecture
Important Cultural Property

Buson reached the peak of his abilities and received his greatest renown after 1778, when he began signing his work with the pseudonym Shain. His masterpiece, *City under Night Sky* (fig. 12), dates from that period. But even as he experimented boldly with subtle monochrome ink washes, he continued painting beautiful works in color. This small, elegant landscape, an orthodox work in the manner of the Southern School, belongs to neither category, yet the fineness of its expression makes it representative of the best of Buson's capabilities.

The white satin ground imparts a coldness to the ink. Buson employed a hemp-fiber brush to build the gentle slope that floats beyond the trees, which, extending diagonally into the middle distance, gradually become indistinct. Spring sunlight breaks through the clouds at right, shining on the distant village. Streaks of yellow here and there may represent fields of blossoming rapeseed; a blurred gray wash on the left side of the composition, a drenching rain. Buson, a poet who could have written of the languid, elusive atmosphere that attends a spring shower, here articulates a universal statement on nature.

After his collaboration with Taiga in 1771 on *Ten Pleasures and Ten Conveniences*, Buson may have harbored feelings of rivalry. He barely mentioned Taiga's death (1776) in a letter written to a disciple two days afterward. In subsequent letters,* he stated that his style should be considered as Southern School. The letters reveal Buson boasting about his work just at the time his art was progressing rapidly. Perhaps Taiga's death emancipated him from his self-consciousness and allowed him to see new directions worthy of pursuit.

Satō

* Ōtani Tokuzō et al. *Buson Shū* (A Collection of Buson), *Koten Haibungaku Taikei* (Library of Classic Literature) 12, (Tokyo: Shūseisha, 1972).

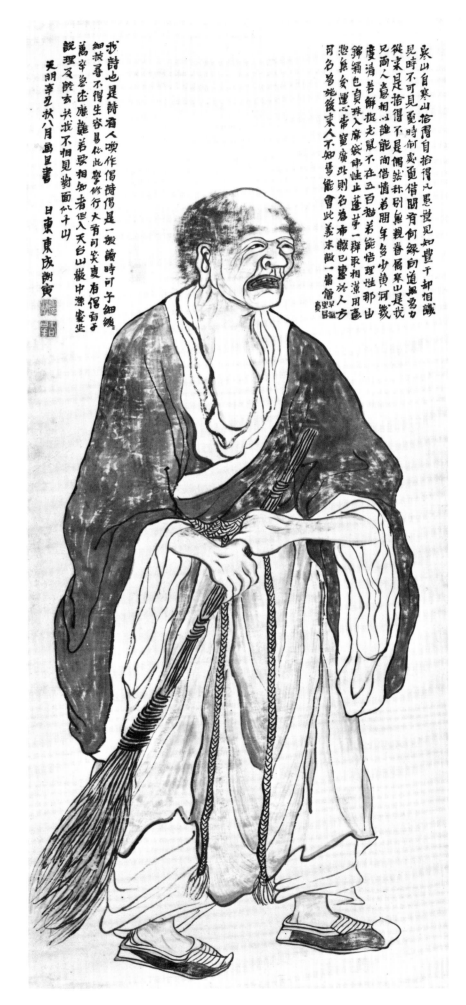

寒山自寒山拾得自拾得凡愚豈見知豐干卻相識
見時不可見覓時何處覓借問有何緣向道無為力
從來是拾得不是偶然稱別無親眷屬寒山是我
兄而人意相似誰能尚借情若朋年多少黃河幾
度清苦解捉走鼠不在五百狐若能恰理性那由
錦綺色負珠入席裝錦性止蓬荜一群取相漢用薦
憁然安運忍帝寬此則名洛布報巳憲於人方
可名為施後求人不知為能會此義求戲一富僧望間

我詩也是詩有人喚作偈詩偈是一般讀時可子細�
細披尋不得生容易依此學修行大有可笑更有偈言子
萬事忽忘應離若要相知者他人入天台山巖中穩密坐
說理及晚去共戎不相見對面似千山

天明辛丑秋八月寫旦書

日東東成謝寅 [印][印]

120

50 YOSA BUSON
(1716–83)

The Eccentrics Kanzan and Jittoku
Dated 1781
Pair of hanging scrolls; ink and light color
on paper
Each 134.7 x 58.1 cm (53 x 22 7/8 in.)
"Kanzan"
Signatory inscription: *Tōsei Shain of Japan*
Square intaglio seals: *Sha Chōkō in* and *Sha
Shunsei*
'Jittoku"
Signatory inscription: *Painted and inscribed
in autumn, the eighth month of [1781], Tōsei
Shain of Japan.*
Square intaglio seals: *Sha Chōkō in* and
Shunsei
Teramura Yōko Collection, Kyoto

Kanzan (Chinese: Hanshan) and Jittoku
(Chinese: Shide) were Buddhist monks of
the Tang dynasty. According to legend,
Jittoku was an abandoned child, found and
raised by Bukan (Chinese: Fenggan) of the
Guoqing Monastery on Mount Tiantai.
Jittoku worked in the kitchen there;
Kanzan, a hermit, begged for rice at his
door. In other accounts Kanzan and Jittoku
are considered manifestations of the
bodhisattvas Monju and Fugen. The two
became popular subjects of Zen painting
partly because of their colorful, disrepu-
table appearance and partly because their
words and deeds struck responsive chords
among those who longed for relief from the
mundane. Kanzan is depicted traditionally
reading a scroll or writing on a rock, while
Jittoku normally holds a broom.

The garb and demeanor of Buson's
eccentrics preserve something of the style
of Ming artist Liu Jun (sixteenth century),
whose work Buson knew. This is attested
by Buson in his inscription on a Liu Jun
painting of Kanzan and Jittoku. Strong
expression through trembling lines is char-
acteristic of Buson's figural style.

An inscription on the box built to con-
tain these paintings indicates that the artist
presented them to his student Teramura
Hyakuchi (1748–1835). Perhaps the aged
Buson sought to portray his relationship
with Hyakuchi, a Haiku master and his
acolyte, as that of the two eccentrics. Above
the figures are passages from the anthology
Hanshan shi (Poems by Hanshan) attributed
to Kanzan.

Satō

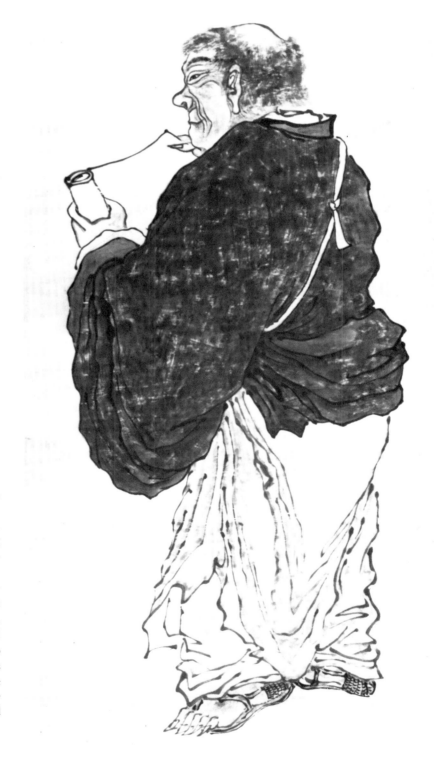

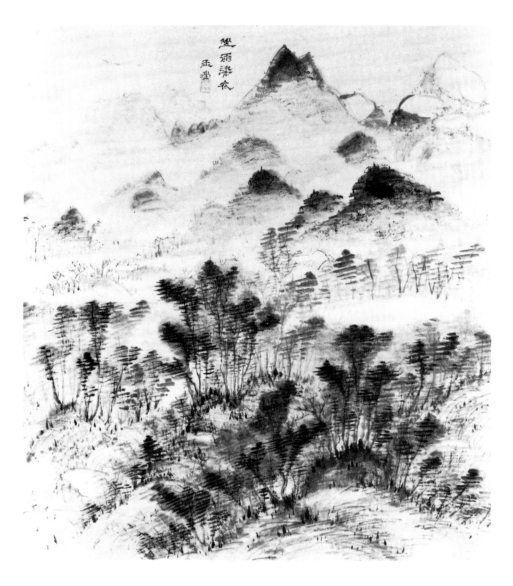

51 URAGAMI GYOKUDŌ
(1745–1820)

Mountain Landscape after a Soaking Rain
Early 1810s
Hanging scroll; ink and light color on
paper
37.3 x 31.8 cm (14 5/8 x 12 1/2 in.)
Title with signature: *Mountain Landscape
after a Soaking Rain, Gyokudō*
Rectangular relief seal: *Kin'ō*
Ohara Ken'ichirō Collection, Kyoto
Important Cultural Property

In 1794 Gyokudō renounced his position at
Ikeda domain in order to live the free life,
wandering about the countryside. He sup-
ported himself as a builder of Chinese lutes
and music teacher, medical practitioner,
and promoter of calligraphers and painters.
According to his memorial marker, written
by Rai San'yō (1780–1832), he happily
painted for anyone who offered him wine.
Thus it seems that painting was not really a
livelihood for him. A true literatus, he
painted rather for his own and his friends'
enjoyment.

From his youth Gyokudō is said to have
loved painting the mountain ranges of his
native countryside. While some may see his
characteristic brush strokes as no more
than dots piled up meaninglessly, others,
putting aside preconceived expectations of
the depiction of nature, can appreciate
Gyokudō's unique vision. The artist
arrived at an impression of nature that
stretched the limits of his painting tech-
nique. For the foreground hillocks and for-

est he applied dark, horizontal dots and
dabs on top of lighter, arrowlike lines and
strokes. The distant mountains overlap,
dim and light peaks alternating. An
impression of humid mountain atmosphere
is created through the subtle nuances of
light and dark ink and twisting brush
strokes. But for a solitary figure at lower
left who leaves the soaked forest behind to
make his way to the village in a distant
clearing, Gyokudō's poem seems to
describe this painting:

> Traces of rain remain on the tinged
> leaves of the green mountain,
> No one stirs in my humble cottage
> amidst the cold autumn colors.*

The viewer is left with an unforgettable
impression of the beauty of ink.

Satō

* Gyokudō's poems were published in 1794 as
Gyokudō Kinshi Shū (A Collection of Gyokudō, the
Lute Player).

122

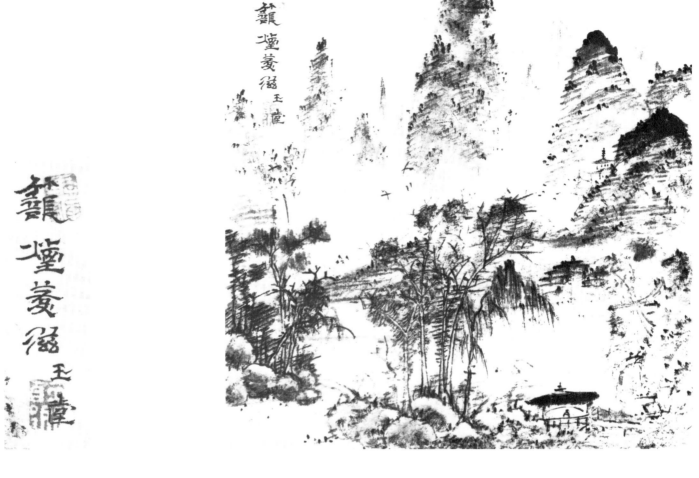

52 URAGAMI GYOKUDŌ
(1745–1820)

Enveloping Mist Arouses and Nourishes
Late 1810s
Hanging scroll; ink on paper
26.5 x 24.3 cm (10 3/8 x 9 5/8 in.)
Title with signature: *Enveloping Mist Arouses and Nourishes, Gyokudō*
Rectangular relief seals: *Kin wa waga ka nari* and *Suikyō*
Idemitsu Art Museum, Tokyo
Important Cultural Property

Gyokudō seems to have learned painting on his own, and his work attracted few supporters. He did not, like Taiga and Mokubei, focus his attention on composition; instead he experimented with the interplay of ink, water, and paper. Many of his large hanging scrolls, vibrant with uninhibited brush strokes, nevertheless fall apart spatially. Certainly his finest creations are those in small format, in which his brushwork appears to advantage. The two works in this exhibition represent his finest achievements.

As the title of this work suggests, mist trapped in the mountain valleys has given rise to the damp atmosphere. White paper suggests mist, while varied, blurred ink captures the mountains, trees, and rocks. Here Gyokudō deliberately merged ink and paper with his exceedingly delicate touch. The viewer's eye is led naturally into the watery depths of the lakeside view, and even though this is but a miniature scene, the grandeur of nature is conveyed.

Stylistic differences between this painting and *Mountain Landscape after a Soaking Rain* (cat. no. 51) show the artist to have progressed in his final years. Based upon the few dated works in his oeuvre, *Mountain Landscape after a Soaking Rain* should be a work of the artist's sixties, while this painting may date to his seventies.

Satō

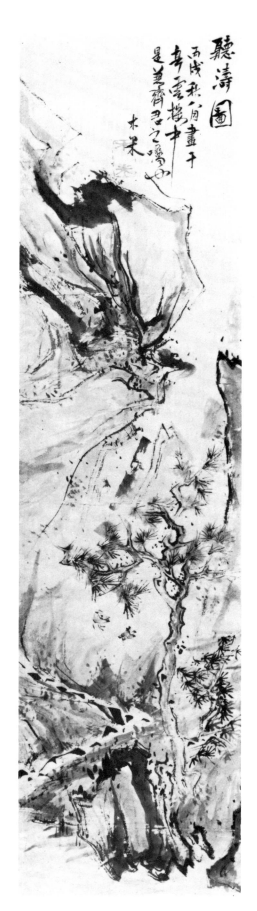

53 AOKI MOKUBEI
(1767–1833)

Listening to the Wind and Waves
Dated 1826
Hanging scroll; ink and light color on
paper
66.0 x 16.0 cm (26 x 6 1/4 in.)
Title with signatory inscription: *Listening
to the Wind and Waves: in autumn, the eighth
month of [1826], painted while I was at the
Teiun Pavilion at the request of the owner,
Kensai, Mokubei*
Rectangular relief seal: *Mokubei*
Wakimura Reijiro Collection, Kanagawa
Prefecture

Born the eldest son of a Kyoto restaurateur,
Mokubei studied the connoisseurship of
antiquities with Kō Fuyō, with whom he
also may have studied seal carving. With
the encouragement of Kimura Kenkadō
(1736–1802), an Osaka art patron, Moku-
bei, at about age thirty, was inspired to
become a potter. His interest in painting
may date from this period as well.

Mokubei painted mostly for his literati
circle, which included doctors, monks,
Confucian scholars, tea masters, wine-
makers, seal carvers, and other artists living
in Kyoto and Osaka. Fuyō and Kenkadō,
both of whom were close to Taiga, may
have introduced his paintings to Mokubei.

In any case, Tanomura Chikuden wrote in
Chikudensō Shiyu Garoku (Painting Record
from Chikuden's Studio) that sixty years
after the deaths of Taiga and Buson only
Mokubei preserved their spirit. Many of his
paintings indeed continue Taiga's composi-
tion, subject, and color sense.

This work, though small, is characteris-
tic of Mokubei's landscape style. The
elements twist and turn from the bottom to
the top of the long, narrow composition.
Lines and dots contrast with expanses of
ink or color wash. A scholar and his servant
appear weightless in the wind that rushes
through the pine boughs. The powerful
brush strokes are similar to those in *Prepar-
ing Tea above a Mountain Gorge* (dated
1824; Powers Collection, New York).
Mokubei admired the works of Ming
painters, such as Li Shida (fl. late sixteenth–
early seventeenth centuries), Zhang Ruitu
(fl. early seventeenth century), and espe-
cially the strangely angled cliffs of Mi
Wanzhong (fl. 1595–1628).

Listening to the Wind and Waves and
another painting, dated the fourth month
of 1826, *New Greenery with Rain* (Idemitsu
Art Museum), were both painted at the
Teiun Pavilion for a man named Kensai.
This may have been Senju Kensai (1784–
1854), the noted Kyoto Confucian scholar.

Satō

54 OKADA BEISANJIN
(1744–1820)

Magnolia
Datable to 1816
Hanging scroll; ink on paper
155.0 x 47.0 cm (61 x 18 1/2 in.)
Poem with signatory inscription: *Beiō at age seventy-three*
Rectangular intaglio seal: *En'un kuyō*; square intaglio seal: *Denkoku no in*; square relief seal: *Shigenshi*; square intaglio seal: *Issui isseki*
Takahashi Haseo Collection, Yamagata Prefecture

The events of Beisanjin's early years are unknown, but by 1775 he had opened a rice shop in Osaka, and his paintings had received some measure of recognition in the city. Sometime before 1790 he was employed by the Tōdō clan and had moved to their residence. His friends by then included Kimura Kenkadō, Uragami Gyokudō, Rai San'yō, Tanomura Chikuden, and other literati. Many works from this period survive. Sometime before 1810 he severed his connection with the Tōdō domain and became a recluse.

Beisanjin was a self-taught painter. Chikuden wrote in *Chikudensō Shiyu Garoku* that, although his painting "followed Huang [Gongwang, 1269–1354], he created his own style." Beisanjin's landscapes, like those of Dong Qichang, who also emulated Huang, have a decidedly abstract character both in form and brush stroke. This characteristic imparts an unusual flavor to his bird-and-flower paintings as well.

The two works in the exhibition (see also cat. no. 55) are among the most powerful of Beisanjin's flower paintings. A spring magnolia blossoms here behind an odd-shaped rock from China's Lake Tai region in Jiangsu Province. This fresh vision of a flower subject in ink, with its contrast between white paper and twisting, ropelike brush strokes of stems and rock is not found elsewhere in Japanese or Chinese painting. According to Beisanjin's inscription, he could not think of an appropriate poem to accompany his painting. His son, Okada Hankō (1782–1846), composed the verse that Beisanjin included here.

A taste of Zen in pale ink,
The glow of spring touches the flower petals.
Will they appreciate the beauty of my verse
And a poem about white snow in springtime?

Satō

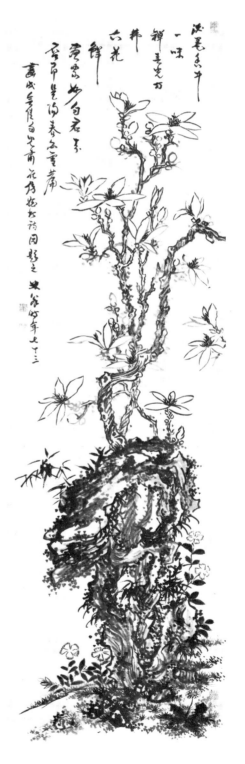

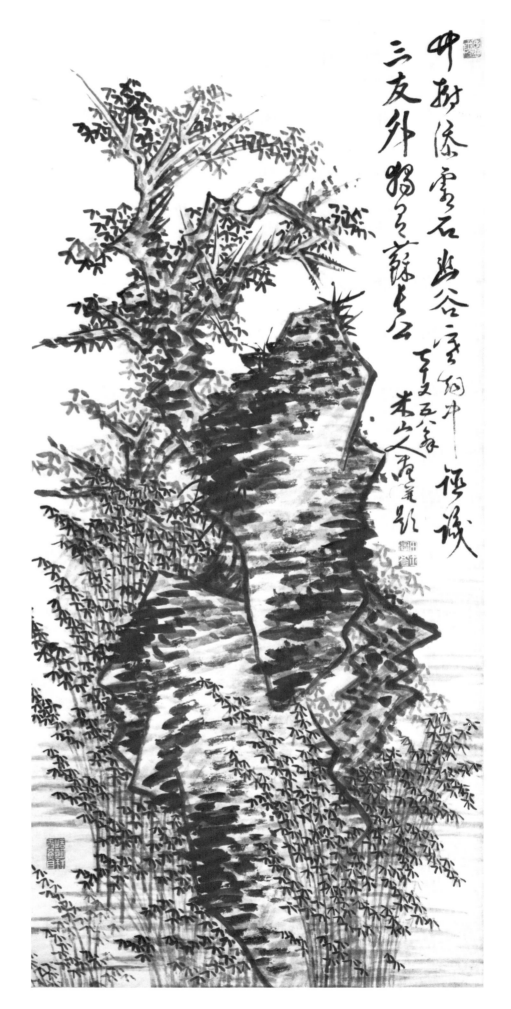

126

55 OKADA BEISANJIN
(1744–1820)

Bamboo and Rock
Datable to 1818
Hanging scroll; ink and light color on
paper
116.8 x 53.2 cm (46 x 21 in.)
Poem with signatory inscription: *Painted
and inscribed by the old man Beisanjin at age
seventy-five*
Square intalgio seal: *Fūryu zaika*; double
rectangular intaglio seals: *Denkoku* and
Shigen; rectangular intaglio seal: *Meishu o
sute gyomoku o rōsu* (I discard masterpieces
and play with forgeries)
Wakimura Reijiro Collection, Kanagawa
Prefecture

Like *Magnolia* (cat. no. 54), *Bamboo and
Rock* is also a masterpiece of Beisanjin's late
years. Here the artist rendered the tradi-
tional subject in an unusual style. The rock
in particular, defined by heavy outline and
short, dark horizontal strokes, recalls the
style of Zhu Da. It is not known whether
Beisanjin or any of his contemporaries
actually knew of Zhu Da, yet works
transmitting his style must have been im-
ported to Japan, since reflections of it
appear in the works of Beisanjin, Jakuchū,
and Kyōsho.

The tree that seems to grow from the
rock spreads its branches wildly, while the
bamboo leaves resemble the footprints of a
bird in their random, repetitive patterning.
Looking every bit like a child's painting,
Bamboo and Rock confirms Chikuden's
description of Beisanjin's style as possessing
an archaic awkwardness; the painting
appeals with childlike naivete:

> Bamboo and trees are beside a frosty
> rock
> In a secluded valley, amidst wintry
> clouds.
> Of those who do not slander the three
> friends
> There is only Su Dongpo.*

Satō

*In *Chikudensō Shiyu Garoku*

奉祝
鐵翁禪師笑正
佛田生憲

128

56 TANOMURA CHIKUDEN
(1777–1835)

White Clouds and Verdant Mountains
Datable to 1827
Handscroll; ink and light color on paper
24.7 x 182.0 cm (9 3/4 x 71 5/8 in.)
Three inscriptions signed: *Offered to the Zen Master Tetsuō, who laughs as he corrects it, Chikuden Seiken*
Double square intaglio seal: *Ken in*; oval relief seal: *Shinsen fūdo*
Tokyo National Museum

Chikuden was born into the family of physicians who served the Oka clan of Bungo (now Oita Prefecture). A Confucian, he became headmaster of the domain school, but in 1811–12 local peasants rose in rebellion. In 1813 Chikuden resigned from his duties when his proposals for reform were rejected. Later he often traveled to Osaka and Kyoto, devoting himself to poetry, calligraphy, and painting. As an intellectual who was the very model of a Chinese literatus, Chikuden fully understood the theories of China's orthodox Southern School. His paintings are primarily drawn in fine, delicate lines with a minimum of ink wash. This handscroll with its moist dots and washes is an exception.

Chikuden resided in Nagasaki in 1826–27 and there studied contemporary Chinese culture. His painting progressed rapidly after this stay. *White Clouds and Verdant Mountains*, produced in Nagasaki, prob-

ably resulted from an encounter with Mi-style Chinese paintings. Chikuden's second inscription, describing the circumstances of its creation, agrees fundamentally with a record in the author's *Jiga daigo* (Inscriptions on My Paintings). There he calls this work *Colored Landscape Handscroll in the Manner of Little Mi*. Perhaps this painting is a distant reflection of Mi Youren's *Cloudy Mountains*, though Mi's attention to composition and beautiful color is something that had long since vanished from the Chinese paintings that Chikuden might have seen. Nevertheless the artist managed to revive his motifs and brush styles to integrate houses, mountains, and white clouds.

The painting was given to the Zen master Tetsuō (1791– 1871) of Shuntokuji, who was himself a devoted follower of Qing painting.

Satō

57 NAKABAYASHI CHIKUTŌ
(1776–1853)

Streams and Mountains Deep and Distant
1790s
Hanging scroll; ink on paper
119.0 x 42.5 cm (46 7/8 x 16 3/4 in.)
Signatory inscription: *Hisshō*
Square intaglio seals: *Seishō no in*, *Azana Hakumei*, and *Chikutō*
Yabumoto Kōzō Collection, Hyōgo Prefecture

Chikutō, the son of a Nagoya doctor, first studied painting with Yamada Kyūjō (1747–93), a Nagasaki-school artist. His artistic career received its initial stimulus from Kamiya Ten'yū, a wealthy miso and soy sauce merchant, who collected old paintings and introduced the young artist to his literati friends. At Ten'yū's home, Chikutō gained valuable experience copying the collection. Later, having begun an independent career as a painter at age twenty-two, he discovered his writing talent and began composing treatises on painting.

Traditionally Chikutō is thought to have called himself Hisshō or Jōshō during his stay with Ten'yū; only upon leaving did Ten'yū give him the pseudonym Seishō. This painting signed Hisshō, but bearing a Seishō seal, would seem to discredit that traditional account. It is obvious that the work is from the artist's early period. The solid, blocky forms of the mountains suggest that Chikutō was familiar with the works of Tang Yin (1470–1523); they contrast markedly with the saturated ink dot Mi-style landscapes of the artist's later years.

Chikutō first visited Kyoto in 1802, moving there in 1815 to devote himself to the study, imitation, and inspiration of orthodox Southern School painting. While living in Kyoto, he copied twenty-six Ming and Qing paintings, among them three works by the late Ming artist Zhang Hong (1577–1668), who often painted real places "topographically." Chikutō did not pursue this interest in naturalism. In general, his landscapes have a strong element of abstraction. Depictions of actual scenery, such as Mount Fuji, nevertheless form a separate category of his work.

Satō

58 YAMAMOTO BAIITSU
(1783–1856)

A Stream Descends amid Dense Bamboo
Circa 1850
Hanging scroll; ink on satin
130.5 x 51.3 cm (51 3/8 x 20 1/4 in.)
Signatory inscription: *Baiitsu Yamamoto Ryō painted this at the southern residence of Yūchiku Sōro.*
Rectangular intaglio seal: *Meikei*; square intaglio seal: *Ryō in*; square relief seal: *Baiitsu*
Nagoya Municipal Museum, Aichi Prefecture
Important Art Object

Baiitsu received the patronage of Kamiya Ten'yū, as Nakabayashi Chikutō had. After Ten'yū's death, Baiitsu accompanied Chikutō to Kyoto but did not settle there. Having traveled to western and northern Japan, he returned to his native Nagoya, visiting Kyoto and Edo from time to time. The son of a sculptor, Baiitsu, is said to have studied with Yamamoto Rantei (fl. mid-nineteenth century), a Kanō-trained Ukiyo-e artist, and with Chō Gesshō (1772–1832), a Shijō-style painter.

Like most literati artists, he frequently copied Ming and Qing paintings and was skilled at reproducing the qualities of his models. This painting is representative of Baiitsu's style. For it he may have consulted a work like Li Shida's *Sound of a Spring amid Bamboo* (Tokyo National Museum). Yet even if this work has something of the character of a copy, it has surpassed its putative model in expression. An acute sense of atmospheric change and of deep distance pervades this scene, created through the subtle interplay of ink and the sheen of satin. The textured bamboo groves are marvelously drawn.

Satō

59 TAKAHASHI SŌHEI
(c. 1804–35)

Dragonfly on Bamboo
Dated 1831
Hanging scroll; ink and light color on
paper
109.0 x 31.7 cm (42 7/8 x 12 1/2 in.)
Poem with signatory inscription: *In the
tenth month of [1831] I drew this at
Kyōchuyūkashō. Sōhei U*
Double-bordered oval relief seal: *Sōhei*;
rectangular relief seal: *Kōu*
Hasegawa Yoshio Collection, Yamagata
Prefecture

Sōhei came from a merchant family in
Bungo (now Ōita Prefecture). At nineteen
his painting talents were discovered by
Tanomura Chikuden, and he came to
spend time at the latter's residence. Like
Chikuden, Sōhei's friends included numer-
ous Kyoto and Osaka bunjin, among them
Rai San'yō and Uragami Shunkin.
Chikuden's hopes for his student were
great. Numerous letters from Chikuden to
Sōhei provide valuable criticism and
instruction in painting. They make refer-
ence as well to the younger man's frailty,
which led to an early death. In 1833, having
heard a false rumor that Sōhei had died,
Chikuden included a line of praise about
his student in one of his painting treatises.

Sōhei, who preferred bird-and-flower to
landscape painting, usually imparted a feel-
ing of delicacy to his works. The precar-
iously balanced rock drawn in fine texture
strokes echoes Chikuden's style, but the
beauty of Sōhei's light ink and color em-
phasizes the differences between the hard
rock and soft bamboo, a mark of his own
style. The inscription reads:

> In the late afternoon sun not a soul stirs
> in the streets.
> Only a dragonfly perches atop the sharp
> bamboo.

This work beautifully captures Edo-period
sensitivity to transient nature and may also
reveal Sōhei's thoughts about his own frag-
ile existence.

Satō

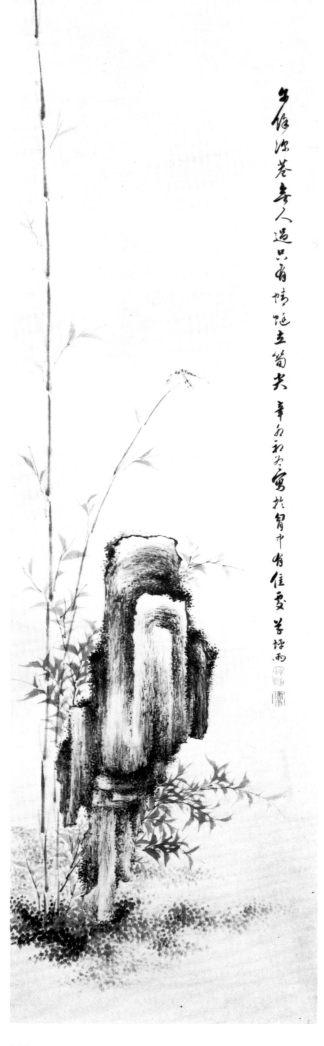

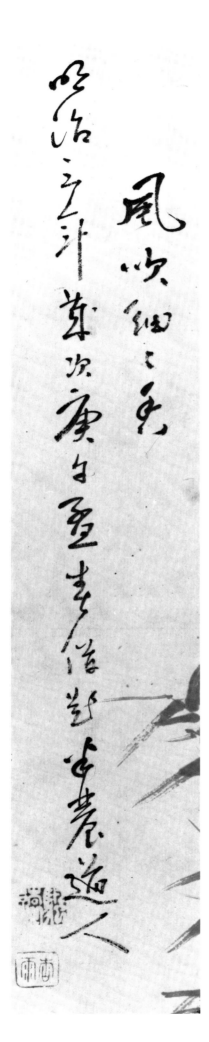

60 HOASHI KYŌU
(1810–84)

Wind Stirs a Delicate Fragrance
Dated 1870
Hanging scroll; ink on paper
168.1 x 21.3 cm (66 1/8 x 8 3/8 in.)
Title with signatory inscription: *Wind Stirs a Delicate Fragrance: first month of [1870] [painted] and inscribed by Hanno dōjin*
Square intaglio seal: *Hyōen*; square relief seal: *Kyōu*; rectangular intaglio seal: *Shichisekinada no chōsha*
Ogino Kyūjirō Collection, Okayama Prefecture

Born the son of a wealthy farmer in Bungo (now Ōita Prefecture), at age fifteen Kyōu became Tanomura Chikuden's pupil. He studied Confucian subjects as his teacher advised and traveled to Osaka and Kyoto, where he studied painting and poetry with Shinozaki Shōchiku (1781–1851), Uragami Shunkin, and Rai San'yō. He also visited Nagasaki, then returned to Kyoto, where he became acquainted with Nukina Kaioku (1778–1863), Okada Hankō, Nakabayashi Chikutō, Gotō Shōin (1797–1864), and other Nanga painters. Kyōu returned to his native region upon receiving news of the death of Chikuden and rarely traveled afterward.

His master's influence is felt strongly in Kyōu's landscape paintings. The wit of this ink bamboo, however, is absent from most of his other works. The design of tall, straight stalks contained within an extremely elongated format recalls compositions by Suzuki Kiitsu (1796–1858), a somewhat older Rinpa-school painter.

Satō

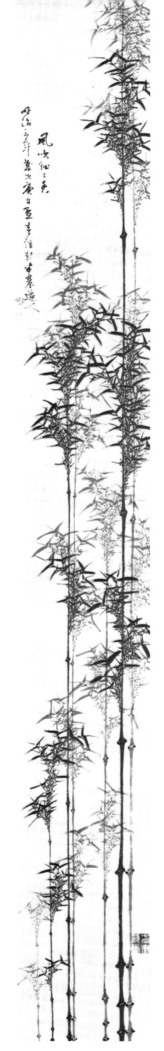

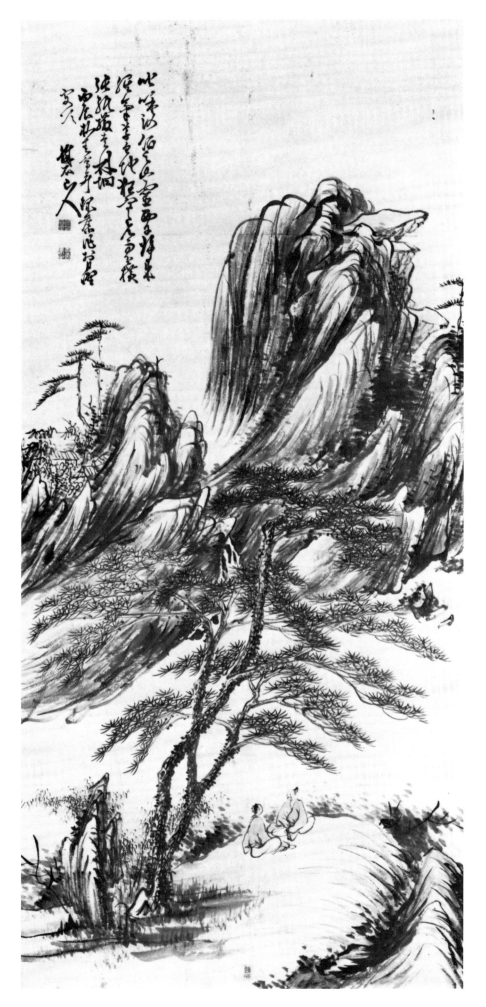

61 FUJIMOTO TESSEKI
(1816–63)

Sages beneath Twin Pines
Dated 1856
Hanging scroll; ink and light color on paper
128.3 x 56.6 cm (50 1/2 x 22 1/4 in.)
Poem with signatory inscription: *In the third month of [1856] I painted and inscribed this old work while at Hino [illegible character]. Tesseki sanjin*
Square intaglio seals: *Gen Shinkin in* and *Kibi danshi*; rectangular relief seal: *Tesseki*
Ogino Kyūjirō Collection, Okayama Prefecture

At the end of the Edo period a movement arose to spurn the demands of foreign powers and restore the country to imperial rule. One of the most vociferous proponents of these sentiments, was Fujimoto Tesseki, who sought to overthrow the decaying Tokugawa regime by military force. Born in Okayama, Tesseki left feudal service in 1840 to move to Kyoto. For the next eleven years he traveled throughout the country, and upon returning to Kyoto began to air his political views. In 1863 he joined the Tenshugumi loyalist faction, which was soundly defeated by government forces. He died in battle at Totsugawa.

Most of his works are landscapes painted in a coarse style. In this characteristic scroll the mountains bend as if yielding to a tempest, while the foreground remains quiescent. Strokes piled up in well-ordered clusters enliven the picture surface. The conventional subject of sages engaged in contemplative discourse seems at first incongruous in view of Tesseki's stirring career.

The artist studied painting with Itō Kachiku (1805–81), a follower of Uragami Shunkin. He may also have received instruction from Tetsuō during a visit to Nagasaki.

Satō

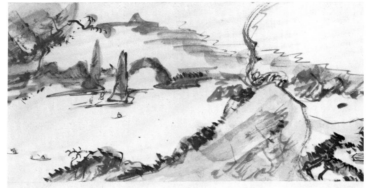

62 HOSOKAWA RINKOKU
(1779–1843)

Landscape
Dated 1831
Handscroll; ink and light color on paper
19.5 x 401.0 cm (7 5/8 x 157 7/8 in.)
Signatory inscription: *On a fine day [in
1831] I visited Shūgan senshi [Koishi Genzui
(1784–1849)] at his Yōsekkyo dwelling. He
asked about the countryside that I had passed
through, so I painted this landscape to take the
place of words. Rinkoku sanjin Kiyoshi*
Oval relief seal: *Rinkoku*; round relief seal:
Kiyoshi
Colophon by Oda Kaisen (1785–1862)
Kyūridō Bunko, Kyoto

In 1831, en route to his native village, Rinkoku, a lifelong wanderer, stopped in Osaka. From there he accompanied Osaka literati, among them Koishi Genzui, Rai San'yō, Uragami Shunkin, and Oda Kaisen to Tsukigase in Nara, a spot noted for its plum blossoms. According to Rinkoku's inscription, this handscroll depicts scenery of places that he visited. Unfortunately the opening section of the scroll has been lost. It may have begun with a title or more painting.

Not surprisingly, Kaisen's colophon identifies the red-robed figure as the artist, for as Tanomura Chikuden wrote of Rinkoku: "Using a saturated brush, he paints freely according to whim, with no practice beforehand. Amazingly, his figures all look like the artist himself."*

With Ike no Taiga, Japanese literati

painting had diverged from its Chinese sources in the use of light color washes in landscapes. Ignoring conventions, Rinkoku too employed ink and light colors to produce scenes expressive of his love for travel. This handscroll ranks with the artist's 1835 landscape handscroll as his finest work.

Rinkoku is best known as a seal carver. An example of his work is Chikuden's double-bordered, oval relief seal impressed on *White Clouds and Verdant Mountains* (cat. no. 56). Born in Sanuki (now Kagawa Prefecture), Rinkoku studied seal carving with Abe Ryōzan and painting with Nagamachi Chikuseki (1747–1806).

Satō

*In *Chikudensō Shiyu Garoku*

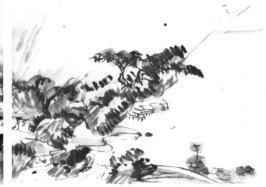

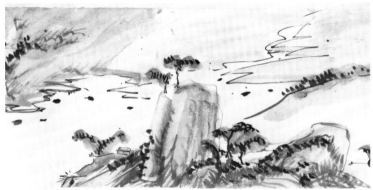
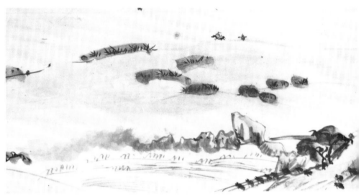

林良山人以鐵事擇扗
天下如其書篆到之妙
拳末七卧做葉圖子待
余言也副眼時但畫
山水之閒日少妙取末屬
書之追書高將為妙人
語書喜衍訪月擦疲足
之人招余出欽坭写
作此巻书故誣信喜
嘉外之畫隨意寄收
山高樹紫水子屋棋蓮
窒恰二昨潭扶雁起扗
古國郡籍硏示教繪
高也山人令日書人晦名
水擇人策書衣人閒之
回是余也笃名枚其
高如此然風神孙荘
名書韵多遂掌一張依之氣
閒氣易得之樂余圖書室
糊點点故扗圖彩繪之
能身放扗圖彩繪余
外今親以之人可華
莫扗人月失遙趨池

語扗書尾
辛和三花朝前二日
友人居侯墨蔵風

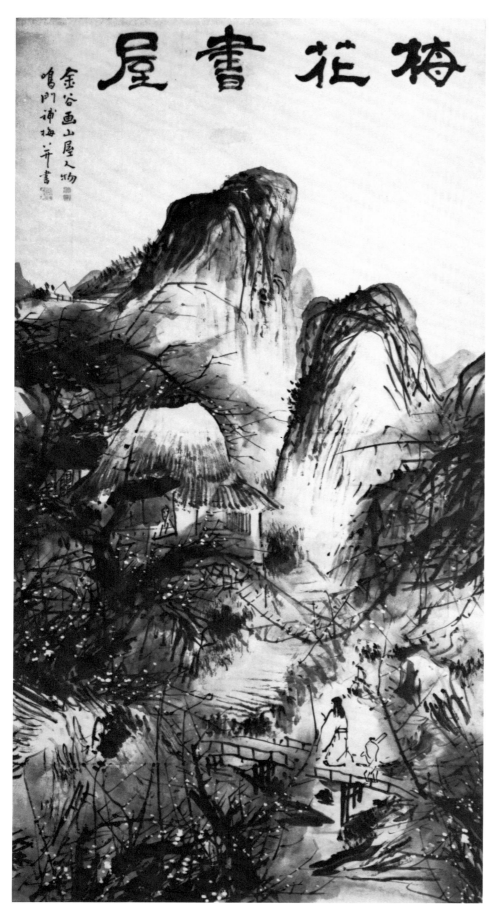

63 YOKOI KINKOKU
(1761–1832)
and SUZUKI MEIMON
(d. 1840)

Plum Blossom Study
Circa 1800
Hanging scroll; ink and light color on paper
182.0 x 97.0 cm (71 5/8 x 38 1/4 in.)
Title with signatory inscription (Suzuki):
Plum Blossom Study: Kinkoku painted the study and figures, while Meimon added plums and calligraphy.
Double rectangular intaglio seal: *Kinkoku*; square relief seal: *Meimon gyo in*
Kaizōji, Aichi Prefecture

As a child Kinkoku was sent to his uncle's temple in Osaka, escaping after a period of mischief. Subsequently he wandered between Edo and Nagasaki. His autobiographical writings describe him as once having been an ascetic mountain dweller, who, paradoxically, indulged in the pleasures of wine and the flesh. During the 1790s the artist settled in Nagoya, remaining for about twenty years. His collaborator on this work, Suzuki Meimon, was a native of Awa (now Tokushima Prefecture).

In this painting a lofty scholar visits a thatched hut surrounded by a thicket of plum blossoms: a subject with a venerable history in Chinese and Japanese literati painting. While Kinkoku often copied the works of Yosa Buson, whom he greatly admired, his brush style is usually wilder and stronger. Here Meimon responded to Kinkoku's energy and added spiky plum branches to enrich the work.

Although *Plum Blossom Study* is undated, it may be a work of Kinkoku's Nagoya years, from the 1790s to about 1820.

Satō

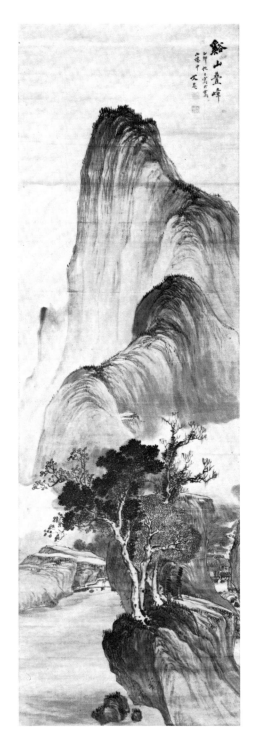

64 TANI BUNCHŌ
(1763–1840)

Streams and Mountains Layer upon Layer
Dated 1795
Hanging scroll; ink and light color on satin
101.5 x 38.9 cm (40 x 15 3/8 in.)
Title with signatory inscription: *Streams and Mountains Layer upon Layer: painted on an autumn day in [1795] at the Shazan Pavilion, Bunchō*
Square relief seals: *Tani Bunchō in* and *Tanishi Bunchō*
Yabumoto Kōzō Collection, Hyōgo Prefecture

Bunchō was a pivotal figure among bunjinga painters in Edo, his native city. His father, Rokkoku, had gained fame as a poet while serving as a retainer of the powerful Tayasu family. Bunchō also served the family and as a result came to the attention of the prominent official Matsudaira Sadanobu (1758–1829). He accompanied Sadanobu on trips to see ancient paintings in temples and shrines. After studying with the Kanō artist Katō Bunrei (1709–82), Bunchō associated himself with Watanabe Gentai (1745–1822), a painter in the eclectic manner of Nakayama Kōyō. He also studied Chinese painting with Kitayama Kangan (1767–1801) and had some exposure to imported Chinese and Western works. Bunchō's own students included Watanabe Kazan and Tachihara Kyōsho.

Although Bunchō painted in a great variety of styles, this work must be counted among his most orthodox Southern School-style creations. The undulating mountain ridge enlivened by the shiny satin ground may be derived from Ming paintings, such as those of Tang Yin and Wang Jian. Yet compared with the works of either Buson or Mokubei, literati painters of Kyoto who experimented with the same materials, this work by Bunchō lacks any distinguishing traces of the artist's personality. Painted well before such artists as Gyokudō, Mokubei, and Chikuden modified the Kyoto Nanga styles, its regulated brush strokes and cool color harmonies do not depart from Chinese models. Bunchō, active until the beginning of the nineteenth century, later transformed his own delicate style into a more expressionistic vision.

The Shazan Pavilion of the artist's inscription was his studio.

Satō

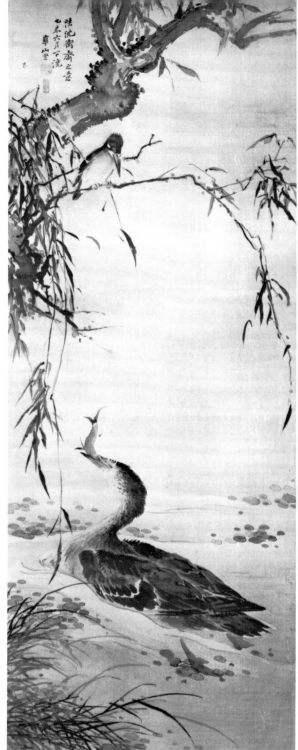

65 WATANABE KAZAN
(1793–1841)

Cormorant Catching a Fish
1840?
Hanging scroll; ink and color on silk
110.4 x 42.0 cm (43 1/2 x 16 1/2 in.)
Signatory inscription: *My painting method
follows Shen Hengzhai [Nanpin]. Painted in
the sixth month of [1835] by Kazan Nobori*
Square relief seal: *Watanabe Nobori in*; rectangular intaglio seal: *Ōho*
Yabumoto Sōshirō Collection, Tokyo

In 1839 the Tokugawa government rigorously suppressed scholars of the progressive "Dutch Learning" (*Rangaku*). Kazan was subjected to house arrest at his native Tahara domain in Aichi Prefecture. During this period he ostensibly refused to sell his paintings, but he nevertheless created works that his friends continued to sell secretly for him. According to a passage in his diary, he gave Suzuki Shunzan (1801–46?) two paintings on the first day of the seventh month of 1840: a colored landscape and a picture of a cormorant catching a fish. If this is the painting mentioned in the diary, which seems likely, the actual year of execution might have been 1840. Several

works by Kazan from his period of incarceration were similarly backdated.

In his inscription Kazan claimed to have been painting in the style of Shen Nanpin, and a work by the artist dated 1838 is, in fact, in a style close to Nanpin's. In it a kingfisher, perched on a willow, watches fish in the river below. In this painting, however, the kingfisher glares at a cormorant swallowing his intended prey. Perhaps Kazan saw the cormorant as a metaphor for the Tokugawa government that had in similar fashion deprived him of his livelihood. Whatever his reasons, Kazan transformed his earlier composition by injecting greater tension. The mature

brushwork is a far cry from works of his youth, which were merely straightforward copies of Shen Nanpin-style compositions. The depiction of the cormorant, from its delicate lines to its broad ink surfaces, provides evidence of Kazan's acute observation of nature. Not only is this the finest of his bird-and-flower paintings, but it stands out among his works noted for their color by the unexpected use of ink wash.

This painting was formerly in the collection of the Komuro family, powerful patrons of Tani Bunchō and his students.

Satō

66 WATANABE KAZAN
(1793–1841)

Dog
Circa 1841
Hanging scroll; ink and light color on silk
120.8 x 50.2 cm (47 1/2 x 19 3/4 in.)
Signatory inscription: *Painted on the*
thirteenth day of the eighth month of [1837]
by Zuian koji
Rectangular intaglio seal: *Kazan*
Kurokawa Kobunka Kenkyūjo, Hyōgo
Prefecture

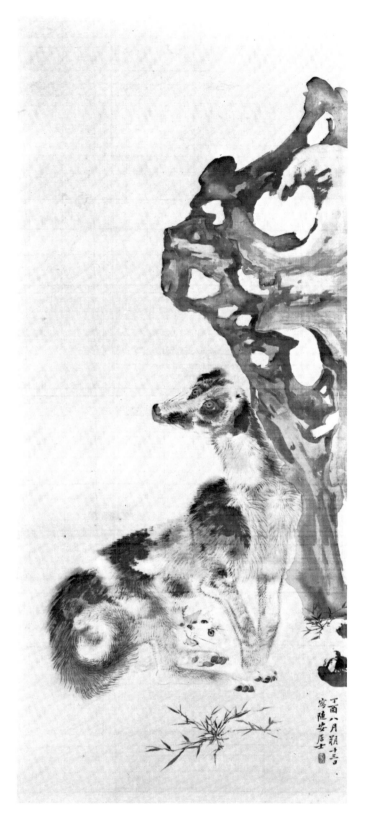

Although this scroll is dated 1837, Kazan only began using the name Zuian koji after his incarceration in 1839. Thus, this is probably a falsely dated work of the artist's later years. A comparison with an album of his sketches reveals an identical dog, and together with other works indicates that the scroll was created in 1841. Indeed, if the month and day in the inscription are correct, the scroll may have been painted just two months before the artist committed suicide.

Precedents for the composition of a dog posed before a Taihu rock are to be found in works of the early Ming court, such as a hanging scroll by Bian Wenjian (fl.1420-40) in the Yanagi Takashi collection. In Kazan's work, ink has largely replaced color; the carefully shaded surfaces of the rock resemble a work (in the Osaka Municipal Museum) by the obscure Qing artist Hu Yuan. Kazan's fine drawing does not overcome the rather lifeless quality of the painting, and while this may result from trying to merge life drawing with a Chinese model, it is more likely a measure of the artist's troubled life. The look of the dog, the hole in the rock, and the seedy appearance of the grass all seem to evoke Kazan's frazzled condition.

Additional pertinent material has been discovered: a rough study sketch of the dog was reproduced in *Watanabe Kazan sensei kinshin zufu* (Illustrated Catalogue of Works Produced by Watanabe Kazan While in Confinement) published in 1941.

Satō

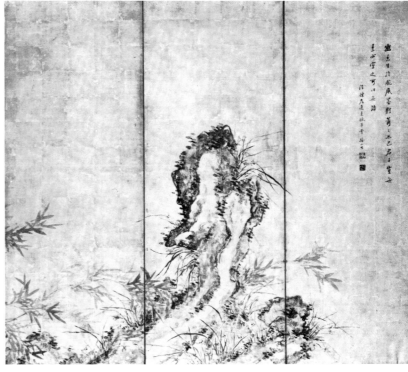

67 TSUBAKI CHINZAN
(1801–54)

The Four Gentlemen
Dated 1850
Pair of six-fold screens; ink and light color
on gold foil
Each 162.0 x 360.0 cm (63 3/4 x 141 3/4 in.)
Right screen
Poem with signatory inscription: *After*
Chen Laolien, Takkado Chinzan sei
Square relief seal: *Chinzan shiin*; square in-
taglio seal: *Chinzan*; rectangular relief seal:
Chinzanbō
Left screen
Poem with signatory inscription: *On an*
autumn day in [1850], after Baiyang shanren
[Chen Shun], Chinzan Hitsu
Square relief seal: *Chinzan shiin*; square in-
taglio seal: *Chinzan*; rectangular relief seal:
Chinzanbō
Imperial Household Collection

Chinzan was a bureaucrat in the Toku-
gawa government who, like Watanabe
Kazan, first studied painting with Kaneko
Kinryō. When Kinryō died (1817),
Chinzan became Kazan's pupil. Because
his governmental stipend proved insuffi-
cient, Chinzan, again like Kazan, was
forced to rely on his painting for additional
income.

Asano Baidō (1816–80), a student of
Chinzan, wrote that his teacher began by
painting in the fine and delicate style of
Zhang Qiugu (fl. in Japan 1871-88) but
changed in his late thirties. His mastery
was greatest in his late years with works
notable for their refined elegance, espe-
cially during the period from 1849 to 1853.
These screens of 1850 confirm Baidō's
testimony.

Plum, bamboo, orchid, and chrysan-
themum, symbols of the noble character of
bunjin, were nicknamed "the four gentle-
men." Although Chinzan painted the sub-
ject on gold foil, he did not strive for deco-
rative effects. Rather he used the gold to

impart a warm, painterly quality to the ink.
In one of his letters, he wrote: "Even when
it is painted in ink, bamboo is bamboo.
Even when it is painted in red, bamboo is
bamboo. Even when the essence of bamboo
still hides in the brush, the crisp wind alone
causes it to come forth. This is what is
meant by 'writing ideas' (*shai*). 'Painting
from life' (*shasei*), however, allows one to
succeed at writing ideas."

Chinzan used light color sparingly to
paint the wind-blown bamboo. The es-
sence of his style derived ultimately from
the naturalistic transformation of
mokkotsu by Yun Shouping (1633–90).
The inscription on the right screen indi-
cates that he followed Chen Hongshou
(1599–1652), while that on the left men-
tions Chen Shun (1483–1544). While it is
difficult to verify these claims, the style of
the chrysanthemum does recall Chen
Shun's.

Satō

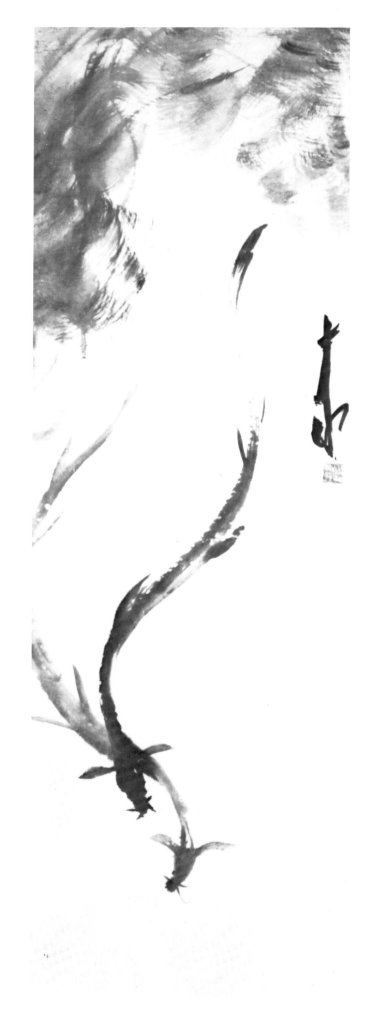

144

68 HAYASHI JIKKŌ
(1777–1813)

Two Eels
Early nineteenth century
Hanging scroll; ink on paper
126.6 x 40.0 cm (49 7/8 x 15 3/4 in.)
Signed: *Jikkō*
Square intaglio seal: *Jōbun shujin shi in*
Yamauchi Yūkō Collection, Tokyo

Hayashi Jikkō was born the eldest son of a sake brewer in Mito but was raised by his uncle, a dealer in soy sauce. Although he inherited his uncle's business, Jikkō's outlandish conduct led him to squander his family's holdings. Many of the artist's inscriptions betray his disaffection with society and reveal his rebellious personality.

The influences on Jikkō's work remain unknown. His freely brushed paintings of birds and flowers, frogs, insects, and ghostly apparitions exhibit extraordinary individuality, as do his landscapes and figures, when seen in context of works by his contemporaries. Although he has been likened to the Yangzhou Eight Eccentrics, his style also resembles that of early Qing painters of ink flowers and other subjects. The style of the Maruyama-Shijō school had reached eastern Japan by the 1790s and may have had some influence on Jikkō's training as well.

Here the artist painted two eels swimming in a river. His effortless brush strokes vary in intensity and saturation, describing the writhing eels. In the upper left, his brush, dextrously wielded, suggested muddy turbulence.

The painting of fish submerged in water, usually utilizing a mokkotsu technique, has a history in China from as far back as the tenth century. This painting should be seen as a variation on that theme, though its refinement may come from the Maruyama-Shijō school.

Satō

145

69 TACHIHARA KYŌSHO
(1785–1840)

Grapes
Dated 1835
Hanging scroll; ink and light color on silk
89.6 x 40.0 cm (35 1/4 x 15 3/4 in.)
Signatory inscription: *While thoroughly*
drunk in the ninth month of [1835], I painted
these grapes in a wild manner. In all the realm
there is only my name. Ha Ha. Retainer
Tachihara Nin
Square intaglio seal: *Tachihara Nin in*;
square relief seal: *Nin*
Bunkachō
Important Cultural Property

Most of Kyōsho's extant works exhibit cautious brushwork and dense compositions. These grape vines are much freer than his usual creations, exuberantly painted in ink and indigo. Here and there dark, dry ink was used for accent amid the intertwining tendrils. Light ink, saturated with water into which dark ink has been floated, defines the leaves. The grapes, in pale and dark indigo and ink, exhibit a rich harmony of light and shade. In the lower half of the composition the artist blew indigo onto the painting surface.

Kyōsho, a retainer of the Mito domain, joined Tani Bunchō's circle after moving to Edo. It is uncertain whether he studied with Hayashi Jikkō, but he seems to have had the opportunity to examine works by Li Shan (1686–1762), one of the Yangzhou Eight Eccentrics. The origins of Kyōsho's palette and brush methods may be found among the works of early Qing flower painters. Vines that fill the painting surface appear among the works of Zhu Da. While such influences rarely appear in Kyōsho's paintings, this freely brushed work, executed while the artist was intoxicated, surpasses any of his possible models. It is a most unusual example of Edo-period ink flower painting.

Satō

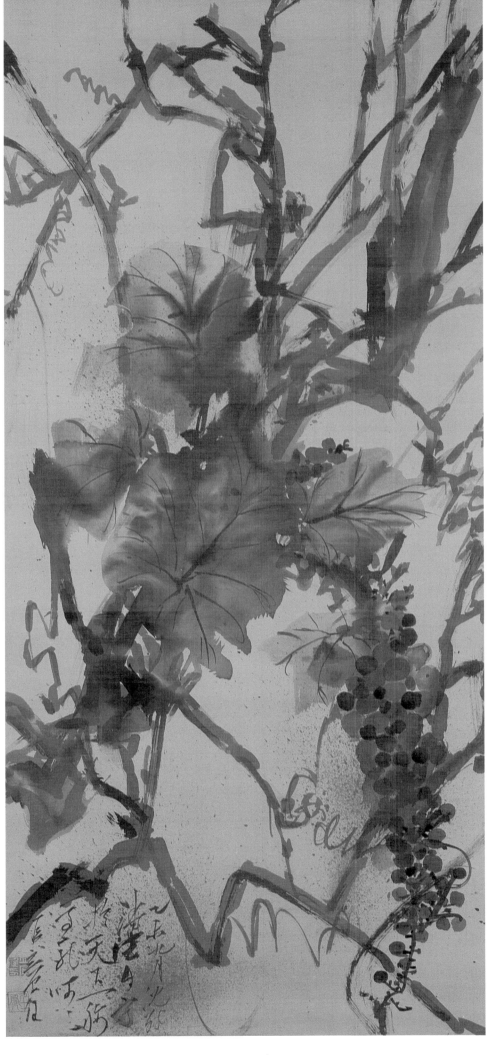

147

70 SHŌRIN SANJIN
(d. 1792)

Peonies
Late eighteenth century
Handscroll; ink on silk
37.3 x 342.2 cm (14 5/8 x 134 3/4 in.)
Signatory inscription: *Painted by Ringan*
Square intaglio seal: *Ringan no in*; square
relief seal: *Shōrin sanjin*
Title inscribed by Shibano Ritsuzan (1736–1807)
Yabumoto Kōzō Collection, Hyōgo
Prefecture

Born in Nagasaki, Shōrin sanjin studied painting with Kumashiro Yūhi (1712–72), a translator and Nagasaki-school painter, who had worked directly with Shen Nanpin. Active first in Kyoto and Osaka, by 1780 the artist had moved to Edo, where he gained some measure of fame.

The serene, yet free execution of the ink wash peony that opens this scroll calls Yūhi's famous *Chrysanthemum* to mind. The flowers that follow, however, employ brush and ink in painstaking imitation of a polychrome painting technique. Although it is doubtful that this was modeled on Shen Nanpin's style or even anything Chinese, the careful gradations of ink and outlines are reminiscent of post-Song paintings of the lotus-and-waterfowl theme.

The sources of this handscroll may be found in the works of Sō Shiseki (1712–86), a follower of Shen Nanpin. Shiseki's painting of a lion, based on a zoological treatise by John Johnstone (1603–75) published in Amsterdam in 1660, suggests that this type of painting may in fact be an attempt to imitate Western copperplate engravings.

Shibano Ritsuzan (1736–1807), who inscribed the title on this scroll, was a noted Confucian scholar in the service of the Tokugawa government.

Satō

71 ITŌ JAKUCHŪ
(1716–1800)

Roosters
Early 1760s
Two-fold screen; ink on paper
Each 139.4 x 62.4 cm (54 7/8 x 24 5/8 in.)
Square intalgio seal: *Tō Jokin in*; round
relief seal: *Jakuchū koji*
Kurokawa Kobunka Kenkyūjo, Hyōgo
Prefecture

It is recorded in *Jakuchū koji juzō no ketsumei* (Epitaph in Memory of Layman Jakuchū) that Jakuchū gave up imitating Chinese paintings to raise chickens, which he then drew from life. Fowl, particularly roosters, became his specialty, and many examples survive both in color and in monochrome ink. The earliest of these roosters in ink appear in the wall paintings of 1759 at Rokuonji and in a pair of screens of birds, flowers, and vegetables from the same year. The intentional inelegance of those Rokuonji works has been avoided in this screen, his finest example of roosters in monochrome ink. Characteristic of Jakuchū's technique is the drawing of each feather in blotted ink wash. Especially unusual is the rooster in the right panel, whose dappled black and white feathers are drawn with the same care as those in his polychromed paintings.

Satō

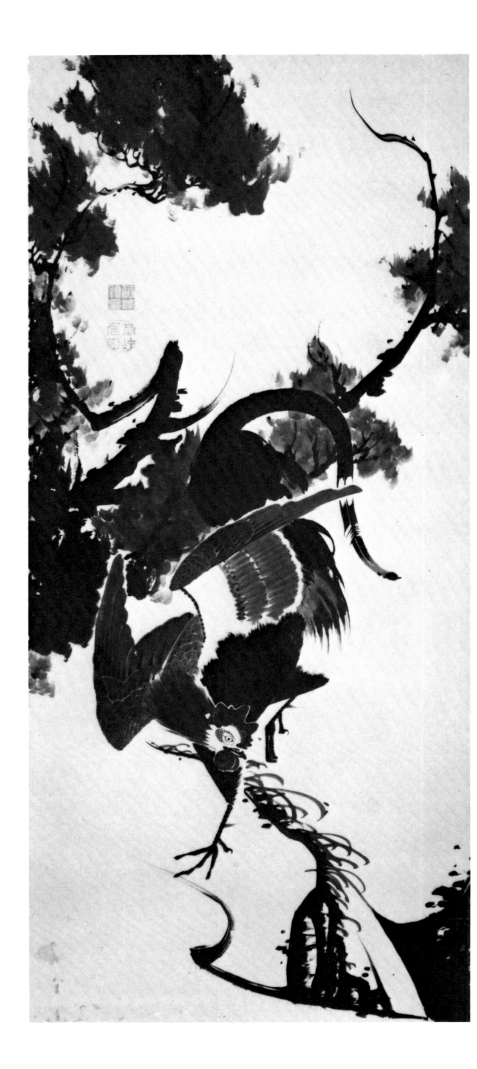

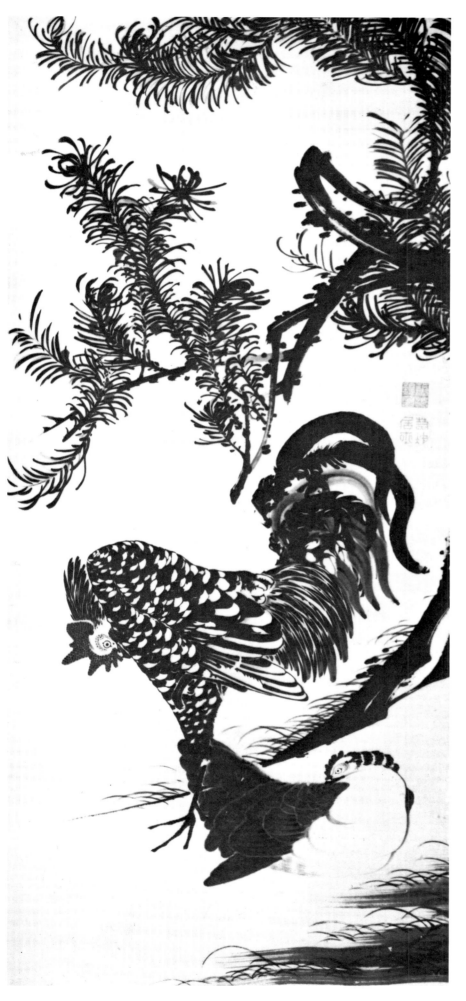

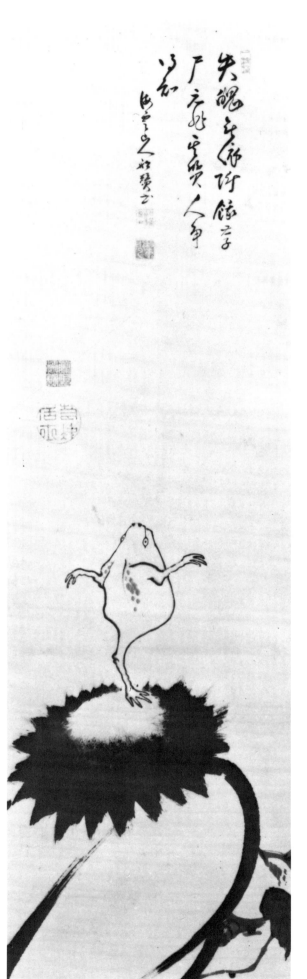

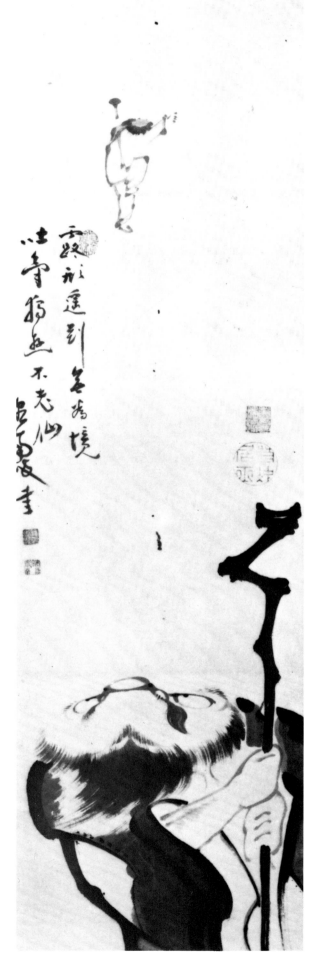

152

72 ITŌ JAKUCHŪ
(1716–1800)

The Daoist Immortals Tekkai and Gama
Late 1760s–early 1770s
Pair of hanging scrolls; ink on paper
Each 102.5 x 29.6 cm (40 3/8 x 11 5/8 in.)
Square intaglio seal: *Tō Jokin in*; round
relief seal: *Jakuchū koji*
"Gama"
Inscription by Gessen Jōtan (Kaiun,
d. 1769)
"Tekkai"
Inscription by Jakushō
Takahashi Kayo Collection, Kyoto

This pair of hanging scrolls depicts the Chinese immortals Gama and Tekkai (see cat. no. 25). In a famous pair of paintings (at Chionji, Kyoto) the Chinese artist Yan Hui (fourteenth century) portrayed these immortals with craggy face and threatening demeanor. Beginning with Sesson, however, Japanese artists preferred to portray them with benign, even jesting expressions.

Although this is the only playful portrayal of immortals among Jakuchū's known works, he was apparently fond of parodying classical themes. These two figures are especially humorous. A three-legged toad dances atop Gama's tonsured skull. Tekkai, turning his face to the sky, purses his lips to blow out his soul. Jakuchū's customary ellipses define their bodies with brushwork so forceful it seems to rend the paper.

One possible source for this painting may be Kōrin's *Hotei Kicking a Ball*. The composition of Hotei craning his neck at the ball he has just lofted skyward is quite similar to that of Tekkai. The encomia by two Zen monks are poems in praise of Tekkai.

Satō

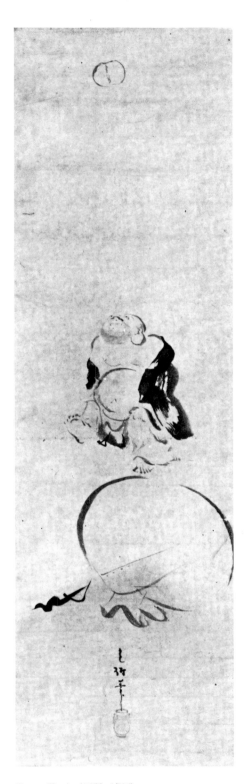

Ogata Kōrin (1658–1716)
Hotei Kicking a Ball
Late 1690s
Hanging scroll; ink on paper
102.4 x 29.1 cm (40 3/8 x 11 1/2 in.)
Private collection

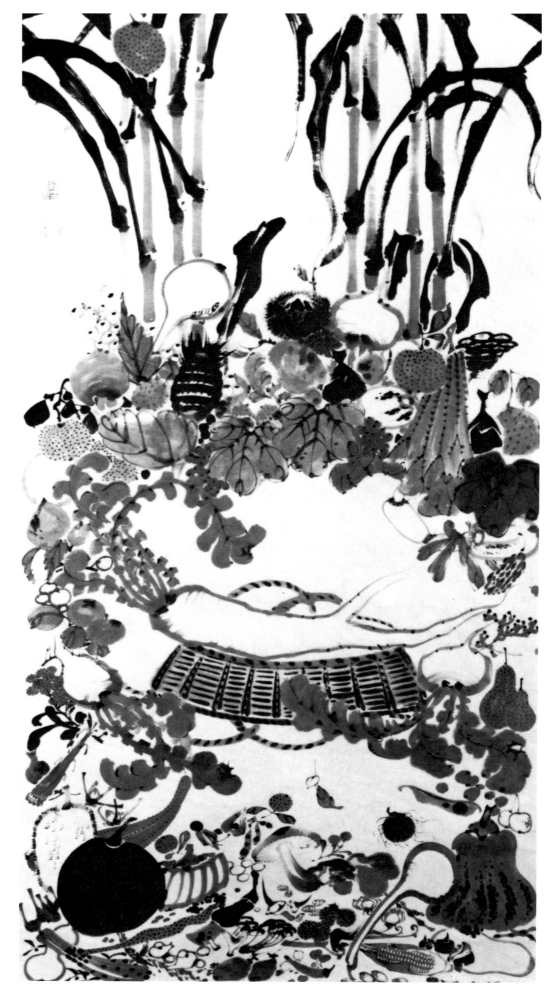

154

73 ITŌ JAKUCHŪ
(1716–1800)

Parinirvāna of a Radish
1770s
Hanging scroll; ink on paper
181.7 x 96.1 cm (71 1/2 x 37 7/8 in.)
Square intaglio seal: *Tō Jokin in*; round
relief seal: *Jakuchū koji*
Kyoto National Museum

Numerous versions of the death of Buddha
Sākyamuni survive in Japanese painting
from the eleventh century onward; this
work, one of the best examples of
Jakuchū's ink wash paintings, is an eccen-
tric variation on the theme. Fruit and
vegetables stand in for the figures of the
Buddha, his disciples, and the multitudes
that mourned the *Parinirvāna*. A daikon
(large, white radish) reclines on an over-
turned basket, while more than fifty fruits
and vegetables surround it "overcome by
grief." The persimmon, peach, turnip, cit-
ron, taro, eggplant, melon, lotus root, chest-
nut, bitter melon, pear, field pea, cherry,
squash, corn, horsetail, lily bulb, ginger,
mushroom, arrowhead bulb, nettle, hot
pepper, dried persimmon, fresh ginger,
yam, cucumber, bottle gourd, bladder
cherry, winter melon, and bamboo shoot
are clearly recognizable. Cornstalks take
the place of sal trees, while the citron at
upper left is meant to be Sākyamuni's
mother, Queen Māyā, who descends from
heaven to mourn his death.

Born the son of a greengrocer on Nishiki
Street in Kyoto, Jakuchū drew each and
every familiar fruit or vegetable with
knowing sensitivity. Ordinarily lifeless ob-
jects breathe and move as they strain to
look closely at Sākyamuni, fall to the
ground in grief, or bow in reverence. The
brushwork is never sluggish in its marvel-
ous contrasts of light and dark ink.
Although this painting may be seen as a
parody, Jakuchū's own Buddhist piety,
which bordered on animism, permeates the
work. His reverence palpably underlies his
fine sense of humor. Indeed *Parinirvāna of a
Radish* was a cherished possession of
Kyoto's Seiganji temple.

Satō

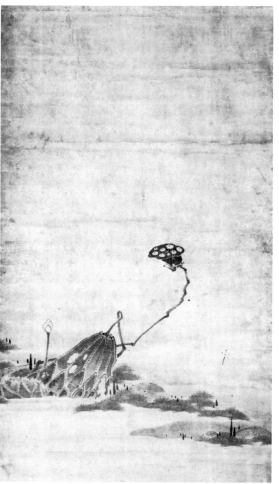

74 ITŌ JAKUCHŪ
(1716–1800)

Lotus Pond
Datable to 1790
Six fusuma panels remounted as hanging
scrolls; ink on paper
Each 158.5 x 89.5 cm (62 3/8 x 35 1/4 in.)
Right panel
Square intaglio seal: *Tō Jokin azana Keiwa*
Left panel
Square intaglio seal: *Tō Jokin in*; round
relief seal: *Jakuchū koji*
Saifukuji, Osaka

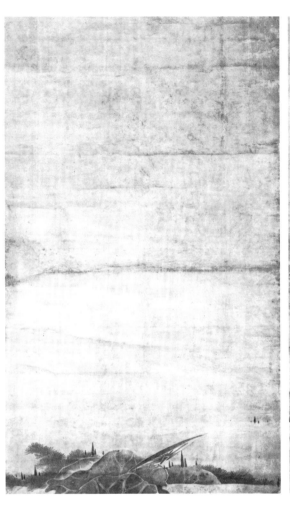

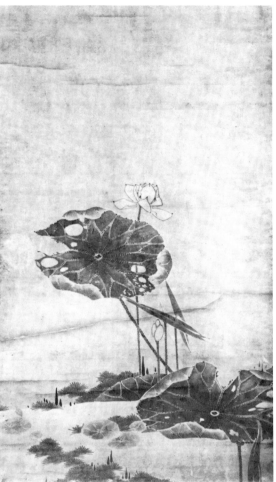

When Jakuchū's studio was destroyed in the great Kyoto fire of 1788, he may have moved to Osaka for a while. The Yoshino family became his benefactors and commissioned these six fusuma panels for Saifukuji, their family temple, in 1790. On the obverse Jakuchū painted brightly colored roosters, hens, and chicks cavorting against a gold foil background. But on the side enclosing the inner sanctum of the main Buddha hall, the mood abruptly shifts to this subdued monochromatic glimpse of late autumn lotuses. (As symbols of the Buddha and metaphors for his teachings, lotuses often adorned the devotional halls of Buddhist temples.)

The world expressed by these withered lotuses is tranquil, yet Jakuchū's odd angles and worm-eaten leaves somehow make these plants look as if they had grown on some distant planet. Jakuchū's early ink painting style, seen at Rokuonji, followed Chinese models from the Piling region of south China. Ink was applied in flat washes to create a mosaiclike quality. Although he abandoned this style after 1760, in his late years he once again adopted the subtle graded washes seen here. His contemporary, Hiraga Hakusan (1728–79), visited the ailing artist at Sekihoji in 1794. In *Shōsai hikki* (Shōsai's [Hakusan's] Notes) paintings of this style are described: "On the fusuma panels he had painted lotuses that looked like ink rubbings," suggesting forms left white against surrounding ink wash.

Satō

157

75 SOGA SHŌHAKU
(1730–81)

Kanzan and *Jittoku*
Circa 1759–64
Pair of two-fold screens; ink on paper
Each 169.2 x 185.0 cm (66 5/8 x 72 7/8 in.)
Kanzan
Signatory inscription: *Painted by Heian
Soga Jirō Fujiwara Kiyū*
Square relief seals: *Shōhaku*; square in-
taglio seals: *Kodō* and *Soga Kiyū*
Jittoku
Signatory inscription: *Painted by Kōen
Ranzan dōjin Soga Kiyū nyūdō Shōhaku*
Square relief seals: *Sogashi* and *Shōhaku*;
square intaglio seals: *Kodō* and *Soga Kiyū*;
Private collection, Hyōgo Prefecture

158

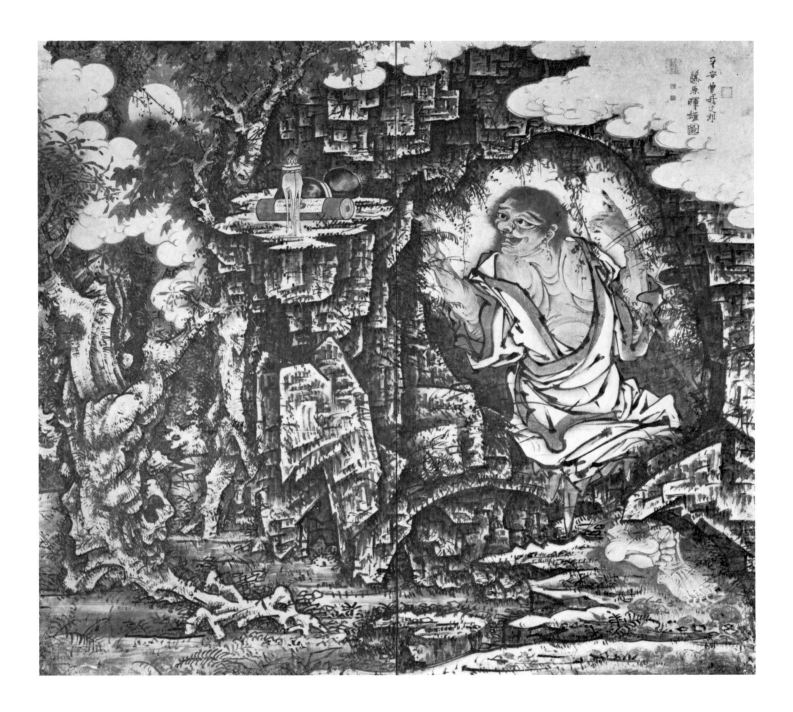

Although Shōhaku's *Kanzan* and *Jittoku* in Kōshōji temple are more famous, he painted this pair of screens first, when he was in his early thirties. Based on their style, composition, the calligraphy of the signatures, and the assortment of seals, these screens seem to date between 1759 and 1764. Fine, dense brush strokes cover the painting surface, creating an almost oppressive sense of power. The style of this work is close to the artist's *Assembled Immortals* (1764) screens, where ink landscape surrounds full-color figures. The "hacked-out," angular rocks that shelter Kanzan may also be found in the right screen of *Assembled Immortals*. A screen (pp. 160–61) depicting the immortal Kume Sennin, dated 1759 (Museum of Fine Arts, Boston), is similar in composition to

Kanzan: each figure sits in a cave beyond the protruding roots of ancient trees.

Certain elements in Shōhaku's screens do not appear elsewhere in the Japanese tradition of Chinese-style painting: the dramatic juxtaposition of lights and darks; the rippling lines of Jittoku's costume; or the mossy rocks from which the waterfall cascades. Perhaps these aspects of Shōhaku's work betray the influence of the late-Ming eccentric figure painter Chen Hongshou or the heavily dotted landscapes of Xie Shichen (1487–after 1567). As a close friend of Ike no Taiga, Shōhaku could have become aware of these currents in Ming and Qing painting.

Satō

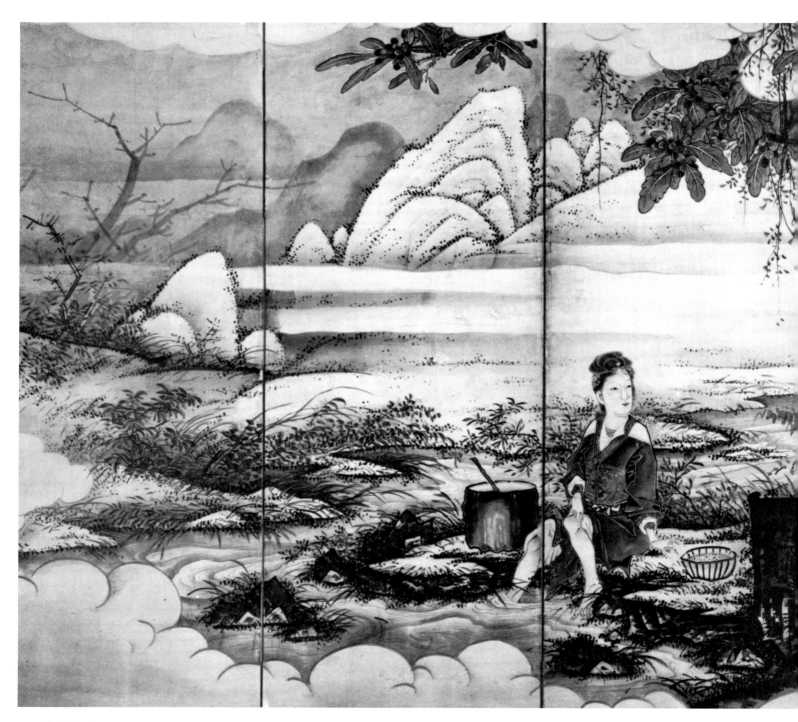

Soga Shōhaku (1730–81)
Kume the Transcendent and His Wife
1759
Six-fold screen; ink on paper
157.5 x 383.4 cm (62 x 151 in.)
Museum of Fine Arts, Boston

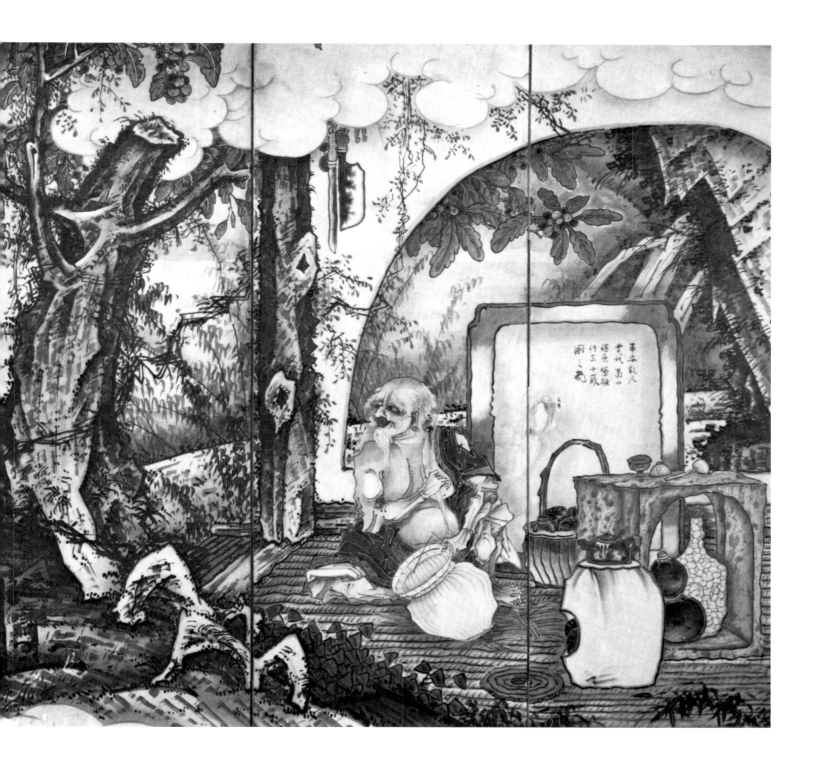

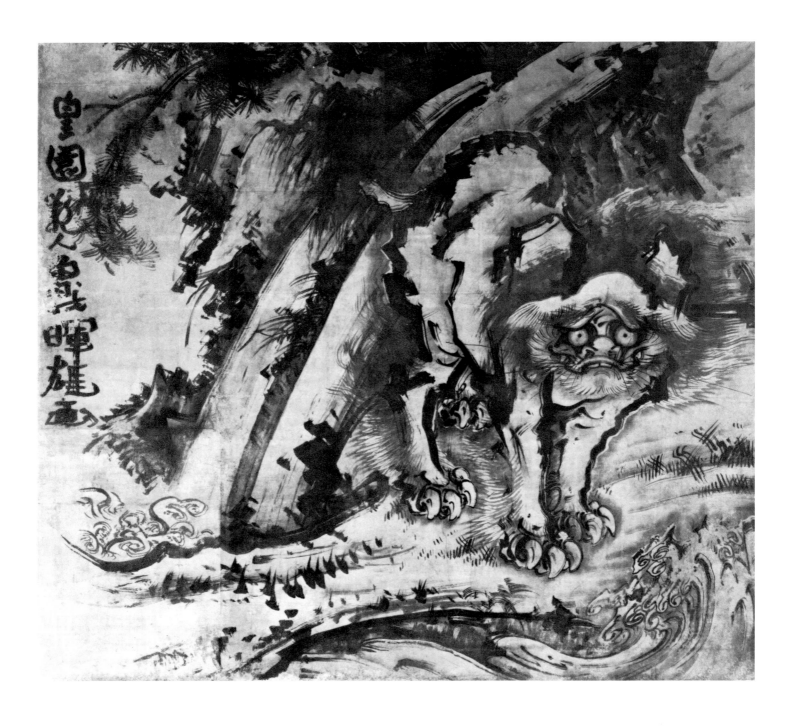

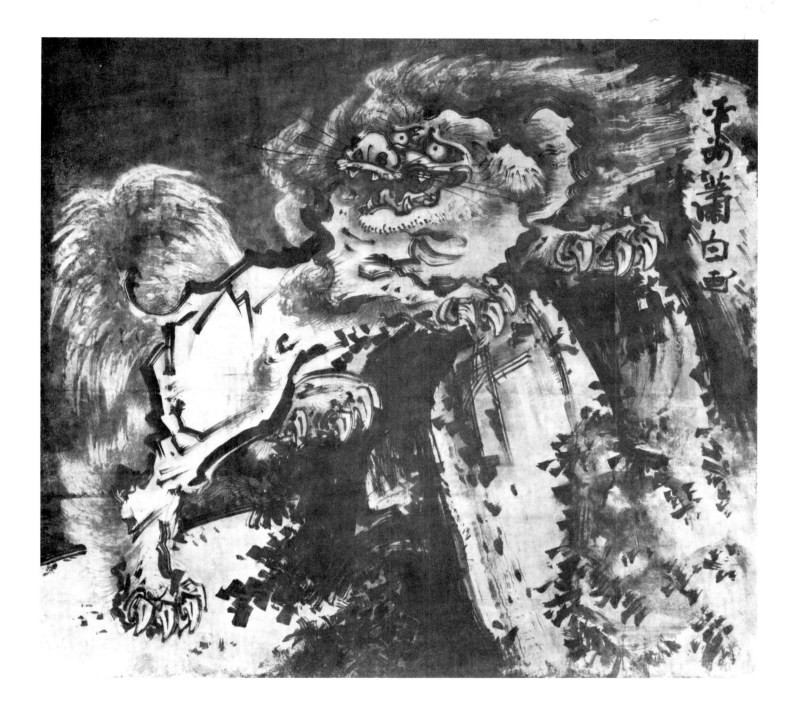

76 SOGA SHŌHAKU
(1730–81)

Chinese Lions
Circa 1764
Pair of hanging scrolls; ink on paper
Each 225.8 x 246.8 cm (88 7/8 x 97 1/8 in.)
Right scroll
Signatory inscription: *Painted by Shōhaku of Heian*
Left scroll
Signatory inscription: *Painted by Soga Kiyū, useless man of the capital*
Chōdenji, Mie Prefecture

These Chinese lions were originally pasted onto walls in the sanctuary of the main hall at Chōdenji, a Tendai temple on the outskirts of Matsuzaka City. The pair, one with its mouth open, the other with its mouth closed, flanked a tenth-century wooden devotional image. Shōhaku traveled to the Ise region on at least two occasions. The Chōdenji paintings probably date from his second visit, in 1764, since they are similar to works done while the artist was in his mid-thirties.

The ink painting of Shōhaku's thirties represents one of the richest and liveliest styles of Edo-period sumi-e. The brush, which scampered across the paper, conveyed in a rare heroic burst the wildness of the lions. They in turn have something of the expression of Sōtatsu's famous *Wind and Thunder Gods*, though Shōhaku aptly injected a sense of the fantastic, characteristic of Edo-period art, into his work.

Satō

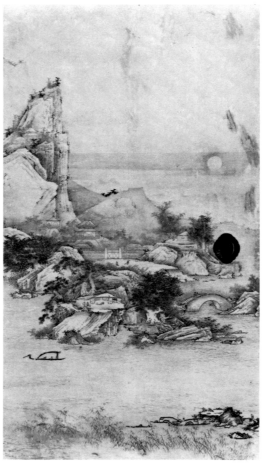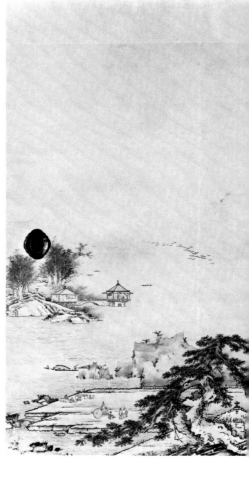

77 SOGA SHŌHAKU
(1730–81)

Pavilions in a Landscape
Early 1770s
Four fusuma panels; ink on paper
Each 168.7 x 92.5 cm (66 3/8 x 36 3/8 in.)
Right panel
Signatory inscription: *Painted by Soga Shōhaku*
Square intaglio seal: *Jasokuken Shōhaku*; square relief seal: *Soga shi*
Monogram
Osumi Yaemon Collection, Shiga Prefecture

The family residence for which these fusuma panels were made was located between two stations — Ishinobe and Kusatsu — on the old Tōkaidō highway. During the Edo period the family medicinal trade flourished, and its residence prospered as a teahouse and inn. Shōhaku must have lodged there during one of his journeys. These panels were painted for an upper chamber in the old inn; on the obverse is a composition of pine, bamboo, and plum, which decorated the adjoining room. Paintings of birds and flowers and those by the Chinese literatus Huang Shangu adorned

other areas of the inn.

By the 1770s Shōhaku had already given up his robust brushwork in favor of more delicate, brittle strokes. During this period he produced many landscape screens that incorporated motifs and styles from Kanō- and Unkoku-school paintings. Nevertheless he transformed his models to produce his own somewhat eccentric view of Chinese scenery. This landscape may depict the scenery of West Lake.

Satō

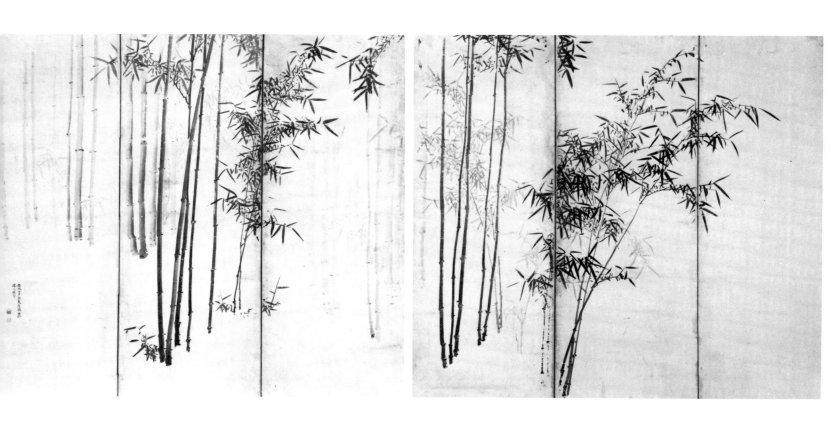

安永丙申季夏應舉畫於
圓光精舍

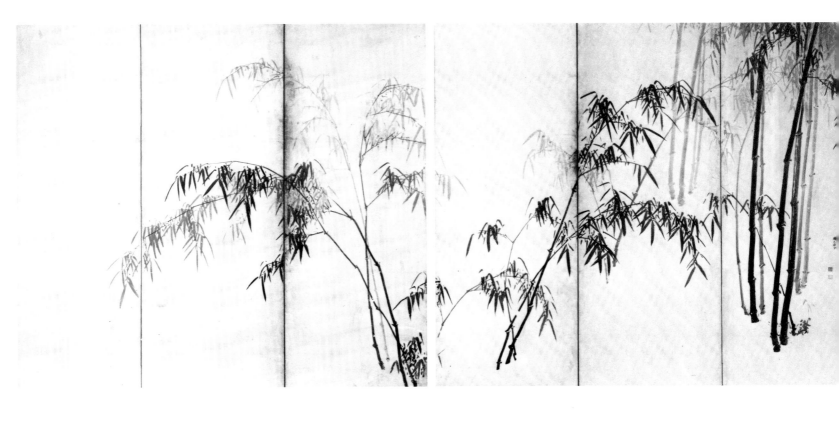

78 MARUYAMA ŌKYO
(1733–95)

Bamboo
Dated 1776
Pair of six-fold screens; ink on paper
Each 160.5 x 352.5 cm (63 1/4 x 138 3/4 in.)
Signatory inscription: *Painted by Ōkyo at Enkō Retreat in the summer of [1776]*
Square intaglio seals: *Ōkyo no in* and *Chūsen*
Enkōji, Kyoto
Important Cultural Property

According to temple records, Shunkō Genkō (1727–87), the abbot of Enkōji at the time these screens were painted, represented the sixth generation of his family to hold that post. Enkōji was a temple of the Nanzenji line, and in 1785 Shunkō became the 307th abbot of Nanzenji itself. Apart from his commissioning of these screens, little is known about his relationship with Ōkyo, although he may have commissioned a 1785 portrait by the artist of Shinshū, the 304th abbot.

During the earliest stages of sumi-e, which ended with the beginning of Muromachi, it was nonprofessional, monastic artists who painted bamboo, plum, and orchid. From the succeeding Muromachi and Momoyama periods there is not a single example of ink bamboo. That is because ink bamboo was almost exclusively a literati subject. It did not gain long-lasting favor in Japan until the Edo period, when Yanagisawa Kien, who had a

famous bamboo garden, and others went so far as to make a speciality of painting bamboo and even incorporated the word *bamboo* in their studio names. Many Edo-period Nanga artists painted the subject, while experimenting with and perfecting their calligraphic brush techniques, for the brush strokes used in the two pursuits are similar.

These screens differ from literati compositions, since Ōkyo endeavored to paint a realistic view of a bamboo forest. Rain batters and bends the thin stalks in the right screen. In the left screen the depth of the forest, whose stalks are engulfed in misty rain, is beautifully rendered in pale ink. Ōkyo painted a similar composition of a flock of sparrows in a bamboo grove on a pair of screens dated 1785. Both are fine examples of the success of Maruyama-school compositions.

Miyajima

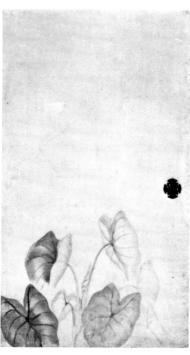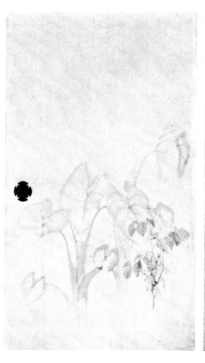

79 MATSUMURA GOSHUN
(1753–1811)

A Field of Taro Root
Circa 1800
Four fusuma panels; ink on paper
Each 168.5 x 92.5 cm (66 3/8 x 36 3/8 in.)
Left panel
Signed: *Goshun*
Square intaglio seal: *Goshun no in*
Kyoto National Museum

Goshun suggested depth not only by subtle shifts from dark ink to light and by the zig-zag placement of these taros and soybeans but also by enshrouding the scene with the humidity of a summer's day. A background lost in mist strengthens the impression. These panels are examples of the artist's finest work.

Goshun first studied with Yosa Buson, thoroughly capturing the latter's style. Four years after his master's death in 1783, he joined Maruyama Ōkyo and his workshop, painting fusuma for Daijōji in Hyōgo Prefecture. Gradually he changed his style in response to his contact with Ōkyo, as evidenced by the naturalism of these panels. Although the artist left no word of his activities at that time, he may have forsaken his bunjinga training because the style of Maruyama Ōkyo was becoming ever more popular. Goshun's stylistic change began about the time he made a second set of fusuma panels for Daijōji in 1795, the year Ōkyo died. Paintings done the following year for Myōhōin show Goshun's transformation completed. Later he tried to maintain the dominant position and fame of the Maruyama school.

Miyajima

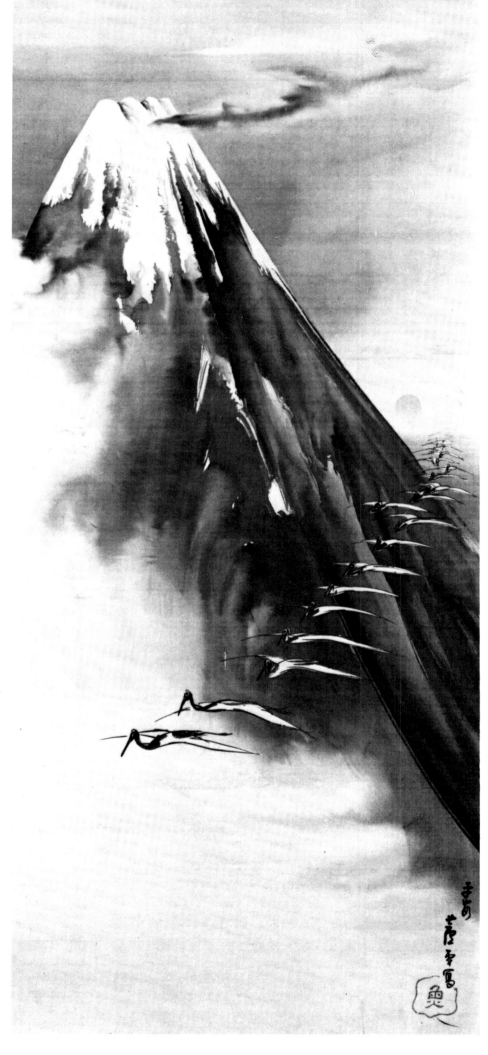

80 NAGASAWA ROSETSU
(1754–99)

Cranes Flying by Mount Fuji
Mid-1790s
Hanging scroll; ink and color on silk
157.0 x 70.5 cm (61 3/4 x 27 3/4 in.)
Signatory inscription: *Heian Rosetsu*
Irregular relief seal: *gyo*
Private collection, Okayama Prefecture

On a trip to Miyajima in 1794, Rosetsu received favors from a merchant family for whom it is believed he painted this scroll. The signature, close in style to that on the artist's *Eight Views of Miyajima* of the same year, helps date this work.

Skillful brushwork and bold compositions are characteristically, if paradoxically, paired in Rosetsu's work. Mount Fuji's volcanic cone widens from tip to base, but in a striking departure from conventional views, Rosetsu emphasizes the mountain's height by painting it within a long, narrow panel of silk. The artist favored such pointed, triangular shapes, and in this case he accentuated the surface with coarse, powerful brush strokes. Lower down, the mountain dissolves in ink wash mist. The clearly drawn line of cranes, diminishing in scale as it recedes, is also unusual for this period. Such a painting reveals Rosetsu's tendency toward extreme contrasts.

Miyajima

Nagasawa Rosetsu (1754–99)
Monkey
1786
One six-fold screen of a pair; ink on paper
159.0 x 361.0 cm (62 5/8 x 142 1/8 in.)
Sōdōji, Wakayama Prefecture
Important Cultural Property

81 NAGASAWA ROSETSU
(1754–99)

Playful Monkeys on a Rocky Cliff
Early 1780s
One six-fold screen of a pair; six-fold
screen; ink and light color on paper
169.5 x 375.6 cm (66 3/4 x 147 7/8 in.)
Square intaglio seals: *Rosetsu* and
Masakatsu
Private collection, Osaka

Although the date of Rosetsu's entry into
Maruyama Ōkyo's workshop is un-
documented, a screen by him entitled *Cus-
toms and Famous Places of Higashiyama* was
painted at the Maruyama residence in 1778.
Thus it appears Rosetsu must have been
associated with Ōkyo by his early twenties.
During his travels to south Wakayama Pre-
fecture in 1786, Rosetsu painted numerous
temple fusuma and wall panels. From the
style of the seals, this screen of monkeys
seems to be among the few surviving works
that could have predated Rosetsu's travels.

A pair of screens at Sōdōji in Wakayama

Prefecture feature a similar composition.
Rosetsu, in fact, often painted more than
one version of a composition, subtly vary-
ing his designs or techniques with each
rendering. The Sōdōji version, painted en-
tirely in ink, features one white monkey
rather than the three seen on the cliff here.
Moreover, in this screen the subdued brush
strokes of the rocks and the red and green
accents among the ivy prefigure the bolder
Sōdōji screens.

Miyajima

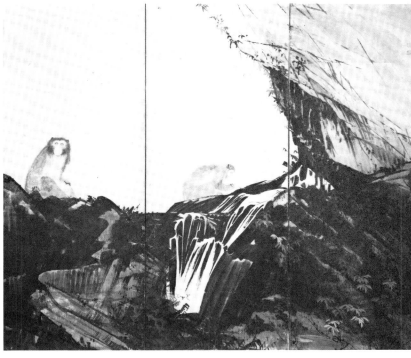

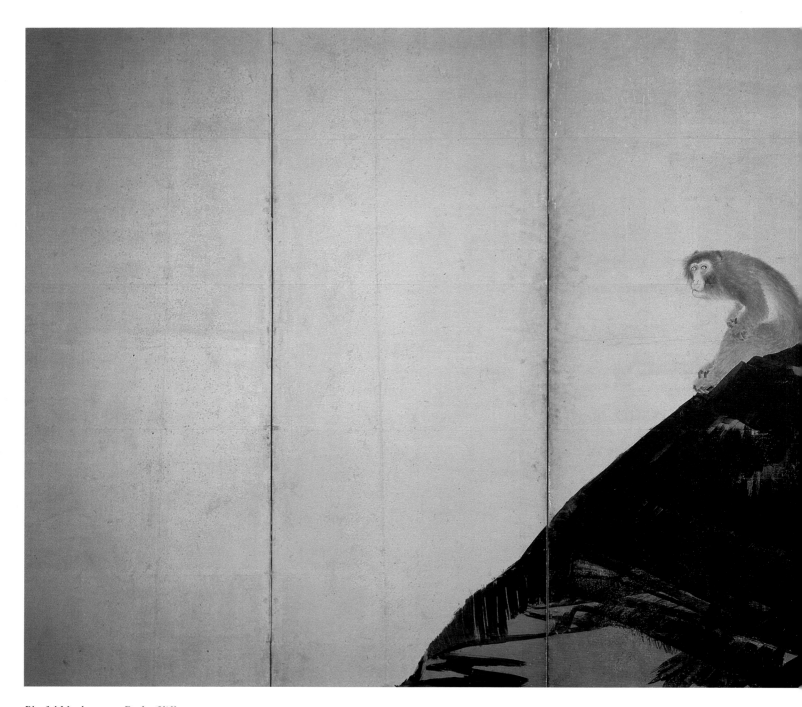

Playful Monkeys on a Rocky Cliff
(cat. no. 81)

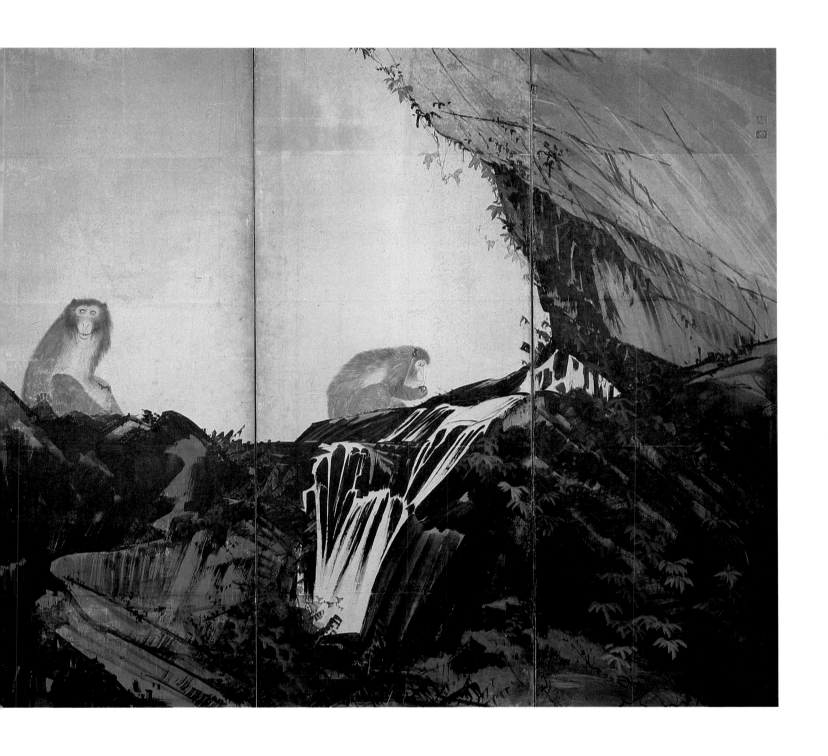

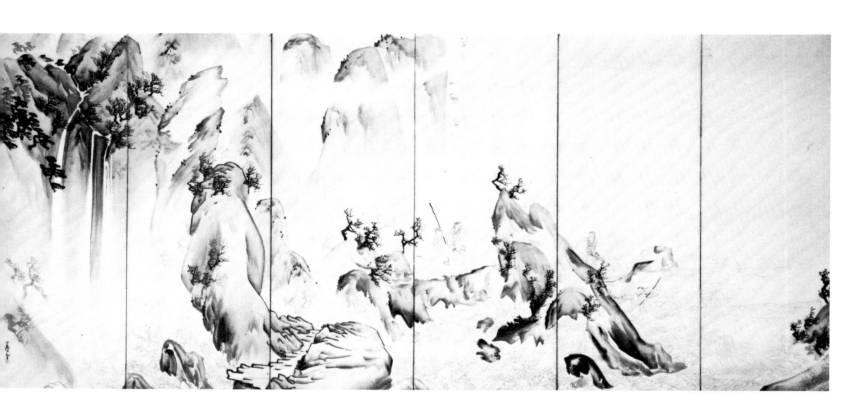

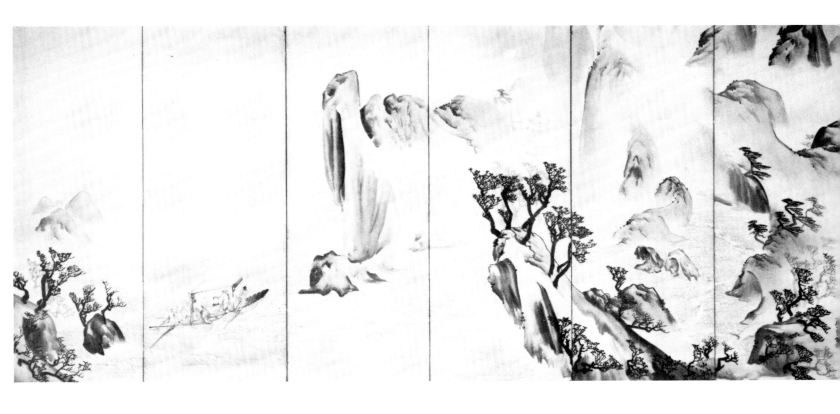

82 NAGASAWA ROSETSU
(1754–99)

The Red Cliff
Datable to 1790
Pair of six-fold screens; ink and light color
on paper
160 x 360.4 cm (63 x 141 7/8 in.)
Right screen
Signatory inscription: *Sketched by
Nagasawa Rosetsu*
Square intaglio seal: *Inkyo fu*
Left screen
Signed: *Rosetsu*
Square intaglio seal: *Inkyo fu*
Private collection, Osaka

These screens depict the scenery of the Red
Cliff, celebrated in two prose poems writ-
ten in 1082 by the Song literatus Su Shi
(1036–1101). Ike no Taiga, Sakaki Hyaku-
sen, and many other Japanese literati paint-
ers favored this subject, and Rosetsu
painted it on two occasions.

A pair of screens in the Nezu Museum
shares a similar composition and, more-
over, bears the same signature and seals.
While the two sets were probably painted
at about the same time, the Nezu screens
are about two meters wider and thus incor-
porate more negative space. In those
screens, Rosetsu used color sparingly on the
figures alone.

From the density of composition and
color in the Osaka screens, it would appear
that they are the artist's first attempt at the
subject. Rosetsu only began to paint land-
scapes in his thirties, although from that
time they became his primary subjects.

Miyajima

175

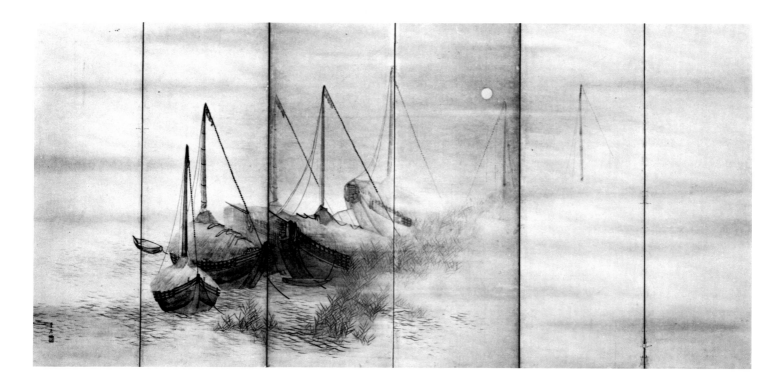

83 OKAMOTO TOYOHIKO
(1773–1845)

Moored Boats
Early nineteenth century
One six-fold screen of a pair; ink and light
color on paper
136.0 x 276.0 cm (53 1/2 x 108 5/8 in.)
Signed: *Toyohiko*
Square intaglio seals: *Toyohiko* and *Shigen*
Kyoto National Museum

Boats covered by rush mats float silently at their moorings beside a reed-clogged shore. The moon rises above the evening mist, which cloaks more distant boats. No man breaks the spell of the gently lapping waves.

This autumn scene is paired with a wintry view of a solitary boat making its way up river. Both screens are imbued with idyllic tranquility.

Boats covered with rush mats, nicknamed *kitamae-bune*, were used by Ōmi merchants to transport products from Hokkaido and northern Honshu to Osaka. This screen could be a reference to a successful merchant's fleet and may have been commissioned with that in mind.

Toyohiko entered Matsumura Goshun's studio in 1798. Goshun himself had painted a version of this theme on fusuma panels for Daigōji; Toyohiko repeated the theme on fusuma for a Shugakuin pavilion in 1824. This screen, reminiscent of Goshun's work, would seem to predate Toyohiko's independence from his master.

Miyajima

176

84 MOCHIZUKI GYOKUSEN
(1794–1852)

Arashiyama
Dated 1843
Six-fold screen; ink and light color on paper
164.5 x 360.0 cm (64 3/4 x 141 3/4 in.)
Signatory inscription: *Painted in autumn [1843] by Mochi Gyokusen*
Square intaglio seal: *Shigeteru no in*; square relief seal: *Shinshō*
Private collection, Kyoto

Arashiyama, located in the western suburbs of Kyoto, is famous as a place to view the moon, and a full moon was originally a part of this screen, an appropriate symbol for an artist whose surname literally means "facing the moon." Gyokusen followed Nagasawa Rosetsu in silhouetting his subject: the Katsura River beneath the rising mist at the foot of Arashiyama. While Rosetsu usually abbreviated his compositions to emphasize a single motif, here Gyokusen drew trees layer upon layer in light and dark ink tones.

Gyokusen came from a family of painters but lost his father an an early age. He first studied painting with Murakami Tōshū (fl. 1800) before entering the studio of Ganku (d. 1838), where he became one of the outstanding students. Later he established an independent studio, practicing the Maruyama-Shijō style. More delicate in execution than Shijō works, this screen captures Gyokusen's lyricism.

Miyajima

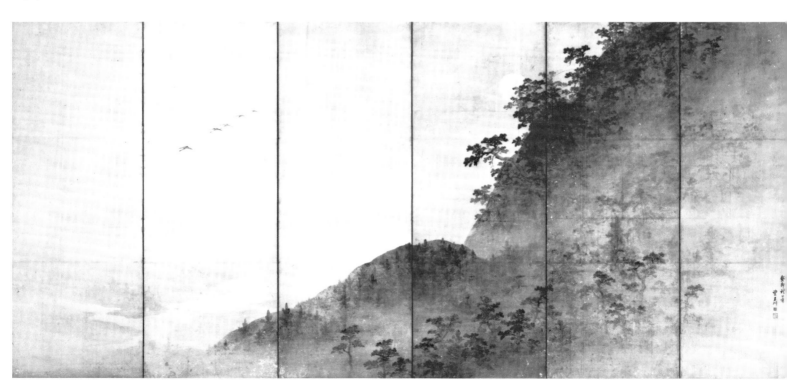

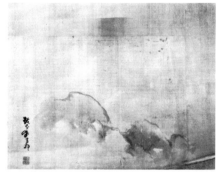

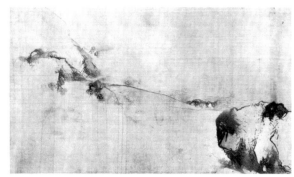
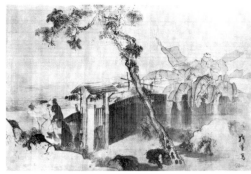

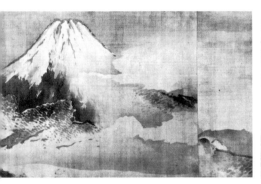
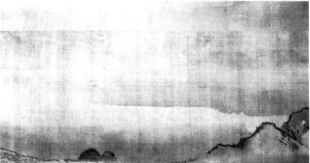
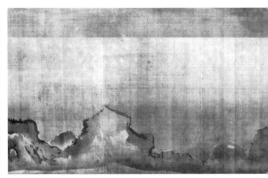

85 SHIBATA GITŌ
(1780–1819)
YAMAGUCHI SOKEN
(1759–1818)
and KISHI GANKU
(1749–1838)

A Handscroll by Shijō School Artists
Early nineteenth century
Handscroll; ink and color on silk
46.5 x 1325.0 cm (18 1/4 x 521 5/8 in.)
"A Boy Tames a Crane"
Signed: *Gitō*
Square intaglio seals: *Gitō* and *Ichū*
"Snow Landscape"
Signatory inscription: *Heian Soken*
Square intaglio seal: *Soken no in*
"Mount Fuji"
Signatory inscription: *Echizen suke Ganku*
Paired rectangular intaglio seals: *Kakan*
and *Ganku*
Tokyo National Museum

This handscroll is composed of paintings by three artists: Shibata Gitō, a pupil of Goshun; Yamaguchi Soken, who studied with Ōkyo; and Ganku, who formed his own workshop in Kyoto to rival Goshun's after Ōkyo's death. Albums combining paintings by various masters became popular during the late Edo period, and this handscroll would seem to reflect the same taste.

Unlike most Shijō artists, Gitō specialized in painting Chinese figural subjects. Here a young boy attempts to hold a willful crane beside a gate sheltered by a banana tree.

Most of Soken's extant works are of beautiful women, but here he is represented by a rare snowscape, the finest segment in the scroll.

Ganku's style derived from his study of Nagasaki-school painting, but here Mount Fuji is defined by heavy texture strokes in dark ink.

Ganku received the honorary title *Echizen no suke* (governor of Echizen Province) in 1808. This scroll therefore must have been painted after that year but before the death of Soken in 1818.

Miyajima

179

GLOSSARY

Bunjin	Japanese literati who emulated the cultivated pursuits of the Chinese gentleman-scholar by practicing painting, poetry, and calligraphy.
Bunjinga	Paintings by Nanga artists who followed the Chinese ideals of literati painting from the seventeenth through the nineteenth centuries in Japan.
Byōbu	A folding screen, usually two or six panels adorned with painting.
Fude	Japanese brush used for writing and painting.
Fusuma	Sliding door panels mounted on a track, constructed of paper over a wood frame, usually adorned with painting.
Gofun	White pigment composed of calcium carbonate (seashells) used as a ground or as a surface embellishment in relief.
Haboku	"Broken ink"; a monochrome-painting technique with texturing strokes to define form. Later in Japan haboku referred to the spontaneous application of successive washes.
Hatsuboku	"Splashed ink"; an expressive technique whereby monochrome ink is splattered on the surface of a painting.
Hōgen	A high priest's title occasionally given to noted artists.
Hōin	A title of the highest priestly rank, also given to artists.
Hokkyō	An honorary title for Buddhist monks and artists.
Ippin	(Chinese: yipin); a category of artists noted for their eccentric paintings produced by bizarre techniques during the Tang dynasty in China.
Kachō	A subject category of painting comprising birds and flowers and other forms of natural life.
Kanga	Japanese ink painting influenced by the styles and techniques of Chinese painting of the Song and Yuan periods.
Kara-e	A mode of Japanese painting of Chinese inspiration illustrating Tang Chinese subjects and styles principally during the Nara and Heian periods.
Mokkotsu-hō	"Boneless" technique; refers to painting without outlines.
Raigō scenes	A Buddhist painting illustrating Amida Buddha and his retinue descending to earth to escort the soul of a dying believer to the Western Paradise.
Sabi	An aesthetic concept based on the Zen doctrine of "mindlessness," seeking eternal beauty that endures despite time or physical change.
Sansui	Landscape painting.
Senzui byōbu	Secular landscape screens painted during the later Heian period in kara-e style; later they were used in Buddhist ordination ceremonies.
Shibui	A Zen tenet that found beauty in restraint; the practical, unassuming, and durable in refined taste.
Shitōga	"Fingertip painting"; a method favored by Nanga artists using their fingers or nails to create unusual effects.
Suibokuga	Japanese ink painting practiced during the Kamakura and Muromachi periods

with line and ink wash. In general usage it refers to ink painting of all periods.

Sumi-e Ink painting executed from the Nara to the Kamakura period which was based on the Chinese linear style of the Tang period. In general usage the term simply distinguishes monochrome ink painting with line and wash of all periods from colorful painting utilizing heavy pigment. Ink sticks of fine charcoal and glue (*sumi*), when mixed with water, create a versatile medium of extraordinary tonal richness.

Tarashikomi A painting technique in which ink, dropped into a puddle, creates accidental patterns in spreading pools.

Tsuketate A technique of layering ink washes that enhances the three-dimensionality of forms in a painting.

Wabi A Zen aesthetic idea incorporating humility and simplicity, developed by Sen no Rikyu, which sought inner beauty concealed under a wretched surface.

Yamato-e As opposed to kara-e, painting in the Japanese style that developed during the Heian period, independent of Chinese influence, utilizing fine lines and heavy color to create images illustrating Japanese themes of literature and legend.

BIBLIOGRAPHY

Books and Articles in English

Addiss, Stephen. *Zenga and Nanga*. New Orleans: New Orleans Museum of Art, 1976.

————, et al. *A Myriad of Autumn Leaves: Japanese Art from the Kurt and Millie Gitter Collection*. New Orleans: New Orleans Museum of Art, 1983.

Cahill, James. *The Distant Mountains: Chinese Painting of the Late Ming Dynasty, 1570–1644*. New York: Weatherhill, 1982.

————. *Parting at the Shore: Chinese Painting of the Early and Middle Ming Dynasty, 1368–1580*. New York: Weatherhill, 1978.

————. *Sakaki Hyakusen and Early Nanga Painting*. Japan Research Monographs 3. Berkeley: University of California Press, 1983.

————. *Scholar Painters of Japan: The Nanga School*. New York: Asia Society, 1972.

————. "Yosa Buson and Chinese Painting." In *International Symposium on the Conservation and Restoration of Cultural Property: Interregional Influences in East Asian Art History*, Tokyo National Research Institute of Cultural Properties, pp. 245–63. 1982.

Covell, Jon Carter. *Under the Seal of Sesshū*. New York: De Pamphilis Press, Inc., 1941.

————. *Zen at Daitokuji*. New York: Kodansha, 1974.

Fontein, Jan, and Hickman, Money L. *Zen Painting and Calligraphy*. Boston: Museum of Fine Arts, 1970.

French, Calvin L., et al. *The Poet Painters: Buson and His Followers*. Ann Arbor: University of Michigan Museum of Art, 1974.

Kanazawa Hiroshi. *Japanese Ink Painting: Early Zen Masterpieces*. Translated by Barbara Ford. New York: Kodansha, 1979.

Matsushita Takaaki. *Ink Painting*. Translated and adapted by Martin Collcutt. Arts of Japan 7. New York: Weatherhill, 1974.

Meech-Pekarik, Julia, et al. *Momoyama: Japanese Art in the Age of Grandeur*. New York: Metropolitan Museum of Art, 1975.

Rosenfield, John M., ed. *Song of the Brush: Japanese Paintings from the Sanso Collection*. Seattle: Seattle Art Museum, 1979.

Shimada Shūjirō. "Concerning the I-p'in Style of Painting." Translated by James Cahill. *Oriental Art* 7 (1961): 66–74; 8 (1962): 130–37; and 10 (1964): 19–26.

Shimizu Yoshiaki and Wheelwright, Carolyn. *Japanese Ink Paintings*. Princeton: Princeton University Press, 1975.

Stanley-Baker, Richard. "Gakuo's Eight Views of Hsiao and Hsiang." *Oriental Art* 20 (1974): 283–303.

Takeuchi, Melinda. "Ike Taiga: A Biographical Study." *Harvard Journal of Asiatic Studies* 43, no. 1 (1983): 141–86.

————. "Tradition, Innovation, and 'Realism' in a Pair of Eighteenth-Century Japanese Landscape Screens." *The Register of the Spencer Museum of Art* 4, no. 1 (1984): 34–66.

Tanaka Ichimatsu. *Japanese Ink Painting: Shubun to Sesshū*. Translated by Bruce

Darling. Heibonsha Survey of Japanese Art 12. New York: Heibonsha/Weatherhill, 1972.

Wheelwright, Carolyn. "A Visualization of Eitoku's Lost Paintings at Azuchi Castle." In *Warlords, Artists, and Commoners: Japan in the Sixteenth Century*, edited by George Elison and Bradwell L. Smith, pp. 87–111. Honolulu: University Press of Hawaii, 1981.

Yonezawa Yoshiho and Yoshizawa Chu. *Japanese Painting in the Literati Style*. Translated and adapted by Betty Iverson Monroe. Heibonsha Survey of Japanese Art 23. New York: Heibonsha/Weatherhill, 1974.

Books in Japanese

Doi Tsuguyoshi. *Hasegawa Tōhaku*. Nihon no bijutsu 87. Tokyo: Shibundō, 1973.

————. *Kinsei Nihon kaiga no kenkyū* (Research on Japanese painting of the early modern period). Tokyo: Bijutsu shuppansha, 1970.

————. *Sanraku to Sansetsu*. Nihon no bijutsu 172. Tokyo: Shibundō, 1980.

Eto Shun et al. *Sansuiga: suiboku sansui* (Landscape painting: Ink wash landscape). Nihon byōbu-e shusei 2. Tokyo: Kōdansha, 1978.

Iijima Isamu. *Tanomura Chikuden*. Nihon no bijutsu 165. Tokyo: Shibundō, 1980.

Kanazawa Hiroshi. *Shoki suibokuga* (Ink wash painting of the early period). Nihon no bijutsu 69. Tokyo: Shibundō, 1972.

Kanematsu Romon. *Chikutō to Baiitsu*. Tokyo: Gahosha, 1910.

Kawakami Mitsugu. *Zen'in no kenchiku* (Architecture of Zen temples). Kyoto: Kawahara shoten, 1968.

Kobayashi Tadashi. *Edo kaigashi ron* (Essays on the history of Edo painting). Tokyo: Ruri shobō, 1983.

————. *Edo Kaiga ii (Koki)* (Edo Painting ii [late]). Nihon no bijutsu 210. Tokyo: Shibundō, 1983.

Kōno Motoaki. *Kanō Tan'yū*. Nihon no bijutsu 194. Tokyo: Shibundō, 1982.

Matsushita Hidemaro. *Ike no Taiga*. Tokyo: Shunjūsha, 1967.

Matsushita Takaaki. *Nihon suibokuga ronshū* (Collection of essays on Japanese ink wash painting). Tokyo: Chūōkōron bijutsu shuppan, 1983.

————. *Suibokuga* (Ink wash painting). Nihon no bijutsu 13. Tokyo: Shibundō, 1967.

———— et al. *Nihon bijutsu kaiga zenshū* (Collection of Japanese painting). 25 vols. Tokyo: Shūeisha, 1976–80.

Miyajima Shin'ichi. *Nagasawa Rosetsu*. Nihon no bijutsu 218. Tokyo: Shibundō, 1984.

Mori Senzō. *Mori Senzō chosakushū* (Collection of Mori Senzō's writings). Vol. 3. Tokyo: Chūōkōronsha, 1971.

Nagoya Municipal Museum. *Owari no kaigashi Nanga* (The Southern School in the painting history of Owari). Exh. cat. 1981.

————. *Shirarezaru Nangaka Hyakusen* (An unknown Southern School painter, Hyakusen). Exh. cat. 1984.

Nakamura Tanio. *Sesson to Kantō suibokuga* (Sesson and ink wash painting of the East). Nihon no bijutsu 63. Tokyo: Shibundō, 1971.

Nakamura Yukihiko. *Nakamura Yukihiko chojutsushū* (Collected writings of Nakamura Yukihiko). Vol. 8. Tokyo: Chūōkōronsha, 1982.

Ōtani Tokuzō et al. *Buson shū* (A collection of Buson), *Koten Haibungaku Taikei* (Library of Classic Literature) 12, (Tokyo: Shūseisha, 1972).

Sakazaki Hiroshi, ed. *Nihon kaigaron taikei* (Compendium on Japanese painting theory). 5 vols. Tokyo: Meicho fukyūkai, 1980.

Sasaki Jōhei. *Edo Kaiga 1 (Zenki)* (Edo Painting 1 [early]). Nihon no bijutsu 209. Tokyo: Shibundō, 1983.

————. *Uragami Gyokudō*. Nihon no bijutsu 56. Tokyo: Shogakkan, 1980.

————. *Yosa Buson*. Nihon no bijutsu 109. Tokyo: Shibundō, 1975.

Shiga Prefecture Cultural Center at Lake Biwa. *Yokoi Kinkoku ten*. Exh. cat. 1984.

Shimada Shujirō et al. *Suibokuga* (Ink wash painting). Zaigai Nihon no shihō 3. Tokyo: Mainichi Shinbunsha, 1979.

Suganuma Teizō. *Kazan no kenkyū* (Studies on Kazan). Tokyo: Mokujisha, 1969.

Suntory Art Museum. *Nanga to shaseiga — Kurashiki Shimotsui Oginoke denrai* (Southern School and Naturalistic paintings handed down in the Ogino family of Shimotsui in Kurashiki). Exh. cat. 1981.

Takeda Tsuneo. *Kanō Eitoku*. Nihon no bijutsu 94. Tokyo: Shibundō, 1974.

————. *Shōbyōga* (Panel and screen painting). Genshoku Nihon no bijutsu 13. Tokyo: Shogakkan, 1967.

———— et al. *Shōbyōga* (Panel and screen painting). Zaigai Nihon no shihō 4. Tokyo: Mainichi shinbunsha, 1980.

Takedani Chōjirō. *Bunjin gaka Tanomura Chikuden* (Literati painter Tanomura Chikuden). Tokyo: Meiji shoin, 1981.

Tanaka Ichimatsu. *Nihon kaigashi ronshū* (Collected essays on the history of Japanese painting). Tokyo: Chūōkōron bijutsu shuppan, 1966.

———— and Yonezawa Yoshiho. *Suibokuga* (Ink wash painting). Genshoku Nihon no bijutsu 11. Tokyo: Shogakkan, 1970.

———— et al. *Suiboku bijutsu taikei* (Compendium of ink wash painting). 15 vols. and two supplements. Tokyo: Kōdansha, 1973–77.

Tanaka Kisaku. *Shoki nanga no kenkyū* (Research on early Southern School painting). Tokyo: Chūōkōron bijutsu shuppan, 1972.

Tochigi Prefectural Museum. *Shazanrō Tani Bunchō*. Exh. cat. 1979.

————. *Watanabe Kazan*. Exh. cat. 1984.

Tsuji Nobuo. *Jakuchū*. Tokyo: Bijutsu shuppansha, 1974.

————. *Kisō no keifu* (Lineages of eccentrics). Tokyo: Bijutsu shuppansha, 1970.

———— et al. *Bunga no hana kisō no tori* (The flower of elegance, the bird of eccentricity). Kachōga no sekai 7. Tokyo: Gakushū Kenkyūsha, 1983.

———— et al. *Edo jidai no bijutsu* (The arts of the Edo period). Tokyo: Yūhikaku, 1984.

Watanabe Akiyoshi. *Shōshō hakkei* (Eight views of Xiao and Xiang). Nihon no bijutsu 124. Tokyo: Shibundō, 1976.

Watanabe Kazan sensei kinshin zufu (Illustrated catalogue of works produced by Watanabe Kazan while in confinement). N.p. 1941.

Yamaguchi Prefectural Museum. *Unkoku Tōgan to Momoyama jidai* (Unkoku Tōgan and the Momoyama period). Exh. cat. 1984.

Yamakawa Takeshi et al. *Kachōga: kachō, sansui* (Bird-and-flower painting: bird and flower, landscape). Nihon byōbu-e shusei 8. Tokyo: Kōdansha, 1978.

Yamane Yūzō. *Sōtatsu to Kōrin*. Genshoku Nihon no bijutsu 14. Tokyo: Shogakkan, 1969.

Yamato bunkakan. *Yosa Buson meisakuten* (Masterpieces by Yosa Buson). Exh. cat. 1983.

Yonezawa Yoshiho and Yoshizawa Chū. *Bunjinga* (Literati painting). Nihon no bijutsu 23. Tokyo: Heibonsha, 1966.

Yoshizawa Chū. *Ike no Taiga*. Nihon no bijutsu 26. Tokyo: Shogakkan, 1973.

————. *Nihon nanga ronkō* (Essays on Southern School painting of Japan). Tokyo: Kōdansha, 1977.

———— and Yamakawa Takeshi. *Nanga to shaseiga* (Southern School painting and naturalistic painting). Genshoku nihon no bijutsu 18. Tokyo: Shogakkan, 1969.

Articles in Japanese

Aimi Kōu et al. "Ryū Rikyō tokushū" (Special issue on Yanagisawa Kien). *Yamato bunka kenkyū* 19–20 (1958).

Doi Tsuguyoshi. "Kanō Shigenobu hitsu Shōshō hakkeizu byōbu" (A screen painting of the eight views of Xiao and Xiang painted by Kanō Shigenobu). *Kokka* 1025 (1979).

Hoshino Suzu. "Nakabayashi Chikutō no shasei — *chōraku shunbozu* no shokai o ki ni" (Introducing *chōraku shunbozu*, an example of Nakabayashi Chikutō's drawing from life). *Kokka* 1075 (1984).

Hosono Masanobu. "Nakayama Kōyō ron." *Tokyo kokuritsu hakubutsukan kiyō* 5 (1970).

Iizuka Beiu. "Rinkoku sanjin." *Shoga kottō zasshi* 160–61 (1921).

Kawai Masatomo. "Yūshō hitsu Shōshō hakkeizu" (Paintings of the eight views of Xiao and Xiang painted by Yūshō). *Bijutsushi* 63 (1966).

Kōyama Noboru et al. "Tokushū Okada Beisanjin, Hankō" (Special issue on Okada Beisanjin and Hankō). *Kobijutsu* 53 (1977).

Miyajima Shin'ichi. "Santo ni okeru Nanpin gafū no denpan" (The transmission of the Nanpin style to three major cities). *Yamato bunka* (in press).

Mochizuki Shinjō. "Okada Beisanjin, Hankō fushi no shōgai" (The lives of Okada Beisanjin and Hankō, father and son). *Kokka* 706 (1951).

Ogawa Tomoji. "*Gamazu* no sakusha Hayashi Jukkō" (Hayashi Jukkō as the painter of *Gama*). *Kokka* 1058 (1982).

Sasaki Jōhei. "Ike no Taiga — Sono seisaku katei ni kansuru ichi kosatsu" (An investigation into the creative process of Ike no Taiga). *Yamato bunka* 65 (1979).

_____. "Ōkyo kankei shiryo *Banshi* bassui" (Selections from *Banshi* relating to Ōkyo). *Bijutsushi* 111 (1981).

Satō Yasuhiro. "Jakuchū ni okeru mosha no igi" (The significance of copying to Jakuchū). *Museum* 364 (1981).

Takeda Kōichi. "Ike no Taiga no shiboku ni tsuite" (Concerning Ike no Taiga's finger painting). *Tokyo geijutsu daigaku bijutsu gakubu kiyō* 14 (1979).

Tanaka Ichimatsu. "Bunsei to Bunsei." *Bijutsushi* 11 (1954).

Tanaka Toyozō. "Ransai Ganku." *Kokka* 362 (1911).

Togari Soshin'an. "Takahashi Sōhei." *Zōkei geijutsu* 24 (1941).

Tsuji Nobuo. "Ise no Shohaku ga — Matsuzakashi no ihin o chūshin to shite" (Shōhaku paintings in Ise, focusing on extant works in Matsuzaka City). *Kokka* 952 (1972).

Yabumoto Kōzō. "Ri Ko hitsu *wantei enkajō*" (Li Heng's *Album of Mist and Clouds*). *Kokka* 1010 (1978).

Yamakawa Takeshi. "Nanki ni okeru Nagasawa Rosetsu no sakuhin" (Nagasawa Rosetsu's paintings in southern Kii). *Kokka* 860 (1963).

Yamane Yūzō. "Eya ni tsuite" (Concerning painting workshops). *Bijutsushi* 48 (1963).

Yokoi Kinkoku. "Kinkoku shōnin gyōjōki" (Life of Yokoi Kinkoku, as translated into modern Japanese by Fujimori Seikichi). *Tōyō bunko* 37. Tokyo: Heibonsha, 1965.

Yoshida Toshihide. "Yamamoto Baiitsu kenkyū josetsu" (Preliminary investigation of Yamamoto Baiitsu). *Nagoyashi hakubutsukan kenkyū kiyō* 2 (1979).

Yoshizawa Chū. "Hoashi Kyōu hitsu bokuchiku zu" (A painting of ink bamboo by Hoashi Kyōu). *Kokka* 955 (1973).

INDEX

Index of Works

Italic numbers indicate illustrations